POP goes KOREA

Behind the Revolution in Movies, Music, and Internet Culture

Mark James Russell

Stone Bridge Press • Berkeley, California

Published by
Stone Bridge Press
P. O. Box 8208
Berkeley, CA 94707
TEL 510-524-8732 • sbp@stonebridge.com • www.stonebridge.com

2012 2011 2010 2009 2008 10 9 8 7 6 5 4 3 2 1

LIBRARY OF CONGRESS CATALOGING-IN-PUBLICATION DATA
Russell, Mark James, 1970–
 Pop goes Korea: behind the revolution in movies, music, and internet culture / Mark James Russell.
 p. cm.
 Includes index.
 ISBN 978-1-933330-68-6
 1. Mass media and culture—Korea (South) 2. Popular culture—Korea (South) I. Title.
 P94.65.K6R87 2008
 302.23095195—dc22
 2008016044

Contents

Introduction

By the time I arrived in South Korea in 1996, this small East Asian nation had already pulled itself out of poverty and overcome its turbulent history to create a modern, middle-class nation. After twenty-five years of frenzied development, most of the major cities had taken shape, roads were laid out, and neighborhoods were well defined. All the really big changes had taken place.

With, however, one major exception—Korea's modern pop culture. The movie industry, music, comic books, television, and more all underwent complete transformations over the next decade. Through no design of my own, I was living there at the time and saw it all. In almost every genre, the changes to Korea's pop scene in the late 1990s and early 2000s were incredible.

When I first arrived in Korea, I taught English. When I asked my students for advice on what Korean movies to watch, I received a lot of embarrassed looks and hemming and hawing. Some students offered an opinion, even with enthusiasm. But I mostly heard embarrassed laughs and advice like "It's all bad." Music was a little different. The first dance-pop wave had already hit, with young people going crazy for Seo Taiji and Boys, and dance groups springing up like weeds after Korea's rainy season. Korea's television dramas were already established, although, as with music, almost no one outside Korea was aware of them. Comic books and animation were extremely popular, with Japan supplying the bulk of the materials.

◄

From the beginning of my time in Korea, these were the aspects of Korea that fascinated me. I checked out what concerts I could find, and while most of them were bad heavy-metal hair bands, I did stumble across the quirky underground group Hwang Shin Hye Band at a tiny underground venue in western Daejeon. When I moved to Seoul, I was so impressed by the energy of the music and art scenes that not only did I want to learn more about them, I wanted to write about them, too. The great dance beats of Saebome Pin Dalgikkot. The bizarre trot parody of Bolbalkkan. The artists and quirky people who populated the bars and all-night establishments of the Hong-ik University neighborhood in western Seoul. Korea had been such a conservative, work-oriented culture for so long, there was a real sense in the 1990s that the arts and pop culture were driving a fundamental change, creating a new Korea. After a few stories for local English-language publications, gradually international newspapers and magazines started buying my articles. When I was lucky enough to stumble into *Billboard* and the *Hollywood Reporter* in 2002, a new career was born.

Today, the huge success of Korean pop culture is well known. At home, South Koreans watch far more of their own movies than Hollywood imports. They listen, dance, and rap to their own music far more than anything from the United States (or Europe or even Japan). Foreign programs have almost vanished from televisions' regular, terrestrial channels, banished to the cable dial.

Abroad, Korean culture similarly caught on in ways no one could have predicted in the 1990s. In February of 2006, for example, giant posters of the Korean singer Rain blanketed the city of Bangkok, far more numerous and imposing than those for Franz Ferdinand or any Western act passing through. In March that year, in the hip Tokyo neighborhood of Roppongi, a new movie theater opened up, chiefly for Korean films. The newest, nicest movie theater in Ulaanbaatar, Mongolia, is run by a South Korean company and usually has at least one Korean film playing. In 2005, the biggest television hit in Hong Kong was not *CSI* or *24*, but the Korean period drama *The Jewel in the Palace*; over 3 million of the city's 6.5 million residents tuned in to see the final episode. And a look around any black market in Asia will reveal an impressive collection of CDs, DVDs, and whathaveyou of South Korean content.

In short, at home, around Asia, and increasingly around the world, Korean movies, music, television dramas, comic books, and more are hot items, both artistically and commercially, winning awards and enthralling fans in ever-larger numbers.

So how did South Korea come to this special point? Who had a vision that Korean culture could compete on the world stage? What was special about Korea and Koreans that enabled them to go toe-to-toe with Hollywood and the Western entertainment machine, which has overwhelmed almost every other culture around the world? What allowed them to compete with Japanese pop culture, which exerts a huge influence around Asia?

Korean History: A Primer

Korea's artistic traditions date back centuries and mirror its long and often turbulent history. Most historians think Koreans are probably descended from the people of Mongolia, but China has been the dominant influence over the centuries. Culturally, Korea's oldest traditions are shaman in origin, with China adding Confucianism and Taoism first, then Buddhism in the fourth century.

The first major government in what is now Korea was called Gojoseon, dating back to 2333 BC according to myth, but more likely, the Gojoseon government developed into a state from the seventh to fourth centuries BC. Gojoseon gave way to the Three Kingdoms period in the first century BC, with Goguryeo in the north, Baekje in the southwest, and Silla in the southeast. In the seventh century,

The Dear Director
Kim Jong-il, leader of North Korea, has long been reputed to be an avid film fan, owning over 20,000 videotapes (no word on his DVD collection). He even wrote *On the Art of the Cinema*, the ultimate book on filmmaking (well, if you are a North Korean filmmaker).

© The People's Korea

Silla teamed up with China to take out its rivals and unite the Korean peninsula. That was followed by the Goryeo dynasty in 918, and the Joseon dynasty in 1392 (also written "Chosun" in another Romanization system). The Joseon ruled Korea until Japan colonized the peninsula in 1910.

The Joseon dynasty began with an incredible flourishing of creativity. Most famously, King Sejong led the creation of *hangul*, the Korean writing system, unveiled in 1446. Although originally considered only for the "vulgar" classes and women, and not widely used until the twentieth century, hangul was nonetheless an impressive achievement. Koreans still take great pride in their writing system.

The thirteenth to the sixteenth century in Korea was a fruitful time for many inventions and innovations. Koreans invented, in addition to hangul, the metal, movable-type press around 1234, years before Gutenberg. (Unfortunately, no one in Korea or China invented the mechanized press, making their inventions much less efficient than the Gutenberg press, which is why Korean and Chinese presses never caught on and revolutionized their worlds.) Koreans were, at the time, one of the foremost masters of astronomy in the world. Water clocks, rain gauges, sundials, and many other technical achievements mark the period.

Unfortunately, the creativity didn't last. The Imjin War of 1592, when the Japanese, led by Hideyoshi, invaded and ravaged much of Korea, resulted in an economic and cultural devastation from which Korea did not fully recover for centuries. The country limped along for the next few hundred years, until the end of the nineteenth century brought European powers to East Asia, along with the rise of Japan.

The other defining aspect of Joseon Korea was its conservative Confucian social order. First introduced to Korea in the Three Kingdoms period, Confucianism had risen and fallen in importance over the centuries, but during the Joseon dynasty, it rose like never before. Under this neo-Confucian philosophy, life was all about hierarchical relationships—man over woman, older over younger, father over son, king over subject; only friends could be equals. Unlike the science of the early Joseon, the neo-Confucian conservatism has lingered into the present, affecting all aspects of Korean society and culture. In this way of thinking, Koreans put a premium on order

and orderly relations, not innovation or creation—one of the biggest stumbling blocks the arts had to overcome to find the success they know today.

As for the arts and artists in Korea, for most of its history, especially during the Joseon dynasty (1392–1910), a gentleman who wrote poetry, painted, or the like was not a professional artist. Rather, the arts were one aspect of the proper pursuits of a man of leisure. Professional entertainers (singers, actors, and the like) found themselves grouped among the lowest of the low—at the same level as prostitutes and slaves. This distinction between the high arts and the baseness of entertainment also lingers into the present and is being transformed only through the many trials and tribulations of some very dedicated artists and businessmen.

Koreans have long been known as singers and lovers of music, as visiting envoys from China pointed out over 1,500 years ago. There were several musical traditions in the Joseon dynasty. The most famous, the long song-story *pansori* (as seen in the Korean movie *Sopyonje*) grew from the shaman culture of Korea's southwest. In addition, farmers' music, courtly music, and many other forms exist. The Joseon-period musicians also invented six different types of music notation; the first and most important, *cheongganbo*, was created in the mid-fifteenth century.

Perhaps the most important thing to know about Korean traditional music was its free, improvisational nature. Unlike the rigid perfectionism of its neighbors (or even that of Western classical musicians), Korean musicians were expected to merge their teachers' styles and come up with something new. This deeply rooted approach to music was a defining trait of Korean musicians until very recently, when modern dance-pop turned that tradition upside down.

In literature, the novel became popular in the nineteenth century, although it, too, has roots that go back much further. Overall, however, the novel rose up in Korea as an extremely conservative medium. Poets argued that novels were inherently immoral and were best burned (along with some novelists). For the novel to gain acceptance, writers had to emphasize the moral nature of the genre, citing how books could help teach people the right way to live. This prejudice exists into the present, and has had no small amount of spillover into other arts.

Modern Pop Culture

But when we talk about Korean pop culture, we are, of course, talking mostly about modern history. Under Japanese colonial rule (1910–45), Japan was the dominant cultural force. Many Koreans went to Japan to study, learning the language and values of Japan, watching Japanese movies, listening to its music. But even though Japan was the biggest cultural force impacting Korea, it was far from being the only force.

The West had a large impact on Korea, in a number of ways. Classical music swept across the nation in the late nineteenth century, changing how Koreans thought about music. Mining, a major part of the economy for many years, brought Western miners and their culture and ideas. The first movie screening in Korea we know of occurred in 1903, although some researchers think films were shown even earlier in the mining areas. Hollywood movies were incredibly popular in Korea in the 1920s and 1930s. In fact, Korea was Hollywood's biggest Asian market in the 1930s, outstripping even Japan and China.

With the liberation of Korea from Japan at the end of World War II, other foreign influences, especially American, entered as never before. The United States and the United Nations maintained control over the Korean Peninsula south of the thirty-eighth parallel, while the Soviet Union moved in on the northern side. After the upheavals of the Korean War, these influences only increased, as tens of thousands of foreign soldiers remained throughout South Korea.

It was a tumultuous time in the West, too, as rock music began to take shape, ushering in momentous shifts in culture and values. The French Nouvelle Vague movement was changing the world of cinema. Rock 'n' roll, country, and other types of strange music began to leak into South Korea, first on the military bases, then soon into surrounding areas and big cities. And everywhere, television was changing how people lived and were entertained, decimating movie attendance (and IQs) in the process.

The late 1950s and 1960s were Korea's Golden Age of filmmaking. Many of Korea's earliest filmmakers and other artists were educated in Japan during this period. Shin Sang-ok studied film at Tokyo Art School before returning to Korea in 1945. Directors like Shin Sang-ok, Yu Hyun-mok, and Kim Ki-young sparked a wave of energy and creativity, and audiences flocked to the theaters in record

numbers. In the 1970s, however, the film industry felt the brunt of an increasingly authoritarian government. Censorship grew more invasive, and the government harassed production companies that displeased them, forcing most of them out of business. In addition, the 1970s saw the rise of TV in Korea, where it quickly displaced cinema as the center of people's cultural lives, much as it did everywhere around the world.

Music followed a similar pattern. Korea's first rock 'n' roll star, Shin Joong-hyun (no relation to Shin Sang-ok), spent several years of his childhood in Japanese-controlled Manchuria, where his father and Japanese stepmother ran a hair salon. Singers like Shin Joong-hyun, He6, and the Key Brothers got their start in the fifties playing covers of Western music on military bases, then in the sixties began writing their own songs for the Korean public, igniting an era of immense creativity. But the seventies brought a government campaign of oppression against the music scene similar to that against film. In 1972, Shin Joong-hyun was asked to write a song glorifying Major General Park Chung Hee, president of the Republic of Korea from 1961 to 1979. When Shin said no, the problems began. First Shin got in trouble because his hair was too long. Then the government started censoring his songs—not because those songs called for revolution, but because they were "too noisy" and "immoral." A popular joke at the time was to change the words in Shin's song "Mi-in" (Beautiful Woman) from:

> You see it once
> You see it twice.

Sexy Siren
After becoming famous as part of the innocent girl-group FinKL, Lee Hyori went solo and became the undisputed queen of sultry. Lee also foreshadowed the future of Korean pop, becoming the highest-paid female singer in the nation despite her light album sales.

To the more sexually suggestive:

You do it once
You do it twice.

The authorities were not amused. (They never are.)

In 1975, during a big crackdown on marijuana smoking, Shin Joong-hyun and many other singers and artists were rounded up. Those caught with the substance found themselves on a blacklist, unable to perform or work. Soon, people forgot all about those noisy rock stars. What rock music remained grew happier and simpler, its words designed to not offend anyone. Musically, too, the sound regressed, with fuzzy psychedelic guitar work morphing into the simple trot melodies that Park Chung Hee so enjoyed from his younger days.

If the 1960s were the Golden Age of movies, the 1970s the glory years of music, then the 1980s were more ambivalent. The movie industry floundered commercially, although a small "new wave" of directors learned how to use film to criticize the military government more subversively. Music was overwhelmingly bubblegum: a combination of syrupy synthesizers, the trot two-step, and the latest in Western pop. Television entered most households, further changing how people spent their time.

But you cannot keep a good people down, and despite the dark days of the authoritarian government, the people were stirring, yearning for freedom. What brought the biggest change of the 1980s, the Seoul Olympics in 1988, spurred Korea's economy to new heights. In the run-up to the Games in 1987, the anti-authoritarian activists finally won out and brought democracy to Korea. The Olympics themselves brought a new wave of foreign influence when athletes and tourists from around the world arrived in Seoul that summer.

In entertainment, too, 1988 marked the first year foreign movie companies could distribute their own films in Korea. The local movie industry convulsed and rioted against the move, in one famous case even loosing snakes into a theater playing *Fatal Attraction*, the first such foreign-distributed movie.

Across the board, things were looking grim for Korean culture by the early 1990s. Movie attendance sank year after year, falling from a high of 173 million in 1969 to less than 50 million in 1998. With the decline, movie theaters kept closing until there were fewer

than five hundred screens in a country of 48 million. At their nadir, Korean films accounted for less than 16 percent of the nation's attendance totals.

The music industry's low point came a couple of years earlier, around 1990. Western music was by far the choice of most Koreans, accounting for the majority of music sales.

Comic books and animation were not even on the radar before 1994, as both were still considered childish, disreputable art forms. Some Korean animation houses did the grunt work for Japanese and American animators. After the original animators did the creative work, they shipped their projects to South Korea, where dozens or hundreds of animators would slave away, adding all the colors and in-between cells needed to turn a piece of animation into a finished product, a long, difficult, and not terribly creative process.

It is at the risk of stating the overly obvious to say that Korean pop culture is not Japanese. Nor is it Chinese. Nor American. While Korean artists and creators have borrowed much from the rest of the world, they have also made those ideas very much their own.

In particular, it is worth pointing out how different the Korean pop culture industry has become from its Japanese equivalent. Although the Korean movie, music, television, and comics industries were for years built very similarly to Japan's (like much of Korean business), it was only when those fields broke away from the Japan model and began to go their own way that Korean pop culture began to boom.

As in Japan, Korea's pop industry for years concentrated on relationships and hierarchies. To become a movie director, for example, you signed on to a director or production company and worked your way up slowly. When you finally became established enough to make your own movie, you did a movie in the style of your teachers.

Movies today, however, are made in a system much more similar to Hollywood. The emphasis is firmly on the consumer now, as opposed to those making the movies.

The big question—the one this book attempts to answer—is how did Korea's entertainment industry grow so successfully at the end of the twentieth century? Of course, there are dozens if not hundreds of stories involved in explaining the changes, challenges, and achievements that comprised that success. This book looks at just

seven of those stories (not including the occasional digression or related story in the sidebars), with the intent to encompass the breadth of Korean pop culture and be symbolic of the changes the industry went through as a whole.

The seven are:

- The media conglomerate: CJ Entertainment began with a $300 million start-up investment in Dreamworks SKG and grew into Korea's largest media company. But theirs is a story about far more than money.

- The blockbuster: A movie industry is nothing without the movies. And *Shiri* was perhaps the most important film in modern Korean history. It was a blockbuster that revolutionized the industry, broke all the records, and reimagined what it meant to make movies in Korea. Director Kang Je-gyu's story parallels the development of Korea's movies, illustrating the fundamental changes that transformed the entire industry.

- The film festival: The Pusan International Film Festival is the brainchild of three movie scholars whose dream was to launch an annual festival dedicated to the best of international cinema. They never expected it to grow into the biggest film festival in Asia.

- Television: Korean TV dramas sent Korean pop culture around Asia. Top TV actor Lee Byung-hun's career path, from naïve bit player to suave star, mirrors the growth of Korean television.

- The pop music scene: SM Entertainment is Korea's most famous music label, home of such acts as H.O.T., S.E.S., and BoA. Founder Lee Soo-man married his love of music and electronics to create a dance-music empire.

- The Internet Revolution: Sean Yang and his brother Il-hwan never intended to destroy the Korean music industry. But their P2P program Soribada did just that. Their story—and the music industry revival—is the story of Korea's Internet revolution.

- Comic books and animation: Korean comic books have found new life, gaining popularity around the globe. And like

comic books in the West, they form one of the most important sources of raw story ideas that inspire the rest of the entertainment industry.

A Note on Korean Language

Numerous systems for Romanizing Korean script have been used and developed over the years, forcing those writing about Korea to choose one or another system.

Usually, the differences are minor (Pusan under the old system versus Busan in the current, Kyongjoo versus Gyeongju). Sometimes, however, the differences are striking. The Chosun of Chosun dynasty, for instance, is spelled Joseon in the current government system.

My preference is for the current system, which I think does a better job with consonants than previous systems and is mercifully free of those annoying diacritical marks. The most confusing thing about the new system, however, is its vowel sounds. Korean uses a number of vowel sounds, many of them quite unlike anything in English.

a = ah, as in "father"	*i* = ee, as in "feel"
ae = ay, as in "way"	*o* = long o, as in "go"
eo = uh, as in "sung"	*oe* = "way"
eu = euh, like a long "schwa" sound	*u* = oo, as in "moon"
ui = we, as in "squeak"	

While I kept the number of Korean words in this book to a minimum, the varied spelling of Korean names is a huge source of confusion. Koreans sometimes use one system of Romanizing, sometimes another, and quite often no system at all. "Lee," "Yi," "Rhee," and "E" are all the same name. The same is true of "Park," "Pak," and "Bak" (no one, to the best of my knowledge, calls himself "Bark"). Some people get creative with their Romanized spellings, while others follow no pattern I can discern. Since most of the names in this book are those of celebrities, I used the spellings by which they are best known, or the ones they use themselves. The official, government-endorsed system for names also calls for family name first, followed by the first name, hyphenated in two parts. For example, Lee Byung-

hun, with "Lee" being the family name and "Byung-hun" being his "first" name. If someone uses a Western first name, however, then I write it in the standard Western way. For example, Robert Kim.

Acknowledgments

Of course, on any project like this, the list of people to whom I owe immense debts of gratitude is extremely long, and there is no way I could hope to thank them all.

First of all, I would like to thank all the people I profiled in each chapter. Their cooperation was more than invaluable; it was the cornerstone upon which this entire book was built.

I also need to thank all the people I bothered for research, data, and other help. I am sure that Eunice Paek at the Korean Broadcasting Commission and Jung Hyun-chang at the Korean Film Council were more than tired of my endless questions, but they kept answering with patience and kindness, as did Cho Sang-hyun and D. J. Ha at CJ Entertainment, Mina Choi at SM Entertainment, Charles Pak at BH Entertainment, Jimmy Jeong at JYP Entertainment, Catherine Park at iHQ, Lewis Kim at Barunson, Joy Kim at Rain's J-Tune Entertainment, Chun Sujin at the Joongang Ilbo, David Shim, Koh Young-whan, Bernie Cho, and too many others to count.

Yang Haengmin was also incredibly helpful with questions, translations, and so much other miscellanea. I owe you big time.

Amber Kim has long been a first-rate interpreter and translator, too, along with Park Hyun-jung. Darcy Paquet has been the leader of the Korean film story, at least among the Internet generation, and his website (www.koreanfilm.org) has been and is invaluable. Although Darcy, as a writer for *Variety* (and formerly for *Screen*), is ostensibly a competitor, I have never felt that way about him (well, almost never).

Thanks to Stone Bridge Press and my editor Nina Wegner, for agreeing to publish this book and shepherding it through the long, long process of publishing.

And of course to the many, many more people who assisted with this project. Sorry I cannot list you all.

As always, any mistakes of fact or interpretation in this book are mine alone.

After starring in the blockbuster JSA: Joint Security Area (pictured here), Lee Young-ae went on to star in the biggest Korean TV drama ever, Dae Jang Geum (aka Jewel in the Palace).

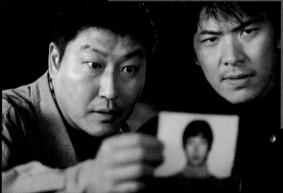

Memories of Murder featured one of Song Gang-ho's best performances, as Detective Park Doo-man (left). Kim Sang-kyung was solid, too, as Detective Seo Tae-yoon.

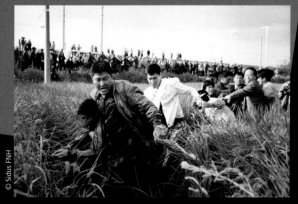

With its great production design and cinematography, Memories of Murder looked amazing, too.

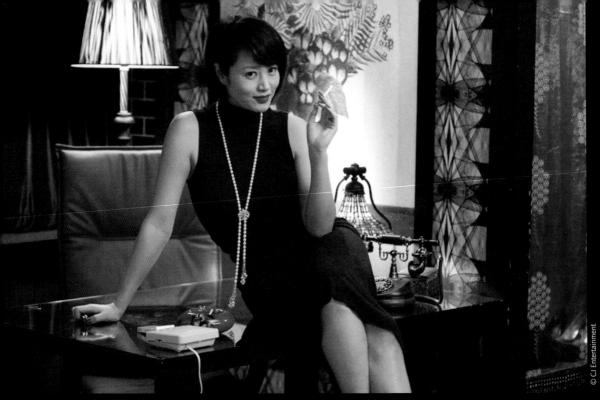

Kim Hye-su revived her career playing the mysterious femme fatale Madam Jung in the 2006 hit Tazza: The High Rollers.

Cho Seung-woo played the gambling neophyte Go-ni in Tazza, a film based on the popular Heo Young-man comic book.

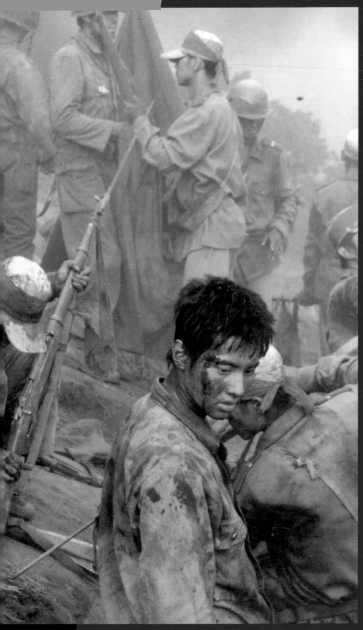

War was definitely hell in Kang Je-gyu's 2004 epic Taegukgi, the third-biggest Korean film ever.

© MK Pictures

Director Kang Je-gyu has revolutionized the Korean movie industry not once, but three times, with his ambitious, commercial epics The Gingko Bed, Shiri, and Taegukgi.

© MK Pictures

To make his epic, Kang used 19,000 military uniforms, 4,000 period costumes, and over 20,000 extras.

The King and the Clown *(2005) was probably the biggest surprise in modern Korean film history, coming out of nowhere to become the second-biggest movie ever, and making an instant star out of Lee Jun-gi (lower left).*

Jeon Do-yeon is the chameleon of Korean cinema, completely changing with each role. For her powerful portrayal of a widow who loses her son in Secret Sunshine, *Jeon won the Best Actress prize at Cannes in 2007.*

© Chungeorahm Films

Bae Doo-na was better know for arthouse hits like Take Care of My Cat, Sympathy for Mr. Vengeance, *and the Japanese film* Linda Linda Linda *before she starred in Bong Joon-ho's* The Host *(pictured above), the most popular film ever in Korea.*

Park Chan-wook's violent thriller Oldboy (2003) *amazed audiences all over the world, making both the director and star Choi Min-shik*

Choi Min-shik played a deadly North Korean agent in Korea's first modern megahit Shiri.

Bae Yong-joon (right) and Son Ye-jin starred in the melodrama April Snow *(2005). Bae, of course, is one of the biggest names when it comes to* hallyu, *or "The Korean Wave," thanks to his starring role in the hit television series* Winter Sonata.

Sol Kyung-gu, one of Korea's most respected actors, had to gain 20 kilograms, learn Japanese, and study professional wrestling to play the Korean-Japanese wrestling legend Rikidozan.

Tony Leung has been to PIFF many times over the years. Here he is with Lee Young-ae in 2004.

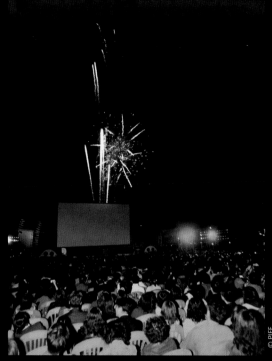

PIFF opens each year before 5,000 people with a grand opening ceremony and plenty of fireworks.

Opening night at the Pusan International Festival takes place on the waterfront, at the Haeundae Yachting Center.

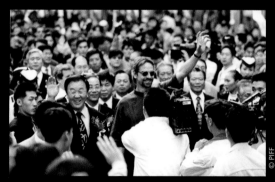

Plenty of stars from around the world come to PIFF each year. Jeremy Irons came in 1997 when his movie Chinese Box *opened the festival.*

Lee Byung-hun had his first big movie hit in 2000 with JSA: Joint Security Area. *Nearly as successful as* Shiri, *it was also the first blockbuster distributed by CJ Entertainment.*

Lee Byung-hun in Japan, promoting his film noir A Bittersweet Life *(2005).*

Lee Byung-hun played a confused student activist in the nostalgic melodrama Once in a Summer.

Lee Byung-hun played one of his darkest roles ever, as the betrayed gangster enforcer Sun-woo in A Bittersweet Life, *directed by Kim Jee-woon (right).*

© CJ Entertainment

Jung Woo-sung played the good guy in Kim Jee-woon's The Good, the Bad, the Weird, *alongside the bad Lee Byung-hun and the weird Song Gang-ho.*

Shin Joong-hyun got his start playing for American soldiers in 1957, when he was still a teenager. He went on to become the godfather of Korean rock music.

남자매력장검

이
수
만

젊음, 그 한가운데서
새롭게 태어난다

Lee Soo-man started as a folk rocker in the 1970s, then founded SM Entertainment in the 1990s and became the biggest music mogul ever in Korea.

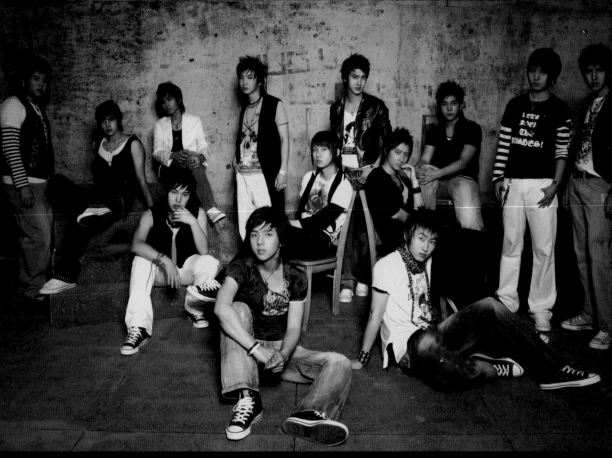

SM Entertainment has created many of the biggest pop acts ever in Korea, such as the sprawling 13-member Super Junior.

© SM Entertainment

One of the biggest girl-groups in Korea was SM Entertainment's S.E.S.

© SM Entertainment

SM Entertainment's supergroup H.O.T started out light and fuzzy, but grew more industrial and edgy with each album.

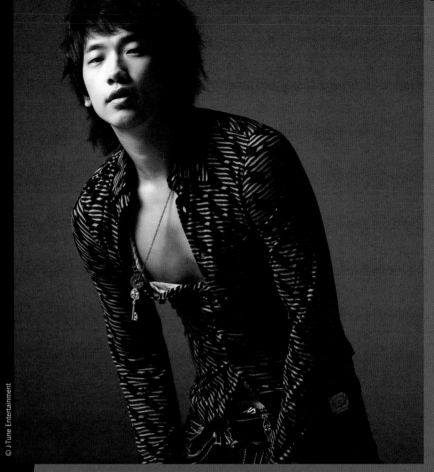

Jung Ji-hoon (aka, "Rain") is one of the biggest stars to burst out of Korea, starring in such Hollywood films as Speed Racer *and* Ninja Assassin.

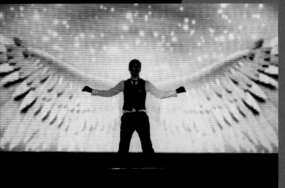

Before he was an actor, Jung Ji-hoon made his name as a spectacular performer, with one of pop music's most elaborate stage shows.

Jung Ji-hoon succeeded thanks to his relentless dedication to improving himself.

© SM Entertainment

Singer Boa has been the biggest Korean pop star in Japan for years, since making her debut there in 2001 at just 14 years old.

© SM Entertainment

© SM Entertainment

Dong Bang Shin Gi has one of the more confusing names in Korean pop. Because each country in Asia pronounces Chinese characters differently, they are called Tohoshinki in Japan and Tong Vfang Xien Qi in China .

Founded in 1998 by SM Entertainment, Shinhwa has moved on to another management company, but continues to be one of the top-selling groups in Korea today.

Korean "Gamblerz" b-boy team member dancing at 2005 World B-Boy Championships in Braunschweig, Germany. As seen in Planet B-Boy, *directed by Benson Lee*

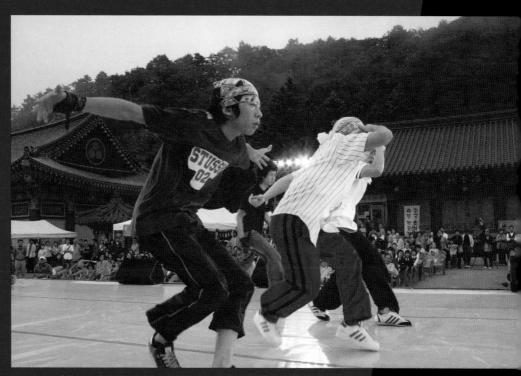

Members of Korean b-boy team "Gamblerz" dancing at a Buddhist temple in South Korea. As seen in Planet B-Boy, *directed by Benson Lee.*

King of Hell, *by Ra In-soo and Kim Jae-hwan, is the tale of a mystical swordsman reborn in the body of a teenager.*

Chronicles of the Cursed Sword, *by Yeo Beop-ryong and Park Hui-jin, is an epic about a young warrior with a rather remarkable sword.*

Arcana, *a fantasy by Lee So-young, tells of an orphan with a magical destiny.*

Rebirth, *by Lee Kang-woo, is the story of a seventeenth century vampire reborn in the twenty-first century.*

Model, *a romantic thriller by Lee So-young, features a struggling artist with a vampire for a model.*

POP goes KOREA

The Deal

By 1995, the Korean movie business was, to put it indelicately, in the toilet. The industry was making fewer films than ever before, fewer people were going to see them, and there were fewer and fewer theaters where you could see them, even if you wanted to. Worst of all, even when people did go, they rarely went to see Korean films—barely one in five tickets sold paid for Korea-made productions. If there were a future for cinema in Korea, one would have predicted it to be all Hollywood, all the time.

So when Miky (Mie-kyung) and Jay (Jay-hyun) Lee, a sister-brother team from one of Korea's most prominent families, decided in 1994 to transform the nation's movie business, the movie business scoffed. Plenty of other rich people had tried, lost a fortune, and left, humbled. What could two young people (in their thirties at the time) who headed a stodgy old sugar refinery have to teach the venerable film community? Who were they to upset the delicate balance that filmmakers, distributors, and exhibitors had created during the past three decades?

The Lees—two greatly different personalities—appeared unlikely to lead Korea's movie revolution. Miky was a down-to-earth academic and eager movie fan, and Jay-hyun a businessman with a taste for sports cars. The sister and brother were raised as part of the incredibly rich and powerful Samsung family, more familiar with microchips and accounting spreadsheets than with celluloid and ce-

lebrities. But the Lees, whose passion for movies led to a vision of what Korean movies could become, defied the doubters, ignored the naysayers, and gambled over $1 billion on their combined abilities to revamp a dying industry.

Saving the Cinema

A generation earlier, Koreans had been huge movie lovers. In 1969, over 173 million movie tickets were sold (in a country whose population then was just 31.5 million). That year, 229 Korean movies were released, plus another 79 foreign films. From 1962 to 1987, Korean films greatly outnumbered foreign imports, thanks to a Motion Picture Law that said distributors could import one foreign film for every three local movies (one reason so many local movies were made). But, throughout the sixties and seventies, the military government censored and harassed film companies, driving most to bankruptcy. With the rise of television after 1969, people steadily shifted their gaze from the silver screen to the boob tube, and cinema attendance steadily dropped.

The Motion Picture Law was changed in 1985, quickly throwing the movie industry completely out of balance. Foreign imports grew swiftly—from thirty imports in 1985 to fifty-one the next year to eighty-five the year after that. In 1988, United International Pictures (UIP) became the first Hollywood studio to distribute its films directly in Korea, to the riotous protests of the local film industry—famously releasing snakes into two Seoul theaters during a screening of *Fatal Attraction*—but the change was inevitable. Hollywood distributors had the muscle and the sexiness, and by 1993, the low point, Korean movies took in less than 16 percent of the box office. The number of foreign releases kept climbing, topping three hundred a year in the 1990s, while the number of Korean films fell, dropping to forty-three by 1998.

If Koreans had little interest in their own cinema at the time, interest in their movies from abroad was positively scant. In 1995, just fifteen Korean movies were exported, bringing in a grand total of $208,679. The rare film might turn up on the festival circuit, but the country was perceived as anything but hip or cool.

One major reason Koreans were not much interested in their films back then was that movie producers were not terribly interested in them, either. The real action was in videocassettes, VCRs, and cable television. The sum of all Korean movie earnings in 1995 barely hit $40 million. That may be more money than you or I have in the bank, but for an entire industry, that is not a lot. The average Korean movie cost just 600 million won in 1990 (around $620,000 at the 2008 exchange rate). Even after large surges in costs throughout the 1990s, the average film budget still reached just 1.2 billion won by 1998.

Korea did have a screen quota, guaranteeing that every movie theater in the nation play locally made films at least 40 percent of the year, about 146 days (although a theater could reduce that to as low as 106 by showing Korean films during certain peak seasons). But the quota had little effect beyond the psychological. Before 1993, it was not really enforced. The movie business was in decline, and attendance shrank year after year. The industry simply failed to make movies that people wanted to see. After Hollywood and the international film industry won the right to distribute their movies directly, without a Korean company go-between, foreign competition grew tougher each year. With small and dwindling revenues, few investors were willing to gamble very much.

The big money was in electronics: VCRs and videotapes. Huge numbers of Koreans were not going to the movie theaters; they were, instead, watching videos at home. For much of the 1990s, the country had over 10,000 registered video rental stores, and probably just as many unofficial ones. As long as a movie made it into the theaters, it was almost assured of making several hundred million won from rental fees at the video stores, around 50 percent of a movie's budget at the time.

Samsung, Daewoo, and LG, big appliance makers, pumped out millions of VCRs in the 1980s and '90s. In addition, Korean companies like SKC and Saehan Media manufactured a huge percentage of the world's videotape. Saehan Media alone accounted for 25 percent of the world market in videotape in 1997, cranking out 400 million tapes that year (exporting over 80 percent of them). SKC made about 12 percent of the world's videotape around that same time. All these companies were investing in movies and entertainment, directly or

indirectly. For example, Samsung created the video distributor Starmax in the 1980s, and from 1992 to 1995 directly invested in and produced movies through various affiliates.

Cable television as well, just started in 1994, was a popular investment route tried out by many of these conglomerates. For many years, it was an expensive flop. The big companies tried to get a piece of it anyway. Samsung had channel Catch One, and Daewoo had Daewoo Cinema Network. All bled money.

The point is, for many of the newest and biggest players in the Korean movie industry, movies themselves just were not very important. The real action was elsewhere. Korean films, neither sexy nor profitable, gave no one reason to imagine a different future.

Making these problems worse was an extremely disorganized and regional distribution system. Korea was divided into seven regions, with a small number of local businessmen controlling distribution in each. Filmmakers made movies mostly for Seoul theaters. When these movies were distributed to theaters in the rest of the country, anything could happen. Regional distributors might dutifully keep track of ticket sales and send their 40 or 50 percent back to the Seoul production house, but then again they might not. Sometimes big hits in Seoul would mysteriously underperform in other parts of the country. It was an unpredictable and at times bizarre system.

For example, back in 1994, one of downtown Seoul's most important theaters, the Joongang Cinema, signed a deal with ShinCine Communications to distribute their film *The 101st Proposition*. The deal called for the Joongang to play the film a minimum number of weeks, with the exception that, should attendance drop below 1,500 people per day, the cinema could put in something else.

That same year, the film everybody wanted to see was Steven Spielberg's *Jurassic Park*. The Joongang owner, like all other theater owners in Korea, was eager to get such an obvious blockbuster onto his screen. *The 101st Proposition, however,* was still under contract, and its attendance was not dropping below the lower limit of 1,500 people. At the time, even the biggest movies rolled out on few screens, usually just fifteen to twenty in the entire nation. In Seoul, a movie would show in only one or two theaters, so it took a long time for everyone who wanted to see a film to get in. With this much

business at stake, getting the blockbuster of the year was a financial bonanza.

So the management at the Joongang took action. First they pulled their ads and promotions for *The 101st Proposition*, and attendance dropped a little. Next, the theater hired some thick-necked goons to stand out front to intimidate customers and prevent them from buying tickets. It did not take long for the film's production company ShinCine to find out about this, but what could they do?

Luckily, ShinCine had good ties with many young progressives willing to stand up for Korean movies. Even in the 1990s, progressives in Korea were used to taking their lumps from the people in charge (be they government or private industry). Plenty of producer Shin Chul's friends had recently gotten work as schoolteachers around the city, so a friend called up the teachers and invited them to bring their students to see the movie.

To further vex the Joongang, one person went to the bank and changed his regular won to thousands and thousands of one-won coins—each worth about one-tenth of a cent, still legal tender, although not in general circulation. With movie tickets costing about 4,000 won each, that added up to a lot of coins.

The students came to see the movie, carrying great bags of one-won coins, much to the consternation of the thick-necked gentlemen and their employer. By this point, the whole mess had turned into an event. The goons tried intimidating the schoolkids, which led to plenty of shrieking and mayhem. Other progressive friends of Shin-Cine came down to support the drive, such as the well-known and always politically inclined actor Moon Sung-keun (who also starred

North Korean Monsters
One of the most memorable films that Shin Sang-ok made while he was kidnapped by North Korea was the monster movie *Pulgasari* about an iron-eating creature that grows from tiny pipsqueak to mountain-sized behemoth.

in the film). Moon stood on a chair, shouting out the importance of Korean culture and Korean movies, the need for the screen quota, and similar credos. The Joongang management called the protestors communists. It was chaos.

In the end, the Joongang got its *Jurassic Park*. Worried that the situation was escalating and that someone could get hurt, ShinCine's owner/producer Shin Chul asked producer Lee Tae-won (then the top producer in Korea) to intervene. Lee negotiated with the Joongang Cinema, and they decided that the dinosaurs would get to play. In exchange, Shin was promised a prime slot for one of his movies the following summer.

The point here is that much of the movie industry was, to be polite, disorganized. At times, to be less polite, it bordered on organized crime and impending anarchy. Instead of competing to make the best movies and getting as many people as possible to watch them, the movie business was focused on protecting itself from risk—keeping costs down and competition weak. Economists call this "rent seeking" (and no, it has nothing to do with looking for an apartment). It occurs when people (or businesses or organizations) look to improve their situation by protecting their market and manipulating the rules rather than by creating wealth or trading. Basically, we're talking protectionism. Many movie industry businessmen in Korea were not taking risks to make money. They had, instead, created a safe system, where no one risked much, but no one made much money either. That safety was little more than illusion. Year after year, the film business continued to shrivel and flounder.

If something did not change, and fast, the Korean movie business risked dying altogether.

Into this confusing and depressing mess came Miky and Jayhyun Lee. Their company CJ Entertainment was born in 1995 on the upper slope of Mount Namsan, a small mountain in the heart of Seoul, just west of the traditional heart of Korea's movie industry, called Chungmuro. Although nobody knew it at the time, CJ Entertainment would go on to revolutionize the Korean movie industry.

Wedged between the city's old downtown and the northern edge of Namsan, Chungmuro had, in the colonial days, once been a trendy Japanese neighborhood. But in the years after the Korean War, it morphed into the home of many of the nation's production

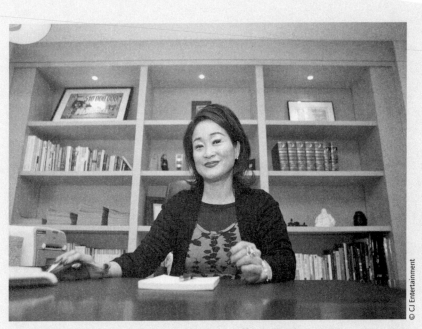
Miky Lee, vice chairman of CJ Entertainment, at her office in Seoul.

companies and major cinemas. Huge and ancient movie theaters lay scattered throughout Chungmuro. The Scala Theater, built in 1935, featured a majestic Italian-style façade, reminiscent of the Teatro alla Scala near Milan. Just south of the Scala sat the giant, redbrick Daehan Theater, one of the biggest theaters in Korea, built in 1955. Between the giants lurked many other theaters, of various sizes and qualities, crammed into commercial spaces and other inglorious venues.

Jay-hyun and Miky had grown up right next to Chungmuro, within a five-minute walk to the Daehan Theater. Miky Lee in particular was a huge movie addict, seeing every film that played at the Daehan. Back then, a person who went to the movies as often as she did was called a "Hollywood kid," even though she loved films from all over the world. In fact, the earliest film she remembers seeing was the Claude Lelouch film *Vivre Pour Vivre*, starring Yves Montand and Candice Bergen, but she saw so many films she cannot be sure which one she saw first. When she recalls her favorites today, her eyes light up—*Mackenna's Gold*, starring Gregory Peck and Omar Sharif, and the films of Olivia Hussey, like *Romeo and Juliet* and *Sum-*

mertime Killer. Not content to watch only the movies showing at the Daehan, her father bought one of the first U-Matic videocassette players (the forerunner of Sony's Betamax), and had his friends in Japan tape movies from television and mail them to Korea. Her father liked documentaries and samurai films, but Miky loved just about everything.

In addition, her grandfather had started Korea's first privately owned television station, TBC, in 1964, and Miky used to go there with him to watch programs, such as the variety shows, as they were being filmed. She especially remembers the singers, classic performers like The Pearl Sisters and Shin Joong-hyun. But in those early days, television ran mostly American programming, featuring shows like *Bonanza*, *Dennis the Menace,* and *The Man from U.N.C.L.E.*

By the 1990s, Seoul's breakneck development was leaving Chungmuro behind. The Daehan was torn down in the late 1990s, replaced with a nice but decidedly unromantic eight-screen multiplex. The Scala limped along, a faded, peeling shell of its former glory, until, in 2005, on the verge of being declared a historical site, it was torn down and turned into a parking lot. Half of Myungbo Cinema's screens were closed, their spaces renovated and turned into the home of MTV Korea. Most of the other small theaters in the area have long since closed. Commercial and residential areas considered hip were now far to the southeast. Even other parts of Seoul's downtown were growing up and cleaning up. But Chungmuro had barely changed. It had grown old and run down, its small shabby buildings lining labyrinthine streets.

CJ Entertainment, however, did not emerge from Chungmuro—it grew from a location above it, perhaps symbolically. Today, CJ Entertainment resides in a shiny modern building in the flashy, cooler parts of the city's south, but in 1995, it called Namsan home, high up in an austere, black, fifteen-story office building.

Now, this is probably a good time to add that I know many people who do not like references to the movies as an "industry" or a "business"—*it's an art, don't you know*. Sure, the movies themselves are what count, and the great success Korean films have had over the last few years required artists, filmmakers with vision and talent, and all that good stuff. However, movies cost money. Big money. Not just money to make, but money for every part of the movie process. Mak-

ing prints of the films for the cinemas (around $2,000 each), convincing people to see the movie (advertising), building the large, concrete boxes where people watch movies—all of these are expensive.

What to do? There had been no shortage of ambitious businessmen looking to take the plunge into the glamorous world of movie making. After all, what's a few tens of millions of dollars compared to the hundred millions and billions of dollars earned in manufacturing and other heavy industries? Plus, one gets to hang out with celebrities. Though plenty of rich people and big companies had attempted to take control of Korea's movie industry, none prior to CJ Entertainment had done much more than get their toes wet. No one really took the plunge. That's what CJ Entertainment did—it took the plunge, going deeper into the water than anyone had gone before.

Korean movie industry success required not just great filmmakers, but also great infrastructure. Creating and maintaining infrastructure, companies, and business models is perhaps not as much fun as spending time with celebrities and great directors. But it is just as necessary. Which is where the Lees and their company CJ Entertainment came in. CJ was the first Korean entertainment company to think big. Sure, several conglomerates had made tentative steps into the movie and entertainment businesses, but CJ's entire *raison d'etre* from the beginning was substantive and ambitious. CJ Entertainment led the whole entertainment industry to overturn the old order (or disorder, depending on how you look at it), breaking down the regionalism and protectionism that had hobbled Korea's movie business. Along the way, they also alienated many, pissed off some, and changed the way the entire film industry worked, helping Korea to become the cultural heavyweight it is today.

CJ Entertainment: A Pre-History

CJ Entertainment is part of the *jaebeol* (Korean business conglomerate) CJ Corp., a company much older than Miky or Jay-hyun Lee. Originally called Cheil Jedang, which means "first sugar factory" in Korean, the company was founded by the giant conglomerate Samsung in 1953.

The story began when Lee Byung Chull, son of a wealthy land-

owner, started a rice mill in the 1930s, a project that soon went bankrupt. Lee regrouped and launched a trucking and real estate business in 1938, calling the new venture Samsung ("three stars"). This also went bankrupt. But the third time's the charm, and by the end of World War II, Samsung was doing quite well. Lee added international trading to the company's portfolio after the war, and grew even more successful during the Korean War. After it, Lee was one of the wealthiest men in Korea.

In 1953, Lee started Cheil Jedang, opening a sugar refinery in Busan. This was a big success, and Samsung (and Cheil) grew rapidly. Cheil also began to mill flour, and kept expanding, producing MSG, then other preservatives and food-related chemicals. From there, it naturally developed into manufacturing pharmaceuticals and other housewares. In 1954, Lee set up the Cheil Wool Textile Company, then kept buying companies and adding affiliates.

On May 16, 1961, Major-General Park Chung Hee carried out a military coup and took charge of the country. Park, former communist organizer (not to mention former teacher and former lieutenant in the Imperial Japanese Army), believed in strong government. He quickly set about reforming the nation, first politically, and, soon after, economically.

Lee at first fled Korea for Japan, worried that Park might have him in his reform crosshairs. But Lee and Park eventually reached an understanding—Lee and Samsung would work with Park and the South Korean government, promoting the projects and people Park wanted, while Samsung would get government favors and easy access to large amounts of credit. It was the birth of the Korean business conglomerate system, *jaebeol*. Samsung flourished, and grew faster and bigger than ever.

In the late 1960s, Samsung began to take a shine to electronics. Samsung-Sanyo Electronics started in 1969, and became Samsung Electronics in 1977. In that same year, Samsung began reverse-engineering color televisions and was soon exporting them, even before any television channels were broadcasting in color in Korea. In 1979, it also started making VCRs, and the next year microwave ovens. But the big shift at Samsung came when the company made the move into semiconductors. In 1974, it bought half of Korea Semiconductors, its first move into microchips, but it was not until the 1980s and

the computer revolution that the scope and significance of this business became apparent.

By the mid 1980s, Samsung was already huge. The "Miracle on the Han," or "Korean Tiger"—choose your cliché—meant that South Korea was no longer the poor, ravaged nation it had been following the Korean War. Incomes soared, jaebeol grew bigger and bigger, and Samsung did, in many respects, lead the way.

Jay-hyun and Miky Lee had grown up firmly a part of the Samsung family, the children of Lee Maeng-hee, eldest son of Lee Byung Chull. Miky was born in Knoxville, Tennessee, where their father attended graduate school in the late fifties and early sixties. The family moved back to Korea when Miky was a toddler (too young to remember anything about life in America). Jay-hyun was born soon after the return to Seoul. The two grew up in a life of privilege, in their grandfather's large house near Chungmuro, along with many cousins and other relatives. Miky Lee was the eldest, but Jay-hyun Lee was the eldest male. Following Confucian tradition, he was raised to be the head of the family, while his sister was free to pursue her studies around the world.

Their father had pretty much retired in the seventies, so it was important to their grandfather, Lee Byung Chull, patriarch of the clan, that his grandson, the heir, be immersed in the family business as soon as possible. Jay-hyun attended prestigious Korea University, where he earned his BA degree in law (he is one of the few jaebeol heirs of his generation who never studied abroad). After graduating, he worked for two years at the Seoul branch of Citibank before coming to Cheil Jedang as a manager in 1983. Jay-hyun started in the

Space Kimchi
With Yi So-yeon set to become the first Korean to travel into space in April 2008, the Korean Aerospace Research Institute made sure she would be able to take kimchi with her. It was no easy feat—usually kimchi is teaming with bacteria, but for space travel, scientists had to find a way to eliminate them from the kimchi.

finance and accounting division, the center of the family business, and moved around the conglomerate over the years.

Lee Byung Chull's death in October 1987 led to a period of some uncertainty within the family as the various branches vied for control of the giant conglomerate Samsung. But by January 1988, Lee Byung Chull's third son, Lee Kun-hee, had come out on top, ascending to chairmanship of the company. Lee Maeng-hee was given control of Cheil Jedang in 1988 (then known by the not-so-sexy name of Cheil Food and Chemicals), as a kind of consolation prize for not getting Samsung, the main focus of the family business.

Cheil was a staid, boring wing of Samsung—dependable, profitable, and not very exciting, certainly a world away from being an entertainment powerhouse, and far from being hot or happening. Food and pharmaceuticals were plain and dull—profitable, but only barely so (in 1994, Cheil netted a profit of just $9.4 million on $1.59 billion in sales). But it was here that Jay-hyun and Miky Lee would make their mark.

The business chugged along for the next few years in a relatively uneventful manner until 1993, when the family decided it was time to split up the company's businesses and let each branch go its own way. Lee Kun-hee's younger sister Lee Myung-hee took control of the Shinsegae department store chain. Lee Maeng-hee took Cheil Jedang, and abruptly passed control on to Jay-hyun. Now free of Samsung, Cheil suddenly had the freedom to pursue just about any option.

So Lee Jay-hyun (with his executives and advisors, of course) sat down and began to map out the company's future. Despite strong pressure from the executive board to concentrate on Cheil's traditional core, Lee decided that if Cheil were to thrive, it would need to diversify. With a foundation in confectionary, Lee thought it natural to continue in consumer-focused businesses, so, squaring the circle, he diversified by staying in consumer businesses: health, convenience foods, and entertainment.

On the entertainment side, Lee decided that, in the decades to come, making stories (original content, to use today's business jargon) would be the ultimate driver of a whole array of new fields. Korea's work-work-work mentality had pulled it up from a poor, postwar Asian nation to a thriving, middle-class country. It was now time

to begin enjoying life. People were just beginning to work less, which meant they had more leisure time. Intellectual property, media, and creative content were the core of the future, even more than the hardware and technology Korea made for export. Whatever Cheil Jedang did next, making stories would allow the company to make its own future.

The Foundation

At the time, Samsung and several other jaebeol were already quite involved in the entertainment business. Samsung owned two television stations, a music label, and distributed the movies of Hollywood studio New Regency Productions (in which it owned a $60-million, 7.4-percent share). Daewoo distributed New Line titles in Korea. But both were minor studios in Hollywood, and both were charging their Korean partners extremely high fees. Lee Jay-hyun saw two major flaws in how the conglomerates approached the entertainment business: (1) their scope was entirely too small and timid for companies of their size, and (2) their budding entertainment divisions were already operating at significant losses. They were fragmented, and they had low budgets and low standards.

If a major company were to enter the entertainment industry, Lee thought, it had better enter as a major player. It made no sense to emulate the small players. He needed a grand approach that could take advantage of his scale and bring something new to the table. He also saw that the company needed credibility. To many people, there was no obvious or natural connection between being a food and pharmacy maker and being in the entertainment business. Why should anyone take them seriously? He would have to create a high-profile connection for Cheil to command respect in the industry.

Lee determined that Cheil could afford $1 billion in capital to launch the new venture, a sum he discovered didn't go far in 1994 Hollywood. Universal Studios was priced in excess of $10 billion. Even minor production houses could cost $100 to 700 million—affordable, but too small to make a major impact. Nevertheless, he was convinced that a big splash was the way to go. Undeterred, he kept looking for options.

Fortunately, at the time, Lee's older sister Miky was in New York City working for Samsung, looking for new businesses the company might invest in. Since earning her BA in 1981 at Seoul National University, Korea's top school, Miky had for the next decade continued studying, first Chinese language and linguistics at Taiwan National University, then Japanese at Keiyo University. She earned an MA in Asian Studies at Harvard University in 1986 and worked there as a teaching fellow, then enrolled in Fudan University in Shanghai to work on her PhD.

But before finishing her doctorate, Miky decided to join the family business, and moved to their new Samsung America office in New York (well, across the river in New Jersey, but why quibble). She was the one who, in November 1994, heard about a tantalizing new movie studio that was being set up by some of the biggest names in the entertainment industry—Steven Spielberg, Jeffrey Katzenberg, and David Geffen: Dreamworks SKG. And they were looking for investors.

Dreamworks was created as a haven for artists, a place where movie creators, not the accountants, had the final say. Unfortunately, many people wanted to invest in Dreamworks and rub elbows with some of the biggest names in global entertainment. Hundreds of people. From Middle-Eastern oil tycoons to American entrepreneurs. The plan at Dreamworks was to build a $2 billion capitalization base. The three founders would throw in $33 million each, and $1 billion would come from a line of credit at Chemical Bank, leaving a shortfall of $900 million. Lee Jay-hyun thought it was an ideal opportunity—more credibility than Cheil could have imagined, and for a reasonable price. Spielberg, Katzenberg, and Geffen knew how sexy their idea was and how much people wanted a piece, so they were determined to keep artistic control. As a result, they were offering a very one-sided deal—they would take your money, but you could have no say in how the company was run. Pay your money and keep quiet.

That Cheil was an Asian company did not help. In the early 1990s, Japan was the great boogeyman of business, a rising juggernaut remorselessly buying up American companies and real estate, forcing Michael Crichton to write really, really terrible books. The fear was particularly acute in the movie industry. Sony bought CBS Records Group in 1988, then Columbia Pictures Entertainment for $3.4 bil-

lion in 1989 (renaming it Sony Pictures Entertainment in 1991). Matsushita Electric, an electronics manufacturer, bought MCA-Universal in 1990. Both companies were considered conservative, ruled by suits and the bottom line, with little regard for Hollywood's art (of losing money) and history (of losing money). In many ways, Dreamworks was a reaction to those deals.

Before the Lees could even begin to put together a proposal, however, there was another giant hurdle to overcome: family. Cheil Jedang might have separated from Samsung, but they were all still part of the Lee Byung Chull family, and family courtesy required them to show Dreamworks to Lee Kun-hee and Samsung first. Samsung too liked the opportunity. So Lee Kun-hee and his executives flew to Los Angeles in February 1995 and met at Steven Spielberg's home to make their $900-million pitch in person. But things fell apart. Through an interpreter, Lee talked about what Samsung was best at: semiconductors. And more semiconductors. "How are they going to know anything about the film business when they're so obsessed with semiconductors?" Spielberg recalled in *Time* magazine. "A complete waste of time." Already nervous about the size of the investment and the language and cultural barriers, the Dreamworks team said no. Samsung, unhappy that Dreamworks had refused to hand over creative control of their nascent company, wasn't exactly banging down Spielberg's door anymore either.

Now Cheil Jedang had the freedom to make its attempt. Miky Lee left Samsung for Cheil, and soon Katzenberg approached them about making a deal. At first, the Dreamworks' founder just talked business, making sure the Lees really understood their plans and goals.

Clazziquai
Kim Sung-hoon (a.k.a. DJ Clazzi), Alex Chu, and Choi Horan were rejected by all the major labels in Korea for not being commercial enough. But today, Clazziquai has grown into one of Korea's most popular indie groups and is now branching out into Japan and Taiwan.

© Fluxus Music

This was a business deal, and it was vital to make sure everyone was on the same page. Miky and Jay-hyun learned how films in America made money—how, at the time, international box office was worth about as much as that of North America, and home video was twice as much again. They learned about music labels and television production. "We knew we would have to create an entire industry," says Miky Lee. "I didn't know anything about the entertainment industry then. I was just excited to be working with Steven and David and Jeffrey. They really were a dream team."

But Miky and Jay-hyun Lee were also able to impress the Dreamworks' dream team with their love of movies and powerful vision— their vision for movies and for Cheil's role in the movie industry. Miky Lee, a slight woman with big passions and an exotic, stylish flair, can go toe-to-toe with anyone when it comes to talking about great movies, both famous and obscure, arthouse and popular. Lee says she was impressed and surprised at how down-to-earth all three of the Dreamworks founders were. "They met me, this small woman, not even a man, who did not speak perfect English but who was not afraid . . . and we just understood each other."

Dreamworks wanted to work with the Lees, but innumerable details had to be worked out. For three months, teams of executives and number crunchers from both organizations squared off in intense negotiations. The original Dreamworks business plan was as big as a New York phonebook. As talks continued, day after day, the deal grew, filling five giant black binders, each five inches thick. Negotiations only became harder after Microsoft billionaire Paul Allen agreed to chip in over half of the money Dreamworks needed, $500 million, taking away much of the Lees' leverage.

Cheil asked for the Asian distribution rights to all Dreamworks movies, and for a real role in running the company. Katzenberg and his partners wanted total control, and even though the three of them (Katzenberg, Spielberg, and Geffen) had paid in only 10 percent of Dreamworks' start-up capital, they were seeking two-thirds of its equity, suggesting they could repay the paid-in capital from Cheil over the next few years. But Cheil did not want to be repaid, not if it meant being shoved offstage. They wanted the clout that Dreamworks could bring, especially since so much of Jay-hyun and Miky Lee's family were against the deal. Many people in their family

thought Cheil had no business in the entertainment business, still thinking that movies were for poorly educated and "low" people. Tying themselves to three of the most respected figures in the world of entertainment was an important factor in gathering support inside as well as outside of Cheil Jedang.

In addition, there was a third party who had to be appeased if this deal were to go through: the Korean government. Back before the Asian economic crisis of 1997, before Korea had been forced to go through a lot of painful restructuring, the national government was much more involved in the running of the nation's businesses. It was all part of the jaebeol system: conglomerates were protected by the government, and in return were controlled by it. And this Dreamworks acquisition—in effect, sending hundreds of millions of dollars *out* of Korea—was just the kind of deal the Korean government was extremely skeptical about. Korea was a nation built on exports (or so the popular thinking went). Korea exported much and imported little. Today, that kind of controlling, mercantile thinking is much less entrenched in Korea. But back then, it was a significant obstacle, and Cheil Jedang had to present a thorough and convincing argument that this deal made good business sense, not just for Cheil, but also for the nation.

So negotiations continued. They were tough, but gradually the two sides developed a kind of camaraderie and mutual respect. Many in the movie business were nonetheless skeptical. But finally, in June 1995, a deal was made. For its $300 million investment in Dreamworks SKG, Cheil Jedang would receive the right to distribute Dreamworks' movies in Asia (excluding Japan, which originally went to UIP, and later to Japanese distributor Kadokawa). The Lees had what they wanted from the beginning: credibility. Being part of Dreamworks meant they were serious. It gave them scale. It made them different from other players and wanna-bes in the Korean movie business. "You cannot make your interests or your hobby into a business," says Miky Lee, adding with a laugh, "But I guess I did." At thirty-five and thirty-seven years old, Jay-hyun and Miky Lee had become two of the biggest movie moguls in Asia. Now they just needed to make some movies.

Making Movies The whole negotiating process with the Dreamworks team had been a crash course in the entertainment industry for the Lees, especially for Miky, who had little business background. After they concluded the deal, on the plane ride back to Korea, Jay-hyun explained to his older sister the full extent of his plans for the future. Dreamworks was the foundation of CJ Entertainment (as Cheil would soon call its movie division) ensuring they had access to some of the best Hollywood films. But they still needed to learn how to become a successful movie studio, that is, how to produce and distribute movies. So CJ Entertainment made its first attempt at producing: J-Com. If you have never heard of J-Com, that is understandable. This was one CJ Entertainment venture that never took off.

In 1995, the biggest success in Korea was not a movie, it was a television show called *The Sandglass* (*Morae Shigae*). The story of two best friends who grow up on opposite sides of the law, but told in the shadow of the Gwangju Massacre of 1980 (where hundreds of civilians were massacred by soldiers in the southwest city of Gwangju after rising up against military rule), became a monstrous hit in January and February 1995, peaking with an incredible 65.7 percent rating, meaning nearly two-thirds of all the households with televisions in Korea were watching. So the Lees hired *The Sandglass*'s director Kim Jong-hak and writer Song Ji-nah, and spent $2.5 million to set up J-Com as a separate entity, based on the Han River island Yeouido, in the center of Seoul.

There were big plans for J-Com. The company talked about sending people to Dreamworks for training, and said that by 1999 it would have completed nine movies, fifteen television programs, and ten animated projects. Reality, however, hit hard and fast. J-Com's first film, *Inshallah* (about a graduate student holidaying in Algeria who gets mistaken for a drug trafficker) was a huge flop. Other projects stalled, burning through money while Cheil waited. Perhaps most seriously, J-Com completely alienated Chungmuro. "We were very ignorant. We thought that film and television were all the same," says Miky Lee. "I naively thought we'd be welcomed by the movie community, but setting up a film company with TV people was a mistake." Before long, J-Com was history.

The period between 1996 and 1998 was turning into a bad time

Despite CJ Entertainment's high hopes, its first original production, Inshallah, *was a big dud when released in 1997.*

for the young CJ Entertainment. Despite her love of their young entertainment business, Miky Lee had to leave the company in 1997 for medical reasons and go to the United States. To have her dream company snatched away, just as it was getting started, for health reasons beyond her control, hurt Lee deeply: "I was annoyed and depressed." It would be years before her health improved enough that she could resume work at the helm of the company she helped to found. With Jay-hyun busy running the entire Cheil Jedang conglomerate (which itself was changing its name to CJ Corp. at the time), a series of Cheil executives took the reins of CJ Entertainment.

Then, at the end of 1997, came the biggest challenge of all, the Asian economic crisis. It began in Thailand that summer, when a weak economy, high interest rates, and large current account deficits caused the baht's value to plummet. From July 2, 1997, to January 1998, the baht's value fell by half. The currency crisis spread quickly beyond Thailand's borders, to the Philippines, Malaysia, and Indonesia. By the autumn, the problem spilled into Korea, where the nation's overvalued won began to take a serious beating. Its value slid

from about 760 won to the US dollar to 900, 1,000, and then 1,200. And it kept falling. In just a couple of months, the won plummeted all the way to 1,700 won to the dollar, and many feared it could keep on collapsing.

For Korea's film industry, it looked like a disaster. Western films accounted for around 70 percent of the box office at the time. Suddenly, all deals signed in the preceding months doubled in cost. International deals, usually signed in US dollars, forced Koreans who imported movies to pay twice as much.

As tough as the situation might be for an importer, who might have several hundred thousand dollars, or even a few million on the line, for Cheil Jedang and CJ Entertainment it was a catastrophe. The $300-million Dreamworks deal was to be paid in three installments, and with the won in freefall, the third $100-million installment was due. Cheil Jedang was a big company, but at the time, money in Korea was tight. Banks were no longer lending. Resources everywhere were stretched thin, to the breaking point. Just affording the $100 million at the original exchange rate would have been incredibly difficult. Now that the dollar was twice as expensive, payment was all but impossible.

The Dreamworks payment schedule was ironclad, with no wiggle room. If Cheil missed a payment, the bank would automatically slap on a $10 to 20 million penalty that Cheil could ill afford. At the same time, Dreamworks desperately needed cash flow, too. It was still the early days of the company. Its first films, like *Peacekeeper*, had fizzled at the box office. *Gladiator* and *Saving Private Ryan* were both in production, eating through money at a fantastic rate. Despite the contract, Jay-hyun Lee decided they would have to ask Dreamworks for flexibility.

As soon as the Cheil team approached Dreamworks, they knew why Cheil was coming and immediately said "No." No bank would lend the money. Cheil negotiators spoke with billionaires all over the globe. But with Dreamworks' value at an all-time low, Asia paralyzed with an economic crisis, and the rest of the world afraid the crisis might spill onto their shores, no one was interested. Cheil negotiators approached every person and every company they could think of for help, but came up empty.

Finally, the Cheil negotiators returned to Dreamworks to say

they had but one option left—to liquidate some of Cheil's Dream-works shares. That, however, was forbidden in the original deal. With the Lees out of choices, Dreamworks investor, Microsoft billionaire Paul Allen agreed in June 1998 to buy enough shares to allow Cheil to make the deadline. As the sale violated the original agreement, everyone agreed to keep this deal a secret. While Cheil Jedang re-mained a significant owner in Dreamworks, it had lost 50 percent of its share, and was down to a $130-million stake.

After that, Cheil and CJ Entertainment quickly recovered. Their first multiplex was opening (more on this in a moment). The won slowly recovered a little, too, inching its way back to 1,200 won to the dollar, taking the worst strains off of the economy. Knowing the J-Com format didn't work, CJ Entertainment went to Uno Film, Shin-Cine, and Myung Film to create an alliance of production companies. Cheil told them that it would provide financial support in return for their making quality movies. "Don't be constrained by anything," Jay-hyun Lee told them. This strategy would prove to be much more successful, as all three companies were churning out plenty of films and more than a few hits.

Ironically, however, the economic crisis that nearly destroyed Cheil and CJ Entertainment also helped revive them, giving the en-tertainment company an unexpected advantage. The crisis forced many potential competitors to hold back or withdraw entirely from the movie business. IMF-mandated restructuring forced many of the most sprawling jaebeol to focus their energies on core businesses and sell off tangential side projects. Suddenly, CJ Entertainment found it had much less competition from its conglomerate competitors.

The Rise of the Multiplex

On that same plane ride back from securing the Dreamworks deal, Jay-hyun had also told Miky it was vital that Cheil establish multi-plexes in Korea. It was not enough to have the movies, they also needed to have the screens to show their films.

Today (in 2008), CJ Entertainment's multiplex franchise, CJ CGV, is the biggest theater chain in Korea, with around 20 percent of the nation's 1,900 screens. But while nice, fancy multiplexes are a given

in South Korea today, as in much of the world, it is easy to forget that in 1995, going to the movies was a completely different experience. Korea's movie theaters of yesteryear were gorgeous heaps of moldy, concrete nostalgia. Large screens with theater-style stages at the front were mounted low, just above the stage. This made them perfect for patrons sitting in the front row, whose entire field of vision was filled by the screen. Most of the one-screen theaters were clustered together in cities' downtowns, a short walk from one another, so you could easily see several films in a day without too much hassle. When it rained, the roar could fill those cinderblock sound stages, especially when the roof did little to keep the water out (just like in Tsai Ming-liang's cinematic poem to the grand old Asian theaters of the past, *Good-Bye Dragon Inn*).

Plus, they served beer. Very civilized.

Sure there were drawbacks—poor sound systems, small lumpy seats, dodgy air conditioners, and the occasional critter scampering across the floor—but they had character. Screens could be more

The Other Majors

Of course, CJ Entertainment did not change an industry by itself, nor is it the only major studio in Korea. In fact, it is not even the only sugar refiner to become a major entertainment powerhouse.

That's right, the Orion entertainment empire—comprised of the movie distributor Showbox, the multiplex chain Megabox, and the cable TV outfit On Media—also got its start in the confectionary game. Orion started as Tongyang way back in 1956, and over the years diversified, spread into sixteen subsidiaries, and grew into a *jaebeol* in its own right (Orion separated from Tongyang in 2001).

The owner of Tongyang, Tam Chul-Kon, was looking to move into something different. "Something fun." So in the mid 1990s, Tam selected three workers in their late twenties, and created Apex, a company with a dream mandate: "Do whatever you want for three years." Its three young executives tried a little of everything—liquor distribution, electronics, you name it—losing money at everything. Even today, Woody Kim (Kim Woo-taek), one

of the original three, today the CEO of Mediaplex, laughs at the thought of the naïve chaos of those early days.

Along the way, however, they created one solid moneymaker for Apex: Tooniverse, a cable TV station that specialized in animation. It was an instant hit. At the time, cable made an insignificant blip in Korea. Begun only in 1994, no one knew yet what to make of cable. But a whole cohort of the Korean population knew what to do with Tooniverse. At its peak, in the early evening, when Korean children were all at home from their cram schools and taekwondo classes, supposedly studying, Tooniverse sometimes scored ratings higher than the terrestrial free-to-air channels (which are normally in a totally different class than cable). Recognizing a good thing, the Apex bosses kept adding channels—movie channels, music videos, computer-game channels—and soon On Media was born. Today, while CJ Entertainment and Mediaplex duel it out for the label of top movie studio,

brown and splotchy than silver. Distributors were known to cut films, not just for content (I remember the cuts made to that shocking piece of violence and depravity, *Before Sunrise*), but to get the movies under a two-hour screening time, which would allow theaters to hold more screenings per day. Focus was optional. The seats, it bears repeating, were lumpy, had no legroom, and often squeaked loudly with the slightest movement.

In one of the strangest quirks, people used to be able to enter the theater any time after buying a ticket. For the top films during the hottest months, that basically meant that everyone with a ticket tried to force his or her way into the movie about fifteen minutes before it ended. When it did end, the seated viewers would get up and push past the new patrons in a mad, chaotic turnover, featuring much squeezing and stepping on toes, but little movement. Then, fifteen minutes or so before the end of the movie, those patrons, who'd already seen the ending in their rush to get in, started heading for the doors, creating an early changeover that then repeated itself.

On Media is the number one cable TV company, accounting for about 20 percent of all the cable TV ratings in Korea.

Around the same time Tooniverse was starting, Apex executive Woody Kim stumbled into the multiplex business. Cheil Jedang had been working on building a gorgeous multiplex in Korea's first Western-style shopping mall, the COEX, in the rich southeast of Seoul, but the jaebeol Daewoo managed to outmaneuver Cheil and win control of the project. But the 1997 economic crisis rocked Daewoo harder than most conglomerates, and suddenly the jaebeol was forced to sell the sixteen-screen theater. At first Daewoo tried to sell it to Cheil, but Daewoo insisted the sale also include two other multiplexes. Because of Cheil's money problems at the time, then-executive director D. J. Ha decided it was too pricy and turned down the offer. Instead, Tongyang bought it and formed a 50-50 joint venture with Loews Cineplex Entertainment, naming the new business Megabox.

Of all the new multiplexes that began opening at the time, the COEX Megabox was the most suc- cessful, thanks to its prime location. It packed in audiences all day, every day. In its first eighty-four days in business, that one theater sold over 1 mil lion movie tickets. Woody Kim knew a good thing when he saw it, and quickly moved to expand the company's show-business businesses.

To complement Megabox, a movie investment and distribution company called Showbox was started in 2002. In 2002, Showbox and Megabox were united to form Mediaplex, and the whole she bang went public in 2005.

In its relatively short history, Showbox quickly found itself distributing many of the biggest films in Korean history—Kang Je-gyu's *Taegukgi*, which broke all the records in 2004 to become the biggest film ever in Korea at the time; Park Kwang hyun's *Welcome to Dongmakgol*, the biggest film of 2005; and Bong Joon-ho's *The Host*, which in 2006 re-broke all of *Taegukgi*'s records.

Woody Kim may not have had any experience in the entertainment business, but he wisely sur rounded himself with people who did, like Jeong Tae-sung, a former movie producer and co-founder

But the theaters had character. And beer.

Throughout the 1980s and 1990s, theaters were on the decline. With most of the country seemingly content to watch videotapes at home, movie attendance dropped year after year. With attendance in decline, so too shrank the number of screens. In 1997, that number bottomed out at just 497. Ticket sales reached their low point in 1996 at just 42.2 million. By comparison, ticket sales hit 173 million in 1969, the biggest year ever for movies in Korea.

When a really popular movie did arrive (usually from Hollywood), long runs in a small number of theaters were the rule. Sellouts for even marginally popular films were common. On weekends, business-minded middle-aged women bought up all the tickets, then scalped them to desperate customers (which is how I saw *Star Wars: Episode I—The Phantom Menace*).

Clearly, an upgrade was in order. But who would spend the millions needed to build modern multiplex theaters—with impressive sound systems, sharp screens, comfortable seats, and the like—when

of the Pusan International Film Festival's Pusan Promotion Plan. Kim made Jeong his Chief Operating Officer, his No. 2. Jeong, a soft-spoken boss, tends to see the business more on the creative side, providing a solid balance to Kim's corporate ways.

Because of the multiplex deal that got Tongyang's Megabox going, CJ Corp's D. J. Ha laughingly blames himself for creating his company's biggest competitor. He also jokes that he is responsible for CJ's other major competitor, Lotte Cinema.

Back in 1996, when Cheil Jedang was just formulating its entertainment plans, Ha was looking for good locations for the future CJ CGV movie theaters. He knew the then-CEO of the Lotte Department Store chain quite well. Ha happened to know that Lotte was planning some major expansions, and thought maybe they could work together. His pitch went well and they agreed on five locations around Korea to try out the plan. But at the very first location, in Ilsan (just northwest of Seoul), CJ and Lotte got into an argument over terms and conditions. Lotte got angry, canceled the whole

project, and paid millions of dollars to CJ for defaulting on the deal. Apparently, however, CJ's multiplex plan was very convincing, because Lotte decided to create the Lotte Cinema franchise. Today it is the second-largest movie chain in Korea, and has expanded into distribution and production, too.

And, of course, there are and have been other majors. Before Mediaplex became CJ Entertainment's biggest movie competitor, Cinema Service held the rival role. One of the most successful movie directors of the 1990s and 2000s, Kang Woo-suk, founded Kang Woo-suk Productions in 1993, changing the company's name to Cinema Service in 1995. From the beginning, Kang prided himself on his pure commercialism, creating a series of commercially successful, if artless movies throughout the 1990s.

Cinema Service exchanged the top Korean distributor spot with CJ Entertainment between 2000 and 2004. For a time, it even had ambitions to be as big as CJ Entertainment, adding a multiplex chain (Primus), a studio and soundstage for film-

the industry was clearly on the decline? Again, CJ Entertainment led the way.

Miky Lee first encountered the multiplex when she went to Harvard and was immediately captivated. Although many people in the West complain about the lack of cultural diversity, to Lee the American movie industry was heaven compared to Korea in the 1980s. Those years, she said, were Korea's "dark age," a time of censorship and general government oppression. Even for someone from a successful family like hers, it was difficult to travel abroad back then, even harder, in many ways, than for the average person. The Korean government was firmly against any kind of conspicuous consumption, and foreign travel was definitely considered a luxury, well worth squelching.

But traveling to America presented a world of choice at every turn, especially for books and movies. Harvard Square had an arthouse cinema, and just down the road were multiplexes with Hollywood fare. Lee met a group of Korean students at school who

ing (Art Service), and a coffee franchise (Holly's). To fuel that growth, Cinema Service merged with the online gaming company Netmarble in 2003, giving it the muscle it needed to play with the big boys. When director Kang smashed the nation's box office records with *Silmido* in 2004, the future looked brighter than ever.

Just a year later, however, the Cinema Service empire was all but gone. Never able to get along with its gaming partners, Cinema Service split from the merger in 2004. Coincidentally, CJ bought Netmarble around the same time, turning the company into CJ Internet. Cinema Service was able to buy its freedom, but CJ kept a large share of the company, including a majority of the Primus multiplex chain, and the two merged their international sales teams.

In addition, as competition heats up now, many other entertainment companies have concluded that they, too, have to grow or risk being swallowed up by their rivals. MK Pictures, iHQ, and Prime Entertainment are three of the largest production houses that have been growing and diversifying.

With so much change constantly fomenting in the Korean movie industry, the contrast with its neighbor Japan is striking. In Japan, the biggest players have dominated the movie industry for decades. Shochiku, founded in 1895 as a kabuki theater group, moved into the movie business in 1920, and is still going strong today. Toho came along in 1932, followed by Toei in 1951. After starting in 1945 as a book publisher, even the relatively young Kadokawa company has been making movies since the early 1970s.

In Korea, the first movie was made in 1923, and the industry flourished for decades, but none of the big studios of the 1960s still exist, cut down by Park Chung Hee's decidedly arts-unfriendly administration. CJ and Cinema Service were both founded in the mid-1990s, Mediaplex after that. Prime, MK Pictures, and iHQ are younger still. Today, five years in the business makes a company a veteran. Companies form, merge, split, re-merge, and metamorph with stunning frequency. While the constant change can be disorienting to some, it can also be seen as a sign of vitality and growth.

organized regular movie nights, where they watched such not-so-high-minded films as *Pink Flamingo* and *Kentucky Fried Movie*. The thought of helping to develop diversity in Korean cinema was an exciting thought for Miky Lee.

So, soon after signing the deal with Dreamworks, the Lees realized they still needed someone to learn from. They asked themselves, "Who is the biggest filmmaker in Asia?" At the time, that person was Raymond Chow, of Golden Harvest of Hong Kong. Golden Harvest and Australia's Village Roadshow had been aggressively expanding their multiplex businesses around South Asia, in Thailand, Malaysia, and Singapore. Chow said he'd been talking with Samsung for years about getting something similar going in Korea, but reported the process as agonizingly slow. For Cheil, slow was not an option. They asked Golden Harvest to make a proposal, and soon Village Roadshow signed on, too. In December 1996, CJ Golden Village, or "CJ CGV," as we now know it, was born.

As with the Dreamworks investment, convincing the foreigners was only half the battle. People at home were just as appalled at the thought of huge multiplexes descending on Korea. Old theater owners were dismissive: "What do you know?" they would snort. "We've been doing this for fifty years." Others called it "doomsday." Village Roadshow was confident; they had built theaters all over the world, so why not Korea? The only way to find out was to try.

But before an attempt could be made, Cheil would have to get some regulations changed. A lot of regulations. The rules concerning movie theaters were put in place in the beginning of the twentieth century, when the Japanese colonized Korea, and had not changed significantly since. There were rules on the locations of bathrooms and on space required between theaters. All told, twenty regulations needed to be changed or rescinded. Each required seemingly endless paperwork and lobbying with government agencies, which required three or four trips to the government daily for months.

What Cheil did have in its favor, though, were sites. Around Seoul were several old Cheil Jedang factory locations. At first they looked around the southwest of the city, in old, rundown Yeongdeungpo and out by Gimpo International Airport. But in the end, they decided on Gangbyeon, in the eastern part of the city, where a new electronics market was just opening. They originally planned

for an eighteen-screen multiplex, but strong objections by Village Roadshow and Korea's other theater operators (who had convincing arguments against the economics of the multiplex), forced a down-scale to eleven.

The CGV Gangbyeon 11 opened in April 1998, and from the first day enjoyed huge turnouts. "It was beyond our expectations," said D. J. Ha, executive director of CJ Entertainment at the time. "We should have opened the eighteen screens." Almost immediately, everyone knew the multiplex idea was a winner.

At the time, CGV was managed by Park Dong-ho, an affable man with a boyish, slightly untucked style and a strong fondness for Peter Drucker's management ideas. Park came from the food products side of CJ Corp., where he'd spent ten years in meat processing. "Although the two businesses are quite different, from a management perspective I saw no big difference," he once told me, then quoted Drucker: "It's all about creating value."

Coincidentally, just as the Asian economic crisis had nearly ruined Cheil, a similar problem in reverse soon happened at CGV. Golden Harvest was moving through a major transition, splitting its operations into production and distribution. The distribution side made an initial public offering, but soon after, its share value fell steeply and Golden Harvest was in trouble. To shore up his company, Raymond Chow sold his company's share of CGV for cash. In 2002, Village Roadshow left, too, selling its shares to Asia Cinema Holdings (a Dutch private equity company), which in turn sold most of its stake to CGV and other investors in May 2005.

The Modern CJ Entertainment In 1997, CJ Entertainment became independent of Cheil Jedang, becoming an affiliate instead of just a division, and in 2000 was fully spun off. Although its first attempt at producing original movies (J-Com) had not gone well, CJ Entertainment remained active in investment, distribution, and international sales. In 2000, it scored its first monster hit, distributing Park Chan-wook's *JSA: Joint Security Area*. *JSA* was just the second "mega-blockbuster" in Korean history, following up a year after *Shiri*, Korea's first. The tale of a mystery at the De-

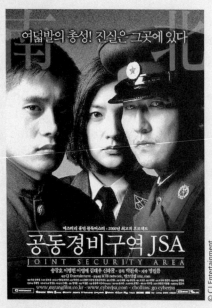

JSA was CJ Entertainment's first big hit.

militarized Zone dividing North and South Korea earned nearly $27 million at the box office (and led to endless bickering over which film was the bigger hit, *JSA* or *Shiri*) and launched the impressive career of director Park Chan-wook.

CJ Entertainment also looked to expand from early on. In 1997, it bought the music video channel M.net, which has ever since been Korea's most popular music-video channel. Its cable wing soon began to grow, adding the Food Channel in 2000, NTV in 2001 (renamed Home CGV in 2002), and many more. And in 2002, it grouped all those television channels together under the name CJ Media. Today, with nine channels, CJ Media is the second biggest cable TV company in Korea.

Other additions include CJ Cablenet (cable-TV multiple-systems operator) in 2000, Internet gaming company Netmarble in 2004 (on-line gaming company, renamed CJ Internet), M-Net Media (music publisher and star management), and CJ Joycube (the Korean distributor of Microsoft's Xbox video game system).

Perhaps most surprisingly, after two years of rumors and false starts, CJ Entertainment bought its number one rival, Cinema Service, in 2004. The two companies had traded the No. 1 and No. 2 top distributor spots, bouncing between 15 and 22 percent of the Korean movie market between 2000 and 2004. Considering that the two companies together accounted for 40 percent of the movie market share, many were frightened of the merger, worried CJ Entertainment would use its leverage to bully the rest of the industry. As it turns out, other competitors quickly rose up to take Cinema Service's place, and although CJ Entertainment continues to be the biggest player in Korea, it is far from overwhelming. In addition, the CJ Entertainment–Cinema Service deal had more than a few bumps,

as Cinema Service separated from CJ Entertainment just months after the deal. But in early 2005, the two merged their international sales departments.

CJ Entertainment's other big move came in 2002, when it went public, followed by CJ CGV in 2005. Why was CJ Entertainment's IPO a big deal? Because being a public company means a much greater level of public accountability. A public business must publish its accounting books for anyone and everyone to see. As a result, businesses become more transparent, making the whole industry more efficient and fair.

After CJ Entertainment went public in 2002, many other Korean entertainment companies followed suit. Mediaplex (owner of Showbox and Megabox) did the same in 2005. And countless production and distribution companies have also gone public, although many of the more recent deals were a lot more dubious in nature. These companies were smaller, and did not have the financial foundation to go public, so many had "backdoor listings." That is, they bought out or teamed up with larger, more stable companies (manufacturers, tech companies, and the like) to improve their bottom line. Now, some of these deals might be shakier than CJ's IPO, done just to raise money for the owner, who then bolts as soon as the share price runs into trouble. The excess of publicly traded movie companies was a major factor in the glut of films made in 2006 and 2007. The important thing is that these deals helped make the entertainment industry more open and transparent.

Ironically, CJ Entertainment has since delisted, going back into the fold of Cheil Jedang (renamed CJ Corp. in 2002), so it can reorganize and perhaps go public again another day. But CJ Entertainment did lead the way to a modern film business in Korea, where business comes first, ahead of backroom deals and egos (not that that there aren't any backroom deals or egos now—this is the entertainment business, after all). And that is a good thing for everyone who loves Korean movies.

Despite all the deals and the business wheeling and dealing, the biggest moment for Miky Lee came at the end of 2004, when her health improved enough that she was finally able to return and rejoin Jay-hyun at the helm of the company she loves. The changes to the Korean movie industry since her departure in 1997 were over-

CJ Entertainment distributed many of Korea's top directors' films, including Kim Jee-woon's
A Bittersweet Life.

whelming. The business had grown and grown, going from strength
to strength. Annual admissions shot from 47.5 million to 135 mil-
lion, and Korean film box office figures soared from 25 percent to
59 percent. "I was really shocked, although not in a bad way," she
says. When I asked her to name some of her favorite Korean films of
recent years, she quickly rattled them off: *Tale of Two Sisters*, *Sym-
pathy for Mr. Vengeance*, *Save the Green Planet*, *A Bittersweet Life*,
and *Secret Sunshine*. All great films. And except for *Two Sisters*, all CJ
Entertainment films.

The industry continued to grow over the next couple of years,
peaking in 2006 with 163.9 million admissions and with Korean
movies taking in 64.7 percent of the box office.

Not all changes in the industry over the years were positive,
though. "I think people were a little proud and complacent," said
Miky. "They got used to making money automatically. No one was
worried, and that worried me." She also thinks that the lack of diver-
sity in the film business is a related problem. "That's something I ask
about every day. It depends on people's creativity. It is not a problem
you can solve with money."

Since its founding in 1995, CJ Entertainment has grown into the

largest movie distributor, investor, and multiplex chain in South Korea, with leading affiliates in cable television, online gaming, music, talent management, and more. Some people praise CJ Entertainment for moving Korean movies and entertainment into the age of globalization. Others deride the company for much the same reason. But together, the Lees were integral to changing the Korean movie industry, turning a large, staid company, known for making snacks, shampoo, and pharmaceuticals, into a sprawling entertainment giant.

Bottom line, though, is that the Lees are still not satisfied. Not with CJ Entertainment and not with the Korean movie industry. "I think we are still in the process of building our industry," says Miky. "We have not accomplished anything yet. We are not there yet."

CJ Entertainment did not single-handedly transform the movie business in Korea. But the changes at CJ Entertainment do symbolize Korea's great industry-wide changes. Despite the many upheavals and trials the cinema scene has been through, and the adversity it has had to deal with, the general trend over the past ten years has been toward transparency and openness, with respect for business fundamentals and the need for high-risk, high-reward entrepreneurialism. No one knows what Korea's industry will look like in ten years (or even tomorrow), but the foundation has been laid.

A foundation, however, is not a house. Business may have created a strong foundation, an environment for filmmakers to succeed, but it did not make the movies. It took visionary and talented filmmakers to push Korean films to the next level. And the most ambitious of these filmmakers is Kang Je-gyu.

The Blockbuster

From the beginning, Kang Je-gyu knew just what kind of filmmaker he wanted to be—just like Steven Spielberg. Big, commercial, and edge-of-your-seat exciting. Trouble is, back in the early 1990s, when Kang's career began, Korean movies were none of those things. The average movie cost far less than a million dollars and was anything but epic. Producers preferred safe projects to ambitious ones, in no small part because their films were financed via loan sharks, not banks. So they made cheap films that could quickly and reliably recoup their investment. How could puny Korean movies possibly compete with the huge $100 million, mega-budget movies of Hollywood? It was an impossibility, not even worth thinking about.

Fashionable Kang, with his sharp haircut and stylish clothes, speaks with certainty in his voice, confident and good-natured. His Seoul office is full of Japanese comic books and *Metal Hurlant*-looking pictures. Fully conscious of his celebrity status as the nation's top director, he plays the part genially, according to many who have worked with him over the years. Known both for his good nature and his intense work focus, Kang would need every bit of that focus and determination to realize his vision of making Hollywood-style blockbusters. Because for Kang to make the kind of movies he dreamed of, he would have to transform the entire Korean filmmaking establishment.

Getting Started Kang Je-gyu had blockbusters on the brain, all the way back in university.

Born in 1962 in Masan, a small port city on Korea's southern shore, Kang grew up watching all the movies he could. In the 1970s, the city's one cinema presented few choices—mostly Hong Kong and Taiwanese action films, Westerns, some Korean films, and the occasional family movie. During his teen years, he would take the bus to Busan, about an hour away, where there were more options. He remembers watching *Doctor Zhivago*, *A Man and a Woman* (*Un Homme et une Femme*), and *E.T.* Kang was into photography as well, and entered his pictures in photography exhibitions and even won a few prizes.

Back in his first year of high school, Kang knew he wanted to make movies. Surprisingly, his parents were supportive from the beginning (while the entertainment industry was at the time held in low regard, Kang says they trusted his decision, even then). He finally left Masan in 1981 and began to study film at Chung-Ang University, just south of Seoul, as did other aspiring filmmakers and actors of the time. Back then, Chung-Ang's film program was more about theories and concepts than the practical aspects of filmmaking, so he had to study film techniques on his own.

But, while many of his peers were fascinated by French New Wave and other art-house favorites from around the world, Kang thought the future of Korean cinema lay in commercialism. To keep the struggling Korean film industry alive, it needed money. Commercial movies added money to the business. Avant-garde movies did not.

It was an era of much change for Korean movies, with the government's revision of the Motion Picture Law in 1986 and the transition to democracy in 1988. On one hand, Hollywood movies were beginning to flood into Korea like never before, putting much pressure on the local film business. On the other, democracy was bringing a level of openness and freedom not seen since the 1960s. Censorship had declined somewhat during the 1980s, but until 1986, all film companies had to be registered with the government. Then, suddenly, anyone who wanted to and had the money could make a movie.

After graduating from Chung-Ang University, Kang wanted to make movies, but had no money to do so. So instead of starting out

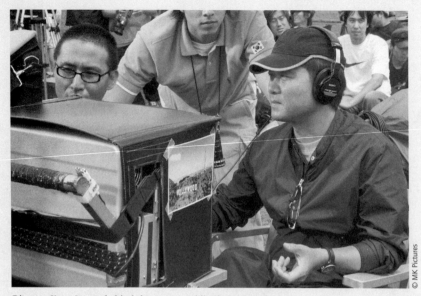

Director Kang Je-gyu behind the camera while shooting Taegukgi.

as an unpaid assistant director, he tried his hand at screenplays. His first script to be turned into a movie was *Well, Let's Look at the Sky Sometime* (1990), directed and co-written by Kim Sung-hong. Next up, Kang wrote *Who Saw the Dragon's Claws* (1991) for Kang Woo-suk (no relation), the most commercial director of the pre-*Shiri* era. And in 1994, Kang wrote the scripts for the two films *Day of the Roses* by Kwak Ji-hyun, and for *Rules of the Game* by Jang Hyeon-su, the most successful of the four.

Although economically the film market was declining in the early 1990s, there was also a sense of optimism and hope in the air. A new generation of filmmakers were attracting attention, people like Bae Chang-ho, Lee Myung-se, Jang Sun-woo, and Park Kwang-su. Older director Im Kwon-taek, who started in the sixties, suddenly found himself one of Korea's most respected filmmakers, thanks to his 1981 *Mandala* and a string of hits that won awards at film festivals all over the world. His 1990 film *Son of the General* became Korea's all-time box office champ, until his 1993 film *Sopyonje* broke that record. First released in Europe, *Sopyonje* earned a domestic release for its controversial content only after it won much praise abroad. In 1993, film critic Tony Rayns organized Seoul Stirring, a special exhi-

bition on Korean films, at London's Institute of Contemporary Arts, along with a book of the same name. In short, Korean movies were already attracting attention and generating buzz.

First Steps Into this fertile soil came Kang Je-gyu. From the beginning, his dream was making big, loud, fun movies, not difficult or pretentious arthouse cinema. Trouble is, big costs a lot of money. And loud and fun do not come cheap, either. While the Korean movie industry was winning critical praise at the time, it was not winning over wallets nearly as well. The country's distribution system bordered on the Byzantine. Without distribution, how can a producer hope to make his money back?

In the eighties and early nineties, regional distributors financed movie producers via promissory notes. But Korean banks did not accept promissory notes. Producers had to go to loan sharks, who converted the notes into cash and took about 20 percent right off the top in "user fees." These high interest rate loans were short term, around three to five months. Producers would try to cover their costs from all those loans, then make the movies as fast as possible. Regional distributors got their money back by distributing films in their individual territories. Seoul was the only place a producer could make his profits.

It gets worse. To help finance the film and minimize the amount of money they needed to get from loan sharks, producers went to everyone in the movie supply chain (like television stations and video distributors) to get money up front, before any film was shot, to minimize their risks. But asking business owners to finance a movie sight unseen once again limited how much a producer could raise. In addition, because all the money was raised up front, it was not unknown for unscrupulous producers to take all the money and just skip town—generating higher borrowing rates for legitimate producers. All these money problems added up, further limiting budgets, and therefore the scope of a filmmaker's project.

So when Kang Je-gyu came up with his fifth script, *The Gingko Bed*, which he wanted to direct himself for a record-setting 1.27 billion won budget ($1.35 million) and oodles of special effects (well,

relatively speaking), most producers would have just said "no" outright. "Impossible." Kang by that point had started his own production company, Film Power Plant, and really wanted to direct *Gingko* himself, but the chances of a first-time director getting to helm such an ambitious project were poor. Luckily for Kang, though, he had teamed up with Shin Chul, one of Korea's most successful producers of the 1990s, and Shin had some new ideas about raising money.

Kang had met Shin through Shin's then-wife, Oh Jung-wan, also a producer (and today president of the very successful BOM Film Productions). She liked the script and convinced Kang to pass it along to Shin.

The Gingko Bed is a Hong Kong-style action-fantasy film about ghosts and past lives. It tells the story of an art teacher named Su-hyun who is haunted by the ancient warrior General Hwang after buying an antique bed made from a giant old gingko tree. It turns out the haunting is not mere chance: a thousand years ago, in an earlier life, court musician Su-hyun fell in love with the warrior's

The Biggest Film Failures in Korean History

Of course, this category begs the question, "What is a failure?" I think it is about more than just money (although losing money is a major part). To be a true failure, one needs to be an artistic failure, too, or at least perceived as being a failure. Which is why, on one hand, I do not include the goofy science fiction film *2009: Lost Memories* (it was bad, but it did better at the box office than people remember, actually breaking even), but on the other hand, I do include films like *Hanbando* (which opened strongly, but sank like a stone as soon as people realized how terrible it was). So, no, this is not a scientific listing, but I think it is useful.

Antarctic Journal (2005) Dir. Yim Phil-sung
After impressing people with his short films, Yim Phil-sung built much support within Korea's film industry. So for his first feature-length film, *Antarctic Journal,* Im was able to cast such big names as Song Gang-ho and Yu Ji-tae. A horror/thriller with overtones of the supernatural, *Antarctic Journal*

was big on mood, but rather short on sense and even shorter on payoff. Audiences got frustrated with the go-nowhere story, leaving the $8 million film a total whiteout in red ink.

Blue (2003) Dir. Lee Jung-gook
Basically *Top Gun* underwater, this big-budget thriller about navy scuba divers was so overflowing with plots and subplots that it washed out most people's interest. *Blue* trickled through the theaters, earning barely $1 million on a $5 million budget.

Blue Swallow (2005) Dir. Yun Jong-chan
Director Yun Jong-chan followed up his 2001 psychological horror film *Sorum* with this historical

fiancée, Midan. The warrior kills them both, and when their souls are reincarnated into a couple of gingko trees, he tries to kill them again. He succeeds in destroying Su-hyun's tree, but Midan's survives and eventually is crafted into a bed. When Su-hyun buys the bed, it reunites him with the ghost of the princess. Unfortunately, it also brings back warrior General Hwang, a nasty killer who wreaks considerable havoc in modern day Seoul until the princess sacrifices herself to save Su-hyun.

Just hours after Kang handed over the script of *The Ginkgo Bed*, he received a phone call at half an hour past midnight. It was Shin, just finishing the script. He loved it and wanted the two of them to work together.

Shin had started his own company, ShinCine Communications, in the early 1990s and was an innovator in the way he looked for different kinds of financing. His film *Marriage Story* was one of the first movies in Korea to be funded by a jaebeol (Samsung). But to make *Gingko Bed* work, Shin knew he would need a whole different approach to put-

biopic about Park Gyeong-won (Jang Jin-young), Korea's first female aviator (well, almost first). It looked like it should have been a fascinating story: a young girl from the poor countryside of Korea, during the Japanese colonial days, grows up to become one of the nation's earliest pilots, back in the day when flying was still a dicey, newfangled thing. So what did director Yun do with his $8 million movie? He jumped right over the natural heart of the story (Park getting an opportunity and then learning how to fly), and spent two hours in a dull soap opera love story.

Plus, any film that contains the cliché dialogue, "Are you Korean? I'm Korean, too!" should be sent immediately to turnaround, for a long and complete rewrite.

Daisy (2006) Dir. Andrew Lau

Three of Korea's top actors: Jun Ji-hyun, Jung Woo-sung, and Lee Sung-jae. One of Hong Kong's most successful directors: Andrew Lau. A script by Kwak Jae-yong (one that he wrote before *My Sassy Girl*). A beautiful location: Amsterdam. Put it all together

and you get—not much. Just a hideously dull ar witless movie about a killer and a cop moonir after the cute, mute artist.

Although no one saw *Daisy*, in Korea or abroa it was saved by the largest pan-Asian presale ev for a Korean movie, taking in nearly $10 millic before filming even began.

Hanbando (2006) Dir. Kang Woo-suk

Can a film that makes $26 million really be a fa ure? If it is, Kang Woo-suk's *Hanbando* qualifie definitely. Kang emerged from the 1990s as one Korea's most successful filmmakers. Blatantly, br zenly commercial, he often proclaimed loudly ho audiences were No. 1 and that he just wanted to entertain. Then in 2004, his *Silmido* became Korea's most successful film (up until then), the first movie to top 11 million in attendance.

With *Hanbando*, however, it is like Kang forgot everything he believed about movies being fun.

ting the funding together. He did something no filmmaker in Korea had ever done: Shin went to a legitimate financial institution.

Ilshin Investment was a newly formed venture capital group that had sprung from the Ilshin Spinning textile company—an incongruous beginning perhaps, but in the early 1990s, the government was encouraging Korea's small and medium businesses to expand. "Venture industry" was the buzzword of the day. Under its president Koh Jeong-suk, Ilshin Investment was dedicated to nursing small companies, like the local affiliates of Giordano and Body Shop, and helping them grow.

Koh had no interest in films. He, however, had hired Kim Seung-bum, who just happened to be a movie fanatic. An easy-going, gregarious guy, Kim developed a love of movies while studying in Japan. He earned his MA degree in political science at Waseda University, then an MBA at Keio Business School. Although Kim is pretty sociable in the present, his first two years in Japan were a lonely time. He had made few friends, so he spent much of his free time in his

This two-hour nationalist sermon about the evil of Japanese imperialism was as silly as it was heavy-handed. The story? North and South Korea are on the verge of friendship and reunification when the vile Japanese interrupt, threatening to engulf the peninsula in war.

These days, director Kang is influential enough that he could get 3 to 4 million people to turn out to watch his home movies. The fact that people took a quick look at this atrocious joke of a movie and ran away as fast as they could is a tribute to the good taste of the Korean people (and the limits of nationalism, even here in the most nationalist of nations).

The Last Witness (2001) Dir. Bae Chang-ho

© CJ Entertainment

Bae Chang-ho was one of the most popular and important filmmakers of the 1980s, with innumerable hits like *Deep Blue Night*

and *The Whale Hunter*, but like so many filmmakers, he was unable to keep up with changing tastes. Despite having the largest budget of his career to work with ($6 million), this 2001 film about a detective investigating a strange and unsolved murder from the 1970s flopped badly at the box office.

Musa (2001) Dir. Kim Sung-soo

Although the historical epic *Musa* actually earned over $11 million at the box office, it was commonly perceived as a failure when it was released in 2001, thanks in part to the wave of pre-release hype and its then-record $7 million budget. Director Kim Sung-soo called his story of fourteenth-century Korean warriors making a desperate last stand against the relentless Chinese army his version of *The Wild Bunch*. Despite the critical drubbing the film received (mostly because of the weak storyline and cliché characters), *Musa* was visually gorgeous, shot in Cinemascope, and featured top Korean actors like Jung Woo-sung and Ahn Sung-ki, along with Zhang Ziyi, fresh from *Crouching Tiger,*

room, watching scores of videotapes, both Japanese and American. Thanks to those endless hours in front of a television, Kim says he fell in love with movies and their ability to elicit emotion from viewers. He returned to Korea in 1990 and approached producer Shin Chul about a job. But when he discovered he would have to work for two years without pay just to break into the movie business, he quickly changed his mind. Instead, he went into business, first as a consultant for the Monitor Group, then at Ilshin.

Kim Seung-bum really wanted to expand his portfolio at Ilshin and try investing in movies, but Koh kept turning him down. Then, in early 1995, Shin Chul came to Kim's office with three scripts he thought Kim might be interested in: *Elevator*, *Tales of the Hot Pepper*, and *The Gingko Bed*. Kim was honest with Shin and admitted he had no idea which script would make the best movie, and requested instead that Shin select the best one. Shin chose *The Gingko Bed*. For the next four or five months, Kim lobbied his boss to allow him to invest in the film. At last, Koh agreed, reluctantly, and made it clear

Hidden Dragon. Director Kim took such a shellacking from critics and audiences with *Musa* that he retreated into much smaller films like *Please Teach Me English* and producing for other directors.

Natural City (2003) Dir. Min Byung-chul

There are sex cyborgs, a rebel-cop-who-plays-by-his-own-rules, and endless rain and general dour. How could that not be a hit? Yu Ji-tae played "R," a grouchy, alcoholic cop of the future who had a serious groove on for his dying cyborg.

Cyborgs tormented by a limited lifespan and a poor understanding of emotions? In a rainy, dreary Earth of the future? Where everyone dreams of moving offworld? Does this remind you of any movie?

Director Min Byung-chul had already lost oodles of money with one attempt at a derivative big-budget action film (*Phantom: A Submarine, 1999*). Why he thought a second one would do better is beyond me.

Oh, it also has one of my personal favorite action-movie clichés, the building with an autode-struct sequence for no discernible reason. Who builds a building (a spaceport, no less) with an autodestruct capability? All my life, I think, I have never been in a building with an auto-destruct sequence, so why are buildings in movies so full of them?

Resurrection of the Little Match Girl (2002) Dir. Jang Sun-woo

While a lot of movies have bombed over the years, Jang Sun-woo's *Resurrection of the Little Match Girl* holds a special place in the annals of Korean cinema history. *Resurrection* sounded like an amazingly high concept, a post-modern follow-up to the Hans Christian Andersen story, combined with cyberpunk cool and cutting-edge special effects. Too bad the prickly auteur Jang had no idea what he was doing. After wasting millions of dollars, Jang ran out of money before the film was close to being finished and had to cobble together a movie with the bits and pieces he had. And it showed.

Costing a then-record 8 billion won ($10 million), *Resurrection* barely made $1 million at the

that if the film lost money, that would be the end of Ilshin's involvement in the movie industry.

Kim immediately got to work on *Gingko Bed*'s financing. At 1.27 billion won (about $1.37 million today), it was among the most expensive films ever made in Korea, if not the most expensive (even though $1.37 million today probably wouldn't even pay for the catering for a Hollywood film like *Titanic*), so turning a profit was far from assured. In fact, Koh, still concerned about the risk, made Kim team up with the Kookmin Bank subsidiary to minimize Ilshin's exposure. But Ilshin's up-front financing gave Kim a great deal of leverage when it came to negotiating his deals with distributors. Regional distributors around Korea offered 400 million won for the theatrical rights, the networks 130 million for TV rights, and the SK Group 500 million for video rights. Despite the movie's cost, Kim was able to raise nearly all of the budget by selling theater, TV, and video rights. Even with prints and advertising, Kim figured they needed to earn just 300 million won from Seoul theaters to break even.

box office in Korea. From time to time, a die-hard Jang Sun-woo fan will try to tell you that *Resurrection* is an amazing movie, just too sophisticated and ahead of its time for audiences to understand. Do not believe them.

Amazingly, despite losing over $9 million on this project, Jang was able to convince some producers and investors to let him make another film. *A Thousand Plateaus*, a Korean movie based on a Japanese folktale and to be filmed in Mongolia, it had the perfect synergy of pan-Asian "exoticism" that inspired French, German, Italian, and Swiss investors to chip in around $850,000 to the movie's $2.3 million budget (a Japanese film company invested $1 million). But just days before filming was to begin, Jang suddenly unveiled a set of demands that would have risen the film's costs greatly, and the project was scrapped.

I do not want to pick on anyone unduly, but I cannot

© Studio 2.0 Inc.

help but notice that three films on this list were by Tube Entertainment (*Tube*, *Natural City*, and *Resurrection of the Little Match Girl*), and I could have included a few more, depending on how one wishes to define flop (*2009: Lost Memories* was an impressive bit of cheese, too). Ironically, Tube's biggest success was one of its cheapest movies—*The Way Home* was a simple, low-budget movie about a spoiled young boy from the city who is forced to live with his mute grandmother in the remote countryside one summer. Despite costing less than $1 million to make, it earned over $25 million.

Rikidozan (2004) Dir. Song Hae-seong

It was as "can't miss" as any film can be. It had a uniquely talented director (Song Hae-seong of *Failan*), one of Korea's biggest stars (Sol Kyung-gu), Korea's most established producer (Tcha Sung-jai), and a riveting, true story about the Korean who became a legendary pro sumo

But Kang Je-gyu could not yet get to work on his movie. Ilshin as a financial institution needed permission from the Ministry of Commerce to invest in *Gingko*. At first, ministry officials were angry, saying the movie business was too disreputable for respectable financial firms to be investing in. But Kim knew how to impress the officials. He emphasized how the film would create jobs, and argued that the computer graphics in *Gingko* made it an IT project. Those were the right buzzwords, and Kim won permission from the Ministry of Commerce.

Finally, Kang was free to get to work. He felt a lot of pressure from Shin Chul and Kim Seung-bum and everyone. There was more than money at stake: if the new financing system were a disaster, it could set the Korean film industry back by years. But getting his money from Ilshin also gave Kang unprecedented independence—the freedom to do pretty much whatever he wanted. He just needed to work with Shin and Kim (Kim was extremely hands-off), not the dozens of busybodies most directors had to wade through.

wrestler, icon, and hero in post-War Japan. It missed. With its slow and lugubrious pacing, *Rikidozan* gave audiences no sense of who this great man was or why he was important to Japan (or Korea). Humorless and plagued by clichés, the $8 million *Rikidozan* disappeared quickly from the cinemas in December 2004, selling 1.6 million tickets in a short, three-week release.

R U Ready? (2002) Dir. Yu Sang-ho

A big-budget film about six strangers on an amusement park ride from hell. When the ride goes wrong, they are thrust into a special-effects-laden adventure. I hope I did not make the story sound interesting, because it wasn't. Wooden characters and no thrills added up to no customers and a box office of less than $300,000. Apparently the filmmakers were not ready at all.

Save the Green Planet (2003) Dir. Jang Joon-hwan

Jang Joon-hwan's *Save the Green Planet* was an odd flop in 2003—it received heavy critical praise

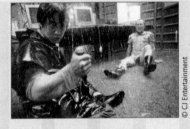

© CJ Entertainment

and good word of mouth. But no matter how hard people raved about *Green Planet* or how many international awards it won, people in Korea just would not go see it. It's the story of a crazy young man convinced that the owner of a chemicals company is in fact a space alien. The man kidnaps the tycoon and tortures him to make him confess about his nefarious plans for Earth. Witty, metaphorical, funny, brutal—it never stood a chance.

Tube (2003) Dir. Baek Woon-hak

It's like *Speed* mixed with *Die Hard*, but on the subway. Yeah, it was that original. Featuring Jay as yet another rebel-cop-who-plays-by-his-own-rules, *Tube* was ignored in droves after its 2003 release. Jay was the cop with a past. T was the bad guy with a past who kills the mayor of Seoul and comman-

More good fortune: casting went well. For the lead role of Su-hyun, he landed Han Suk-kyu, a popular voice actor whose live-action career was beginning to soar. The role of General Hwang went to Shin Hyun-joon, who had found fame in Im Kwon-taek's three *Son of a General* movies. Shim Hye-jin, who had starred in the hit *Marriage Story*, played Su-hyun's present day girlfriend, and Kim Hye-jin played Princess Midan.

Shooting lasted for three months, and there were many difficulties, as one would expect of a novice director and a big-budget project with special effects. The film went way over budget, soaring to 1.9 billion won ($2.1 million). "I hated him at the time," Kim Seung-bum confesses. "Shin Chul made excuses for the problems when I went to visit the set, but it drove me crazy."

Finally, on February 17, 1996, *The Gingko Bed* opened all over Korea, which at the time meant three theaters in Seoul and about twenty nationwide. Unlike today, when films can open on over eight hundred screens, back then small openings were the rule. It was a big

deers a subway train filled with explosives in order to . . . uh, something.

My favorite part? Our hero stuck aboard the doomed subway car (rigged with a bomb, of course) as it speeds to its doom, moving far too fast for him to possibly jump off. Unfortunately, Jay had already jumped and/or fallen from speeding subways throughout the movie about a dozen times, with only a few scratches to show for his trouble.

Like *Natural City*, *Tube* also features a one-letter character—the villain, "T." Is it supposed to be an hommage to Kafka? A sign of artiness? Or maybe the executive producer (both films were made by Tube Entertainment) was just trying to spell "tripe."

Wonderful Days (2003) Dir. Kim Moon-saeng

The advance preview of the racing jetbikes blew everyone away when the filmmakers showed a teaser trailer at the 1999 Pusan International Film Festival. Four years later, audiences were still getting teased.

At around $13 million, when *Wonderful Days* finally made it into theaters in the summer of 2003, the jetbike scene was still pretty cool—but there was precious little else. Director Moon S. Kim, a very talented and nice human being, went back into animation, quietly working on commercials and other projects, saying that animators should animate and leave storytelling to writers. In the polluted, futuristic city of Ecoban, one man dreams of a clean, free future and of seeing the blue sky again.

Yesterday (2002) Dir. Jeong Yoon-soo

Set in 2020, *Yesterday* was the story of a police investigator (Kim Seung-woo), his sidekick (Kim Seon-ah), and a criminal profiler (Kim Yun-jin) on the trail of a mysterious serial killer who is targeting only scientists. Gradually, they discover their case is part of an even bigger mystery, linked to thirty-year-old genetics experiments. Unfortunately, *Yesterday* had the misfortune of being released during the 2002 FIFA World Cup, when Korea's hearts and minds were fixated on soccer, not the movies, and it quickly sank at the box office.

hit, pulling in 452,000 admissions in Seoul alone, according to the Korean Film Council (Ilshin's Kim claims it was closer to 870,000.) Officially, *Gingko* was the second most successful Korean film of the year, behind Kang Woo-suk's *Two Cops 2*. However, regional distributors routinely underreported ticket sales, so no one knows for sure. Ilshin Investment ended up getting about an 80 percent return on its $500,000 investment (Kim says it could have been three times as much had they kept the budget under control and gotten accurate numbers from local distributors). The local press buzzed with excitement over this new hit, lining up for interviews with Ilshin Investment's president Koh Jeong-suk, who was very happy with the publicity. Even the Ministry of Commerce was pleased, thanks to all the good publicity, and soon became much more supportive of movie investment.

A notable point about *Gingko Bed* was that much of its post-production work was done in Australia, where Kang could obtain better quality sound and prints. Before 1995, there was only one studio in

Yonggari (1999) Dir. Shim Hyung-rae

Shim Hyung-rae boasted to all how his Godzilla-esque movie cost around $13 million, making it by far the most expensive Korean film ever made at the time. Well, "times." Shim made this flop twice, once in 1999, then again in 2001, all the while promising it would rival *Jurassic Park*. It did not, nor did the English-teachers-turned-actors impress anyone. North Korea's monster movie *Pulgasari* had more convincing special effects than this dud.

Impressively resilient, Shim came back for more, this time sinking $70 million of other people's money into *D-War*, an "epic" about dragons in Los Angeles (see The Top Ten Biggest Blockbusters sidebar).

But I have saved the "best" for last, because there is no disputing the biggest flop in Korean film history:

Inchon (1981) Dir. Terence Young

Ultimately, all talk of Korean flops begins and ends with the 1981 monstrosity *Inchon*. Produced by the Unification Church and its founder Reveren[d] Moon Sun Myung, *Inchon* cost a mammoth $4[?] million to produce, plus an estimated $20 millio[n] for advertising and marketing, but made barely $[?] million at the box office. Telling the story of Ge[n]eral Douglas MacArthur and the 1950 amphibiou[s] landing at Inchon in the Korean War, *Inchon* wa[s] directed by Terence Young (of *Dr. No* and *Thu[n]derball* fame), written by Laird Koenig and Robi[n] Moore (who wrote the novels *The French Conne[c]tion* and *The Green Berets*), and starred Laurenc[e] Olivier as General Douglas MacArthur, along wit[h] Jacqueline Bisset, Richard Roundtree, and even th[e] great Japanese actor Toshiro Mifune (*The Seve[n] Samurai*, *Yojimbo*).

What did the movie-going public receive for a[ll] that money and star power? "A hysterical historic[al] epic," according to Vincent Camby of the *New Yo[rk] Times*, "the most expensive B-movie ever made[.]" And *Variety* wrote: "Screenplay generally treats a[ll] [characters except MacArthur] as one-dimension[al] buffoons, giving them lines that are unintentio[n]ally laughable." Ouch.

Korea that could encode Dolby stereo for soundtracks—in a run-down complex on Mount Namsan in Seoul. In the government-run Dolby lab, and working with broken equipment, engineers ruled from a position of total control. Because their jobs were guaranteed for life, and because there were no alternatives in Korea, the engineers had little incentive to improve or learn new techniques. One producer told me that when he brought his film to the Namsan complex, the engineer told him point blank: "We're going to do it my way or I won't do it."

The government, which had targeted the movie industry years earlier as a sector to support, broke ground in 1989 on a 30 billion won ($32 million) studio complex east of Seoul, in Namyangju—but the sound mixing studio had yet to be built when Kang was making *Gingko*. In fact, there was a period of a year or two, between the Namsan studio closing and the opening of the new, state-of-the-art Dolby studio, when Korean films had to be sent to Japan, Australia, or the United States for Dolby. This turned out to be a significant boon for filmmakers. Once filmmakers started going to other countries and saw how sound mixing was done elsewhere, they experienced a revelation—a host of new ideas and engineers responsive to their customers. They brought those new insights back to Korea, to use in the new Namyangju studio. By the time the Namyangju Dolby studio opened, filmmakers traveling around the world had greatly improved the quality of sound in movies, assisting the entire Korean film industry.

The great transition in the Korean film industry occurred in the period between *Gingko Bed* (1996) and Kang's next movie *Shiri* (1999). In fact, 1996 was in many ways the low point. Movie attendance fell to 42.2 million admissions, the worst year on record since the government started keeping such records in 1960. But local films were beginning to show signs of bouncing back. Korean movies were slowly increasing their box office share, from a low of 15.9 percent in 1993, to 23.1 percent in 1996. The number climbed steadily over the next few years, as Korea's most important directors of the modern era started making their first films. Consider this list of firsts. In 1996: *The Gingko Bed* (Kang Je-gyu), *The Day a Pig Fell in the Well* (Hong Sang-soo), and *Crocodile* (Kim Ki-duk). In 1997: *Green Fish* (Lee Chang-dong). In 1998: *The Quiet Family* (Kim Jee-

woon), *Girls' Night Out* (Im Sang-soo), and *Christmas in August* (Hur Jin-ho).

In addition, by the mid 1990s, foreign-educated aspiring film-makers were returning to Korea, the first wave after the 1988 government loosening of restrictions on travel and study abroad after the Olympics in 1988. It was clear to people in Korea and beyond that something exciting was happening to movies in Korea.

And, of course, there was the Asian economic crisis. Just as the crisis had spurred the development of Korea's movie industry by forcing out weak companies and improving transparency, so too had it helped out Korean films on a creative level. From the beginning, the Korean film business had been modeled very closely on the Japanese film business. Creatively, that meant a hierarchical system where young, aspiring filmmakers would join an established director's "team" and slowly work their way up the metaphorical ladder. By the time the average director finally got a chance to make his first movie, he was usually fairly old and firmly established in his mentor's style.

But the Asian economic crisis, the rise of a new generation of filmmakers, and the return of so much young talent from abroad produced creative potential and opportunities that normally would not have existed. Aspiring young Korean directors were no longer interested in waiting for a couple of decades to get started. They wanted to make their films, right away, in their own style. In a short amount of time, Korean filmmakers became on average some of the youngest in the world, and much more commercial than their predecessors.

The Asian economic crisis also brought a growing desire among the public for purely escapist fare. Times were hard, and many people were losing jobs or having other kinds of money problems. When they went to the movies, they wanted to forget their troubles and have fun. Under the military dictatorship of the 1980s, such escapism seemed frivolous and disrespectful to many, so movies tended to be more serious. But as time softened the memories of that difficult era, people became more comfortable with fun and entertainment. In addition, the crisis spurred anti-foreign sentiments a bit, as many people wanted to support homegrown goods and services (although I would not want to exaggerate that last point, it was a factor).

Finally, this period saw the rise of full investment funds, which took Ilshin Investment's idea to the next level. Part of the economic

restructuring introduced by the International Monetary Fund forced out many of the jaebeol that were investing in the movie industry (whose owners were usually more concerned with selling videotape and VCRs than making good films), and instead created even more venture funds. Also, when Kim Dae-jung was inaugurated as president of South Korea in February 1998, he brought with him an increased push for cultural content in general. Beginning with Mirae Audiovisual Venture 1 in 1998, full-fledged investment funds were dedicated to the entertainment industry, raising capital from investors. Both the Korean Film Council and the Small and Medium Business Administration contributed to these new funds, and the government provided new kinds of tax relief and incentives.

A Commercial Revolution

Even before *The Gingko Bed* was finished, Kang was ready to start on his next film. Despite all the action and special effects, *Gingko* had very much been a melodrama at heart, its emotional pyrotechnics even larger than its physical spectacles. "I wanted something more masculine," Kang said. He had been thinking about some sort of spy-action story for some time, and when he saw Jerry Bruckheimer's action orgy *The Rock* that summer, he felt inspired. He started to work on the screenplay that became the most remarkable commercial Korean film in history—*Shiri*.

Named after a common and rather tranquil freshwater fish that shows up throughout the uncommon and high-octane plot, *Shiri* would go through more than a dozen drafts as Kang worked to ratchet up the film's action. He wanted Ilshin to fund the movie, but Kim Seung-bum was still annoyed with him from *Gingko* and refused to get involved in a second big-budget mess. Kang followed Kim around for three months, but Kim avoided Kang, he says, "like the plague." Fortunately, Kang Jye-gu was a hot item after *Gingko*, and found it fairly easy to get the funding elsewhere. In the end, Samsung Entertainment stepped in with the 2.2 billion won he needed to make his movie.

That 2.2 billion won works out to around $2.4 million in today's exchange rate. But most Western press reports on *Shiri* back then said the film cost around $4–5 million. The reason seems to be that

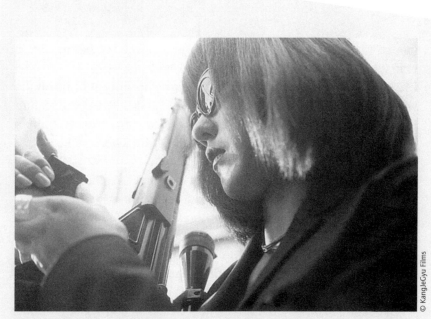

Kang Je-gyu's Shiri *revolutionized the Korean movie industry, blowing all the nation's box-office records.*

the won/dollar rate was much different back then, especially before the financial crisis. So if you include prints and advertising expenses and use the pre-financial crisis exchange rate, you get a little over $4 million. Also, marketers in Korea, like everywhere, like to exaggerate, and they probably did so with *Shiri*'s budget. In any event, that 2.2 billion won was nearly double *Gingko Bed*'s original budget and back then was a lot of money for a film.

Shiri began with a brutal training sequence in North Korea, as dozens of troops are taught how to become elite sleeper agents in the most rigorous and cruel ways possible. The most promising recruit is a beautiful but deadly sniper named Lee Bang-hee (played by Kim Yun-jin, better known to most people today for her role on the American television program *Lost*). She is sent into South Korea along with her boss (the always superb Choi Min-shik), where she becomes an effective agent, killing many government officials over the years.

Hunting for the elusive North Korean killer are two South Korean agents, Yu Jong-won (once again starring Han Suk-kyu) and Lee Jang-gil (an early role for the excellent Song Gang-ho). Yu is engaged to Myung-hyun, a beautiful young woman who owns an aquarium

(hence the fishy title of the film). Gradually Yu and Lee uncover a crafty North Korean plot involving a deadly new explosive called CTX. The North and South Korean governments appear to be on the verge of détente, and the North Korean leader will come to South Korea to watch a soccer game between the two countries. But unbeknownst to either North or South, renegade North Korean agents are planning to blow up both leaders at the game.

Much havoc is wreaked and Yu is hot on the North Korean's heels when—surprise, surprise—it turns out his fiancée Myung-hyun is actually Lee Bang-hee, the North Korean agent. Myung-hyun kills Yu's partner and is on her way to kill the two leaders at the soccer game when Yu and the South Korean forces stop her. But not before Myung-hyun and Yu have a tear-filled showdown in the heart of the stadium.

Samsung had ponied up the whole $2.4 million budget for *Shiri*, but was keeping a tight lid on spending, determined to not go over budget. Over the next few months of filming, every day became a battle to hold down costs. At one point, twenty crew members came down with colds at the same time. Samsung refused to put their doctor visits and cold medicine on the movie's budget, so Kang and his film company ended up paying their medical fees themselves.

As Kang and his team began piecing together *Shiri* in the editing room, they began to gain confidence. The action was crisp, the film looked great. They began to speak with confidence about breaking *Sopyonje*'s 2.3 million box office take for a Korean film. Tellingly, though, no one thought seriously about challenging *Titanic*'s 4.5 million admissions record, the highest box office and biggest film in Korea at the time. They would turn out to be so very wrong (but in such a good way).

Shiri exploded out of the box office like nothing anyone in Korea had ever seen before, bringing its action-soaked love story to theaters on the day before Valentine's Day 1999. Like *Gingko Bed,* it opened on relatively few screens compared to movies these days (although a then-impressive forty-eight screens nationwide), but people flocked to it immediately. Despite mediocre reviews, on opening morning the lineups circled the block at Seoul Theater (then the biggest and one of the most important cinemas in Korea).

Shiri's Seoul attendance topped 1 million in just three weeks. Im

Kwon-taek's *Sopyonje*, the only other Korean film to hit the million mark, took over six months to reach that level. *Shiri* sold 2 million tickets in eight weeks and eventually sold 2.5 million in Seoul by the time its fantastic run was over. Nationwide, it would make about $36 million on an attendance of 6.2 million—soundly beating *Titanic*.

Affecting more than just movie ticket sales, the *Shiri* phenomenon seeped into Korean society. The word "shiri" was used as a brand name for just one item before the movie was released. Three months later, thirty-seven goods called themselves "Shiri"—shoes, umbrellas, detergent, restaurants, and more. A local government in the Gangwon province tried creating a Shiri festival, featuring the fish during its egg-laying season in May. After the Minister of Defense saw the movie, he ordered it be shown to all the soldiers in the country as an educational and morale-boosting tool.

One of the most remarkable, attention-getting parts of *Shiri* (besides a bomb that defied all the laws of physics and exploded downward, from the roof of a building *into* the structure), was its portrayal of North Koreans. Now, to most people outside of Korea (or even to most Koreans today), both Lee Bang-hee and her commander were stereotypical psychopaths. But for South Koreans then, the portrayal of the Northern agents was remarkably sympathetic. The North Korean agents asked how South Koreans could eat hamburgers and get fat while North Koreans starved. They did their best to support their homeland. They were sincere, and they could love and generally act in a way people would recognize as human. Which, after years of virulent anti-communist propaganda spewed by the South Korean government, was something of a revelation. At one point, Choi Min-shik's character even gave a speech about how the same shiri fish swims in rivers on both sides of the North-South border, without a thought as to which side it is on. The timing was pretty much perfect. The former democracy activist and opposition leader Kim Dae-jung had just been elected president and was advocating a "Sunshine Policy" of building trust and making goodwill gestures toward North Korea.

Usually Korea is not front-and-center in the international media, at least for matters cultural (editors seem to be much more fascinated by the North launching yet another missile, or some union guys getting into yet another a fight with riot police), but *Shiri* really

got the attention of people around the world. *Time*, *Asia Week*, and others published features that examined the surprise hit. What did it mean? How could Koreans make an action film that outdid *Titanic*? Was it just a fluke? Was it the sign of something new?

Just a Fluke? One of the most important aspects of *Shiri* is that it got Korean producers excited about film-making. "*Shiri* did not change the movie-making system, like *Gingko Bed* did," explains Kang Je-gyu, "but it did change our sense of the possibilities." Many others in the film industry felt the same. CJ Entertainment had nothing to do with *Shiri*, but Miky Lee was nonetheless impressed by the film. "I was excited and proud that our country could support a film like that." Catherine Park, one of the first international sales agents in the Korean movie business (now head of international business at Korea's major entertainment company iHQ), said, "It restored the Korean people's trust in their own film industry."

Ilshin Investments' Kim Seung-bum had to live with the fact that he had passed on the biggest film in Korean history. "Do you think I made a mistake?" asks Kim, with a self-deprecating laugh. He would go on, though, to have a big movie career of his own. Before *Shiri* was released, Kim had made many other hits for Ilshin, such as *Contact* and *Christmas in August*. Unfortunately, the movie business is fickle, and Kim had made as many misses as hits. After a stretch of four flops in a row, Kim could tell his boss was losing patience with him, so in 1999 he split off to form Tube Entertainment, dedicated to making big Hollywood-style blockbusters just like *Shiri*. After all, no one in Korea at the time knew blockbuster financing like Kim did.

Kim soon learned that making blockbusters was much trickier than he thought. Three of his first four big-budget movies at Tube, unfortunately, were all flops, and the fourth barely broke even—*2009: Lost Memories* did okay, but *Natural City*, *Tube,* and the infamous *Resurrection of the Little Match Girl* all lost millions. *Match Girl* in particular was a great example of how not to make a movie, as it cost close to $10 million but made less than $1 million. Not only that, but delays screwed up their schedule so that all four movies ended up in

production at the same time, tying up $30 million at once, with no money coming in.

Lucky for Kim Seung-bum, CJ Entertainment was going public at the same time but had no films in the works. Kim had films, but no money. In a propitious move for both parties, CJ Entertainment stepped in and helped Kim get through this period, buying Tube's distribution rights for around $5 million. Then Kim had another piece of luck. In the midst of that four-movie bad run, Kim also produced a little film about a young boy whose mother sent him to live

Sometimes less is more. The Way Home *was one of the cheapest films of 2002, but it turned into one the biggest hits.*

with his old, old grandmother in the remote countryside. Costing less than $1 million, *The Way Home* came out of nowhere in 2002 to earn over $20 million, helping Tube get back on its feet again.

Kim would not be the only filmmaker to learn such a harrowing lesson. Less than four months after *Shiri*'s release, another film would dramatically showcase the dangers of this new high-risk/high-reward sort of filmmaking when it does not work out. A monster film called *Yonggari* (1999) was the most expensive movie ever made in Korea, costing close to $10 million. But far from being the *Jurassic Park* its director Shim Hyung-rae envisioned, *Yonggari*'s special effects were pretty cut-rate. Combined with a horrid, moronic script, *Yonggari* flopped—but, well, not nearly as badly as it should have. In fact, with over 1 million admissions (500,000 in Seoul alone), it was the sixth-biggest Korean film of the year. But critics and popular opinion uniformly pronounced Shim's creature feature a disaster.

Meanwhile, there were plenty of other directors and producers looking to replicate Kang Je-gyu's magic with blockbusters of their own. An action film about a submarine, called *Phantom: A Submarine*, did moderately well (although the film was mostly forgettable,

it was scripted by two men who would soon become major figures in the movie scene: Bong Joon-ho and Jang Joon-hwan). But for the most part, the most successful films of 1999 were more modest in budget and more creative in style—the comedy/social commentary *Attack the Gas Station*, the thriller *Tell Me Something*, Lee Myung-se's crazy action film *Nowhere to Hide* (whose rain-soaked climax would go on to provide major inspiration to the Warchowski brothers in *Matrix Revolutions*), and the brilliantly acerbic and bitter drama *Happy End*, which featured Jeon Do-yeon and Choi Min-shik at their best.

At first, 2000 looked similar to post-*Shiri* 1999, with a spate of creatively energized and modestly budgeted hits: Lee Chang-dong's *Peppermint Candy*, Im Kwon-taek's wonderful retelling of the traditional story *Chunhyang*, and Jang Sun-woo's controversial S&M-infused story *Lies*. Hong Sang-soo made his best film to this day, *Virgin Stripped Bare by Her Bachelors*. Kim Jee-woon released the hilarious pro-wrestling comedy *The Foul King*, and Bong Joon-ho finally made his debut with *Barking Dogs Never Bite*. Big budget, empty-headed films like *Bichunmoo* and *The Legend of Gingko* (nominally a follow-up to *The Gingko Bed*, produced by Kang, but with little personal involvement) did decently at the box office, but the results weren't impressive when one considers their costs.

There was a strange divide forming in the movie world. Despite so much creativity and solid box office successes (at least by the modest standards of the time), there was a sense that, without the big-budget, Hollywood-style megahit, the industry was missing something. Suddenly, getting 2 million admissions just did not satisfy like it used to, not when producers knew that 6 million was possible. Was *Shiri* just an amazing fluke? Would Hollywood continue to rule the high end? Would Korean filmmakers have to be satisfied with more modest hits?

Finally, a year and a half after *Shiri* had shocked everyone, along came another hit, this time by a young, unknown director whose mystery-thriller was set on the North-South border. The director was Park Chan-wook, and his film was *JSA: Joint Security Area*.

Park was a surprising choice to follow up the blockbuster phenomenon. More of an intellectual by nature, Park had studied philosophy and aesthetics at the Jesuit-run Sogang University in Seoul. After graduating, he moved on to movie criticism, before segueing into

writing screenplays. His first two movies, *The Moon Is Sun's Dream* and *Trio*, were critical and commercial failures. Park himself usually speaks poorly of them.

JSA, though, was totally different. It shot out of the gates, setting records from the beginning—half a million admissions in Seoul alone in the opening week, and over a million in fifteen days. (*Shiri* took twenty-one days to do the same). *JSA* admissions reached 5.8 million in twenty weeks—fewer than *Shiri*, but rising ticket prices meant that *JSA*'s production company, Myung Film, could claim it was the biggest Korean film of all time (although Kangjegyu Film would argue the point).

If *Shiri* had used a growing sense of North-South rapprochement to pull in huge numbers, *JSA* took the approach several steps further. In Park's film, soldiers of both North and South were not really different at all, just a political line away from being friends.

Unlike *Shiri*, which received praise from Korea's security forces, *JSA* really irked the military. Meetings between border guards, they said, were way too idealistic for the brass to stomach (and bordered on being enemy propaganda). At one point, a veterans' group even took over Myung Film, demanding an apology from the company. Realistic or no, *JSA* came out just three months after the historic summit between South Korean President Kim Dae-jung and North Korean "Dear Leader" Kim Jong-il in Pyongyang, and optimism and unification were in the air. Sadly, it turned out to be hot air, but at the time there was real hope for North-South relations.

The important thing for the film industry was that *JSA* proved that *Shiri* was no fluke. Korean films could pull in 5 million admis-

Burning Past
Namdaemun (or Sungnyemun) was one of the four great gates of old Seoul, Korea's oldest wooden structures and most visible landmarks. First built in 1395, Namdaemun survived wars and time, only to be burned down in 2008 by a disgruntled sixty-nine-year-old man.

© Robert Koehler

sions and make $30 million at the box office—both numbers far better than what the best Hollywood films could do in Korea. Critical raves are nice, as are invites to the world's top film festivals, but nothing makes a producer's eyes widen and pulse race like really big piles of cash.

For the next couple of years, the Korean film industry continued in this vein, with a mixture of big hits, big flops, critical raves, and more than a few really, really dumb movies. Every so often, a few too many months would pass without another *Shiri*-sized hit, and everyone in the industry would grow nervous and begin to say the end was nigh—but then a big film would hit the screens and restore everyone's confidence.

In March 2001, Kwak Kyung-taek released *Friend*, a nostalgic look at young people and gangsters in Busan a generation ago. *Friend* once again reset all the Korean records over its four-month run, totaling 8.2 million admissions ($52 million), a full 2 million more than *Shiri* (ten years earlier, no single film had pulled in 2 million admissions).

In 1996, two Korean films topped 1 million admissions, and two made it to the top ten overall. In 2001, nine Korean films drew 1 million admissions, and six made it into the top ten. This impressive shift was built on the creativity and good business sense of the new generation of filmmakers, but it took the bigger-than-life successes of movies like *Shiri*, *JSA*, and *Friend* to make the film industry really believe in itself. For the man who started it all, Kang Je-gyu, the only question was, "What's next?"

Korean films were also getting more and more notice abroad. Kim Ki-duk became a film-festival favorite for his shocking, twisted images. Veteran director Im Kwon-taek became the first Korean filmmaker to win a prize at Cannes when he shared the Best Director award in 2002 for *Chihwaseon*, a biography of one of Korea's most famous painters of the Joseon dynasty. Park Chan-wook's follow-up to *JSA*, *Sympathy for Mr. Vengeance*, flopped in Korea, but soon picked up a big online following in America. Park's next film, *Oldboy*, was even more striking than *Mr. Vengeance* for its stylized, brutal violence and dark psychology, and this time audiences flocked to it. Harry Knowles at the influential geek site aintitcool.com called it the best film of 2003. *Oldboy* went on to win the Grand Prix at

Cannes in 2004. It was a great era for Korean movies, full of praise and success. People were wondering if it could go any higher. Kang was up for the challenge.

Building a Bigger Blockbuster

Following *Shiri*, Kang could have done just about anything he wanted in the movie industry. He'd made more money for his investors than anyone thought possible, and Korea had yet to suffer from the high-budget flops that scared everyone a couple of years later. Surprisingly, Kang did not get behind a camera again for years. Instead, he spent much of the next period producing movies for other filmmakers. His company Kangjegyu Films produced such movies as *Besame Mucho*, *Over the Rainbow*, and the aforementioned *Legend of Gingko*.

Producing turned out to be a job ill-suited for Kang, and gradually, word got out that he was working on a new movie. And not just any movie, but a really, really big movie. "I was interested in something outside of the limits," Kang said. "I felt some kind of duty as a movie person. I wondered what I should do to contribute to the growth of the Korean movie industry."

He had several ideas for what he might do next, including making a science fiction film in Hollywood with a Western cast and crew. But over time, one idea began to crystallize and grow more captivating to him. In May 2002, three years after *Shiri*, he finally announced his new project: an epic, a great film set in the Korean War, the most expensive movie ever made—*Taegukgi: The Brotherhood of War*.

Aside from the title, Kang kept most of the details of *Taegukgi* quiet. People knew it would star two of the biggest young actors in Korea, Jang Dong-gun (who had starred in *Friend*) and Won Bin. They knew it was a Korean War movie about two brothers. And they knew Kang wanted to release it toward the end of 2003, to coincide with the fiftieth anniversary of the end of the Korean War. But that is about it. They didn't know much else. "I'm not trying to make a realistic war film," Kang told the Korean magazine *Cine21*. "I'm trying to show the Korean War as the point of no return in Korean history."

He started *Taegukgi* thinking the movie would cost a hefty $11 million. That estimate soon went out the window when Kang's line producer told him to expect more like $18 to 19 million. Kang and all the potential investors said there was no way to make $19 million work, so the producer kept crunching the numbers until he worked the budget down to $15 million. While $15 million sounds small compared to the $100 million or so Hollywood routinely spends, Korean movies had a long history of stretching their money; $5 million spent in Korea might look like the equivalent of $15 to 20 million in Hollywood. Still, $15 million was a lot of money. Certainly a lot more than Kang had. And no investors were willing to climb aboard such a huge, risky project. But Kang forged ahead anyway. Kangjegyu Film had just banked a small windfall from a silly sex comedy in the vein of *American Pie* called *Wet Dreams* and had about $3 million handy. Plus, Kang mortgaged his home and threw in all his own money, about another $2 million, bringing the total to $5 million. So, with

The Top Ten Biggest Blockbusters

1 *The Host* (2006) Dir. Bong Joon-ho
Total attendance: 13.02 million (Time to 10-million attendance: 21 days)

How fitting it is that the most successful film in Korean history (for the moment at least) is such a wonderful combination of great effects and strong storytelling. How novel.

Bong made a reputation with the low budget but fascinating *Barking Dogs Never Bite* back in 2000, then followed it up with the modern classic *Memories of Murder* in 2003. *Memories* was especially excellent—loosely based on the true story of a serial killer in the Korean countryside in the 1980s who was never caught, this movie featured gorgeous cinematography and a nuanced script that was at once terrifying and darkly funny, full of texture and meaning while being very accessible. Its 5.1 million admissions made it the No. 15 most successful Korean film.

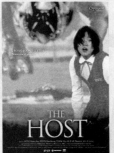

The Host, although not as masterful as *Memories of Murder*, was still a lot of fun and a wonderful jumble of genres. A monster emerges from the Han River in the heart of Seoul and begins eating people all along the shore. The government and military is helpless before the gooey, amphibious creature. Only the father (Song Gang-ho) of one of the victims, and the father's family dare to confront the beast, tracking it down along the river and in the city sewers, until the gory and tragic climax.

After making its debut at the Cannes Film Festival (with great early word in the international press, including strong praise from the *New York Times'* Manohla Dargis), anticipation for *The Host* built steadily over the early summer. It got some help from weak competition—*Superman Returns* fizzled in Korea, *Pirates of the Caribbean 2: Dead Man's Chest* quickly died, and the less said about Kang Woo-suk's *Hanbando* the better. So when Bong's film finally was released, it was perfectly situated for an amazing run.

just one-third of the budget in pocket, Kang took the plunge and started production in February 2003.

With its huge scale, *Taegukgi* was by far the most difficult film Kang had tackled. It would be nothing short of epic. He used 19,000 military uniforms, 4,000 period costumes, and more than 20,000 extras. Real tanks, armored vehicles, and cannons were used or created digitally. Kang re-created the streets of downtown Seoul circa 1950, with all its little shops and stores, as well as wartime Pyongyang.

After all the big-budget flops since *Shiri*, much of the Korean film industry had lost its confidence in the blockbuster, preferring safer bets like comedies, gangster comedies, and romantic comedies. Kangjegyu Films had also done poorly over the previous few years, with the exception of *Wet Dreams*, and now that Kang, gambling everything on his vision, had put all of his own money into the film, the entire company's future hinged on *Taegukgi*'s success.

Over the next few months, Kang managed to film about 30 per-

2 *The King and The Clown* (2005) Dir. Lee Joon-ik

Total attendance: 12,298,280 (Time to 10-million attendance: 45 days)

The King and the Clown was easily the biggest surprise in the Korean film world since *Shiri*. Where even to begin? *The King and the Clown* was a modestly budgeted period piece, about two clowns who had to entertain a corrupt king some five hundred years ago, and historical films usually do not do well in Korea. The movie showcased no major stars. The story featured clearly homosexual characters and themes. And the film was released at the tail end of 2005, in the middle of the incredibly busy holiday season. Often you can tell when a good film is coming from its buzz—advance audiences are talking about it, theater owners are desperate to get extra prints. But that wasn't the case for this little film.

Instead, *The King and the Clown* opened on a modest three hundred screens. Everyone had expected the big movies of the season to be the latest Jang Dong-gun action epic *Typhoon*, or else the lush, true-life story of Korea's first female

© Cinema Service

aviator (well, almost first), *Blue Swallow*. Or perhaps some big Hollywood CGI (computer-generated imagery)-fest like *King Kong* or *The Chronicles of Narnia*. And, in fact, *Narnia* did win that opening weekend. But something amazing began to happen: *The King and the Clown* was pulling in incredible word of mouth. By the following weekend, attendance was surging for *The King and the Clown*, as audiences forgot about everything else. Theaters scrambled to find screens for the unexpected hit. The weekend after that, it did even better. By the middle of March, it had become the best-selling movie in Korean history, a record it held until *The Host* was released later that summer.

3 *Taegukgi* (2004) Dir. Kang Je-Gyu

Total attendance: 11,746,135 (Time to 10-million attendance: 39 days)

cent of the movie. Even though he had put off paying most people at his film company and put off paying the crew, he was rapidly running out of money and needed to raise funds. So in May, he cobbled together a two-minute trailer and headed to the Cannes Film Festival. There, he showed the little piece to foreign buyers and immediately received a great response. Perhaps more importantly, the Korean film company Showbox was interested. After a few discussions, Kang got Showbox to pay nearly $10 million and received enough from Universal Japan to finish the film, freeing himself to make the epic the way he saw fit.

Kang aimed for a December 16 release, but filming finished in October, leaving precious little time for post-production. Every day became a round-the-clock marathon, with the sound crew, computer effects team, and everyone working nonstop. The giant saga proved too much for even Kang to control. Kang's self-imposed five-week editing schedule grew into eight, and the time frame of other parts

An epic story of two brothers in the Korean War, *Taegukgi* was the biggest blockbuster Korea had ever seen at the time. It stars Jang Dong-gun and Won Bin as the two brothers: one a sickly conscript into the army, and the other his protector and a reluctant hero. Ultimately, one brother must die to save the other. Director Kang Je-gyu is the only filmmaker to show up on this list twice. He does not make many films, but obviously he knows how to make films that really appeal to Koreans.

4 *Silmido* (2003) Dir. Kang Woo-suk
Total attendance: 11,108,000 (Time to 10-million attendance: 58 days)

Director Kang Woo-suk showed his considerable clout gathering the all-star cast in this film—Sol Kyung-gu, Ahn Sung-ki, Jeong Jae-young, Hur Joon-hi, and more—in a based-on-a-true-tale film of a secret military team trained in the late 1960s to invade North Korea and assassinate Kim Il-sung. Kang also showed off his considerable resolve, rebuilding large sets after they were completely smashed by a passing typhoon. At one point, *Silmido* was actually to be produced by Columbia

Tristar (in part because of its then-intimidating budget, topping $10 million), but shortly before shooting began, Cinema Service, the production company Kang founded in 1993, convinced him that his movies should be made by them, and he returned to the fold.

5 *D-War* aka *Dragon War* (2007) Dir. Shim Hyung-rae
Total attendance: 8.3 million

Without a doubt the worst film that did the best in Korean film history, Shim Hyung-rae's *D-War* was an incredibly expensive, silly mess. After *Yonggari* bombed badly in 1999, Shim refused to give up his blockbuster CGI dreams, so he set to work making an even bigger, sillier "epic." The result was *D-War*, the story of dragons and monsters invading Los

of post-production work grew, too. Kang could no longer release the film during 2003, the year of the fiftieth anniversary of the end of the Korean War, so he chose a February opening. Unlike in the United States, where the month is a dumping ground for lousy films, February can be one of the biggest seasons in Korea. The important New Year holiday season date floats around between mid-January to mid-February, its specifics determined by the lunar calandar.

As the release date for *Taegukgi* neared, hype for the film continued to ratchet up. Even in the planning stages, Kang had wanted this to become the first movie ever in Korea to reach an attendance level of 10 million. Unfortunately, Kang never counted on a surprising competitor that season, *Silmido*, made by one of Korea's most successful and blatantly commercial directors, Kang Woo-suk.

Silmido was based on the true story of a secret military team assembled in 1969 to assassinate North Korean leader Kim Il Sung. The team was trained on Silmi Island, just off Korea's west coast

Angeles, costing a stunning $75 million (although to be fair, $43 million of that was for capital and other start-up costs in developing the CGI system; the movie itself cost a little over $32 million). With so much money invested, at least Shim was able to put together better computer graphics, with the giant Imoogi worm and the giant dinosaurs with rocket launchers on their backs—the kind of thing any eight-year-old boy would go crazy for. Fun images like that, combined with a blatant appeal to Korean nationalism, equaled success. (The Korean version of the movie ended with a two-minute essay on the screen, talking about how hard Shim had worked for the glory of Korean cinema, while the traditional song *Arirang* played in the background.) *D-War* also received the widest opening in the United States ever by a Korean film, hitting 2,268 screens in September 2007, and earning just over $9 million. *D-War* might not have recouped its enormous budget, but it did far better than anyone would have expected.

6 *Friend* (2001) Dir. Kwak Kyung-taek
Total attendance: 8,180,000

For three years, most of the Korean film scene thought that Kwak Kyung-taek's tragic tale of friendship and betrayal in Busan in the 1970s and '80s was the apex of Korean blockbusters. It was the first Korean movie to top 8 million admissions, a standard that no one else could even approach, before *Silmido* blew it away in the winter of 2003. It was also the film that made Jang Dong-gun into a real star; he has since headlined such movies as *Taegukgi* and *Typhoon*.

7 *Welcome To Dongmakgol* (2005)
Dir. Park Kwang-hyun
Total attendance: 8,002,594

A quirky film based on a popular stage play by Jang Jin, *Welcome to Dongmakgol* was passed over by several studios. But the story of a South Korean, a North Korean, and an American soldier who all stumble into a small village so remote it is unaware the Korean War is raging, struck a chord with audiences. Director Park displayed no small amount of creativity for a debut film, especially in the famous boar-hunting scene.

(close to where the Incheon International Airport now sits), under extremely tough conditions—seven died during the training, including four who were beaten to death for trying to escape. The team revolted against its oppressive commanders in 1971, went on a shooting spree, and commandeered a bus to make an assault on the president's residence, called Cheongwadae. The secret unit made it well into Seoul, to within a few kilometers of Cheongwadae, before they were stopped under heavy gunfire. Only four men survived, and they were swiftly and secretly executed in early 1972.

Released at Christmas 2003, *Silmido* debuted on 325 screens with a barrage of publicity—thanks in part to Kang Woo-suk's excellent connections throughout Korean media circles, but also due to subject matter that resonated with audiences around Korea. Despite its $10-million-plus budget, *Silmido* surprisingly does not look like much, not like a film that pushed boundaries or budgets. But the movie had many of Korea's top actors, including Ahn Sung-ki

8 *May 18* (2007) Dir. Kim Ji-hoon
Total attendance: 7.2 million

Based on the true story of the Gwangju Uprising of 1980, when the people of Gwangju rose up against the military dictatorship of the day, only to be brutally massacred. The Gwangju Uprising has been tackled several times over the years, but usually more tangentially. *May 18*, on the other hand, was pure melodramatic spectacle, as tears flow as freely as blood, as a true-life tragedy is highlighted by a *Titanic*-like love story.

9 *Tazza: The High Rollers* (2006) Dir. Choi Dong-hoon
Total attendance: 6,789,000

Choi Dong-hoon's first film, *The Big Swindle*, received plenty of critical raves back in 2004, but it was only a modest hit at the box office (2.13 million). With *Tazza*, however, and its dark, intoxicating tale of *hwatu* card sharks, love, and be-

trayal, Choi won both with critics and audiences. Baek Yoon-shik once again played a wily, mysterious mentor (something he excels in). Kim Hye-soo received a remarkable makeover to become one the more alluring and believable femme fatales ever in Korean film. Based on a popular comic book by Heo Young-man, a sequel to *Tazza* is currently in the works, rumored to be directed by Jang Joon-hwan (*Save the Green Planet*).

10 *200 Pound Beauty* (2006) Dir. Kim Yong-hwa
Total attendance: 6,620,000

The amusing and light *200 Pound Beauty* was the most successful comedy ever in Korea, surprising most people in the film industry when it became the Christmas hit of 2006. Based on a Japanese comic book, *200 Pound Beauty* made a star out of Kim Ah-joong, who played the title character, an overweight young singer who undergoes radical plastic surgery to become thin and beautiful. Like most Korean comedies, it veers away from humor halfway through and spends much of the latter half generating tears, but audiences ate up the premise.

and Sol Kyung-gu, and it told a violent, engaging, true story that the government only officially acknowledged in 2005. In fact, a military investigation revealed that the soldiers were not pardoned criminals or regular soldiers, as was commonly thought. They were, in fact, all drafted civilians.

Silmido was a big hit, bringing in 1.58 million admissions in its first week—a record for a Korean movie, although just shy of the opening records set by *Lord of the Rings: Return of the King*. But no Hollywood film could stand up to the biggest Korean hits over the long haul. By the end of its run, *Return of the King* had just less than 6 million admissions, while *Silmido* would reach 11.2 million (or about $70 million).

Kang Je-gyu was annoyed and a little deflated to lose the mantle of "first 10-million-admissions movie" to *Silmido*. But it spurred him on to do even better with *Taegukgi*. (Nonetheless, Kang and his crew were legitimately pleased to see another Korean film do so well.)

Bonus: Three Runner-Up Blockbusters

11 *Shiri* (1999) Dir. Kang Je-Gyu
Total attendance: 6,210,000

The film that started it all. Kang's *Shiri* overturned all the accepted wisdom about how well a Korean movie could do. The high-energy tale of deadly North Korean agents who infiltrate the south featured action and special effects much more ambitious than had ever been seen in a Korean film. *Shiri* also featured some of Korea's most famous actors: Kim Yun-jin (*Lost*), Choi Min-shik (*Oldboy*), Song Gang-ho (*The Host*), and Han Suk-kyu (*The President's Last Bang*).

12 *My Boss, My Teacher* (2006) Dir. Kim Dong-won
Total attendance: 6,105,431

At first glance, *My Boss, My Teacher* is almost an embarrassing inclusion to the top Korean blockbuster list. But in a way, it points to the success of the industry, at an industry level. The gangster-comedy *My Boss, My Teacher* features no great stars, no great gimmicks, no special effects, and is not very funny (or so my Korean friends tell me). In fact, it is a bad, bad movie. So I would argue that if a film this bad can do this well, then something essential in the movie business has changed, something deeper in the fundament that speaks to the long-term success of Korean movies. It is also a sequel (to the 2001 film *My Boss, My Hero*), and nothing says Hollywood like mindless sequels.

13 *JSA* aka *Joint Security Area* (2000) Dir. Park Chan-wook
Total attendance: 5,830,000

At first, a lot of people dismissed *Shiri*'s success, saying it was a fluke and could never happen again. *JSA*, however, proved the doubters wrong. The second of Korea's superhits, and the film that launched Park Chan-wook's career, *JSA* proved that there were real, essential changes happening to the movie world in Korea, and that there were some big bucks up for grabs for the gifted and the lucky. Actually, there is some debate about the relative successes of *Shiri* and *JSA*, but these are the Korean Film Council's official numbers, and they are what I use.

Kang set his sights even higher. *Taegukgi* is, to be frank, a much more high-energy blockbuster than *Silmido*. While watching *Silmido*, one wonders where all the money went—and to be fair, a major reason its budget climbed so high was a typhoon that destroyed all the sets during filming. *Taegukgi,* on the other hand, looks every inch the expensive film it is. Fierce battle scenes rocked the screen with a realism never captured in a Korean film. Its production values looked just as good as *Saving Private Ryan* or *When We Were Soldiers* (two war films that came out around the same time, although Kang bristles at the comparison).

Even with the opening pushed back to early February, getting *Taegukgi* done in time was a huge task. Sleep became a luxury. The first advance screening was at the COEX Mall Megabox on February 3. Kang finished the sound mix at 2 p.m. The film ran at 6 p.m. *Taegukgi* opened to the public two days later.

Taegukgi exploded on the scene, occupying a then-record 452 screens (nearly a third of the nation's then-1,400). It opened on February 5, a Thursday, and by Sunday night it had already pulled in 1.78 million admissions ($13 million). Shares of Orion (Showbox's parent company) rose 6 percent that Monday. For the next seven weeks, *Taegukgi* stayed firmly planted in the No. 1 spot, steamrolling the competition. *Silmido* passed the 10 million admissions point at fifty-eight days; *Taegukgi* did it in thirty-nine. By the end of its run, *Taegukgi* had topped 11.7 million admissions (nearly $80 million). Kang had done it again, setting a new standard for Korean films.

People finally got the chance to see Kang's epic story of two brothers caught up in the Korean War. The film begins in 1950 with a family fleeing from Seoul as North Korea invades. The ragtag South Korean army, however, badly needs soldiers. Army officials forcibly conscript the sickly younger brother Jin-sok (played by Won Bin), and when the older brother, Jin-tae (Jang Dong-gun) cannot free his sibling, he joins too, to help keep his brother safe. Jin-tae becomes a reluctant hero, not because he is a great fighter, but just because he tries to keep his brother alive. Of course, as the story goes on, the brothers become separated, and one ends up fighting for the North, leading to a tragic split between the family (mirroring, of course, the split in Korea). In the end, one brother must die to save the other (of course).

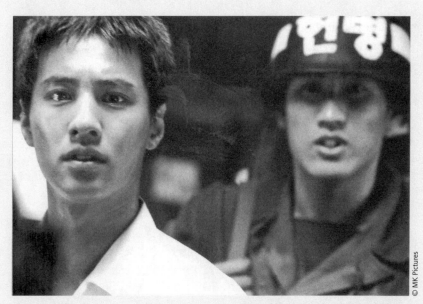

Five years after Shiri *set records, Kang Je-gyu's* Taegukgi *sold nearly twice as many tickets.*

Once again, a major South Korean film would score with the public by focusing on the North-South divide, breaking years of taboos in the process. *Taegukgi* featured the forcible conscription of high school boys, the massacre of communists by the right-wing paramilitary, and North Korean prisoners burned alive by South Korean soldiers.

A Culture of Hits

Of course, there would be more huge hits for other filmmakers over the years, although for a while it looked like nothing would be able to reach *Taegukgi*'s incredible heights. For the rest of 2004 and 2005, nothing came close. But in the very last weekend of 2005, a surprising little film shocked Korea. *The King and the Clown* broke all the rules—it was a mid-budget costume drama, set five hundred years ago (those never do well at the box office in Korea), starring no major actors, and featuring significant homosexual themes. A recipe for failure if there ever was one. *Clown* was released on a decent three hundred screens the same weekend as *The Chronicles of Narnia: The Lion, the Witch*

and the Wardrobe, and just following such big movies as *King Kong* and the latest Harry Potter film. Everyone pretty much expected it to be overwhelmed by the huge Hollywood holiday blockbusters. That opening weekend, *Narnia* just beat it for top spot, pulling in 23.7 percent of the box office to *Clown*'s 23.6 percent.

But then a curious thing happened. *The King and the Clown* did not fade the following weekend. Most big movies drop significantly after their opening week, but *The King and the Clown* actually got stronger. On the second weekend, thanks to great word of mouth, *Clown* was up to 369 screens and 38 percent of the box office, and the weekend after that, 389 screens and 41 percent of the box office. *Clown*'s director, an art-school dropout named Lee Joon-ik, had hoped his curious little film might catch on and sell 4 or 5 million tickets. By the time its theatrical run was over, it had sold 12.3 million, setting a new record.

The King and the Clown was a surprise hit, but, a few months later, another film would again reset all Korean box office records, and this time it would surprise no one. Bong Joon-ho's *The Host* exploded out of the box office at the end of July 2006, with the biggest opening weekend ever (2.6 million admissions) on the most screens ever (620), strong enough for 69 percent of the box office. As well, it has probably received the most well-rounded global success for a Korean film, earning $2.2 million in the United States, $1.8 million in China, $1.5 million in Japan, $1.1 million in Spain, and nearly $1 million in France. Great nowhere, but respectable in many countries.

Bong Joon-ho, after studying sociology at Yonsei University in Seoul, went to film school and entered the movie business in the mid-1990s. He worked as an assistant director on *Seven Reasons Beer Is Better than a Girl* (which, with a laugh, he calls "The worst movie ever in Korea"), then on a couple of more movies, before getting the chance to make his own movie, *Barking Dogs Never Bite*. "In the mid 1990s, the Korean film industry was really open-minded," Bong says. "Hong Sang-soo and Kim Ki-duk made their debut then. Kang Je-gyu was editing his movie right next door to where I was working."

Barking Dogs Never Bite (2000), the story of a university lecturer tormented by the barking of a neighbor's dog, received much praise all over the world for its wry observations on modern life. His next movie, *Memories of Murder* (2005), a dark comedy about police in a

country town on the trail of a serial killer, was one of Korea's biggest critical and commercial successes, winning awards from San Sebastian to Tokyo.

But *The Host* (2006) was his first foray into the science fiction genre. It told the story of a monster that emerges from Seoul's Han River one day to wreak havoc and eat a few people, and the ordinary man who gets pulled into the fray. At a little over $10 million to produce, its cost paled in size to the average Hollywood budget (even a third less expensive than *Taegukgi*'s $15 million), but careful planning and budgeting meant Bong could afford the hundreds of

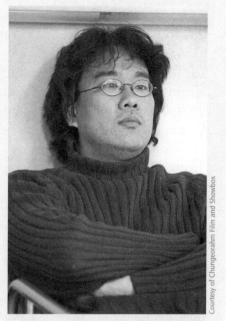

Bong Joon-ho directed the most popular film in Korean history, the monster movie The Host.

effects shots needed to make the monster come to life. And, like all of Bong's films, *The Host* was a delicious layering of intriguing story, dark humor, and deep metaphors about Korean society.

"There are a whole lot of prejudices about creature movies, that they are just childish or just sci-fi," Bong says. "Those prejudices poked me and intrigued me. I took it as a challenge."

Having made the most popular film ever in Korea, *The Host*, it is safe to say Bong overcame that challenge nicely.

Now Bong, like Kang, intends to push the envelope still further in the future. He plans to turn the French science-fiction comic book *Snow Train* into a big-budget movie, but that is at least a couple of years away.

The other big change in the Korean film industry that Kang was an important part of was the rise of Korean movies abroad. Kang's *Shiri* was the biggest Korean film yet in Japan, making nearly $16 million there and helping to start a growing interest in things Korean.

In 1993, all of Korea's movie exports together totaled less

than $200,000. By 1996, the year of *Ginkgo Bed*, they were up to $400,000—a big increase, but still relatively tiny. But from there it started to climb spectacularly, topping $3 million in 1998, $11 million in 2001, $31 million in 2003, $58 million in 2004, and $76 million in 2005.

That surge in exports came from a wide range of countries and for a wide range of reasons. The comedy *My Sassy Girl* was a huge hit with young people in Hong Kong, Taiwan, Singapore, and around South Asia. Melodramas were also big in South Asia, especially in Japan. *Windstruck* made $19 million in Japan, *April Snow* topped $25 million, and *A Moment to Remember* nearly $30 million. *Taegukgi* also did fairly well in Japan, making nearly $10 million, and Bong Joon-ho's *The Host* did well globally.

Korean films that were on the rise in Europe and America were largely of a different sort. Horror, action, and more adult films tended to succeed in the West. Park Chan-wook's *Vengeance* trilogy won huge amounts of praise and media attention. Several writers at aintitcool.com, the same people who raved about Park Chan-wook, also loved *Taegukgi*. Bong Joon-ho, Kim Jee-woon and others also received much praise.

But curiously, the biggest Korean box office hit in the West be-

The Screen Quota

n 1998, in a *Variety* magazine article about the Korean film industry, producer Jonathan Kim talked about the need to preserve Korea's screen quota, referring to a law that guarantees that every movie theater in Korea screen Korean films at least 40 percent of the time. It was an era before Korean movies' great resurgence, when local films made up just a fraction of the box office, and the common feeling was that without a quota the industry would just disappear, overwhelmed by Hollywood. "If we had 40 percent of the box office, then the quota would not be necessary," Kim said.

Cut to the present, and Korean films have hovered around 60 percent of the box office for the past several years. But if you think that producers like Jonathan Kim have changed their minds, you would be wrong. They are still as passionate about

the need for a quota as ever. But it is a passion that ever fewer Koreans share.

The screen quota was started in 1967, originally requiring all movie theaters in Korea to screen at least six homegrown films for at least ninety days a year. The number of days was cut in 1970, but was raised significantly to at least one-third of each year in 1973, then raised again in 1985 to 40 percent of each year (146 days, although theaters could reduce that to as few as 106 days by showing Korean films during the busiest seasons). But given all the other restrictions on imports back in the 1960s and '70s, it was never terribly relevant until Korea opened its movie market to foreign direct distribution in 1986. Once the Hollywood product started flooding in, however, the quota began to take on new importance. Year by

fore autumn 2007 was Kim Ki-duk's quiet meditation on Buddhism and life, *Spring, Summer, Fall, Winter . . . and Spring*, which made just over $9.5 million internationally, including $2.4 million in the United States. Kim's film was considered a bore at home, flopping badly and earning only around $300,000, but its strong "Asian" themes apparently struck many Western viewers as intriguing and exotic.

In 2006 and 2007, however, exports took a major nosedive. The decline has mostly come from Japan, which in 2004 and 2005 made up well over 50 percent of Korean sales. Despite the occasional hit film, by far the majority of Korean films died at the box office in Japan, and Japanese buyers soon learned their lesson. Korean companies can still make money in Japan, but mostly from home video (the DVD market there is huge), and minimum guarantees are almost completely finished—at least for the moment.

The truth is, as the international money started rolling in, many producers in Korea started making movies with their focus on international financing, not on good storytelling. By getting big-name actors, producers could, for a time, guarantee themselves millions of dollars from Japan and elsewhere before shooting a single frame. As a result, many movies made this way were truly terrible. *April Snow* was dull, but the cult of Bae Yong-joon was still strong enough

year, Korean movies lost ground to the overwhelming competition from America until, by 1993, they accounted for 15.9 percent of the box office.

But with the screen quota intent to guarantee that Korean cinemas screen Korean films 40 percent of the year, some began to wonder why Korean movies were getting just 15.9 percent of the box office. Clearly, many theaters were not bothering with the quota.

So some supporters of the film industry got together in 1993 and formed the Coalition for Cultural Diversity in Moving Images (CDMI), an unwieldy name for a group dedicated to keeping an eye on theaters around Korea and ensuring they comply with the quota. Offenders were reported to the authorities, who, once presented with evidence, felt much more compelled to crack down on violators.

The big Hollywood studios were not, of course, fans of this system, and many Korean theater owners despised it. Over the years, American trade negotiators periodically tried to have the quota killed, or at least maimed. Their most serious attempt came in 1998, during the Asian economic crisis, when, despite having a liberal, culture-friendly government in the Kim Dae-jung administration the government looked like it was going to reduce the quota to around sixty days as part of a trade deal with the United States. The government was ready for opposition, but I doubt anyone expected the huge public reaction.

The response of the film industry was immediate, loud, and strenuous, borderline hysterical The Korean public truly supported the film industry. The nation had been shaken severely by the economic crisis, and the general feeling was that the Americans were trying to pick through Korea's economic bones, since killing the nation's cultural

that the film made money. *Daisy* was an even bigger mess, and audiences knew it well before it ever reached the theaters. But that is what happens when films start being made by accountants instead of directors.

Even though Korea's global box office is down, international business, ironically, remains strong. After all, Japan's Happinet Corp. invested nearly $5 million into *The Host* ($3.2 million for the Japan rights and $1.5 million in the movie's equity). John H. Lee's latest film is being made in Japan, in Japanese, with Japanese money. Korean and Japanese movie companies still collaborate on many projects, both with each other and with Chinese and other filmmakers in the region. Korean and Japanese companies have invested heavily in John Woo's *Red Cliff* movies, and several Korean directors are working on projects abroad. Both Hong Sang-su and Im Sang-soo are making films in France, while Kang Je-gyu is working on projects in Hollywood. In short, international ties are probably stronger than ever, as producers and financiers around the region all feel that their home markets are too limiting. Things got a little too crazy for a time, but fads pass, people wise up, and markets adjust.

After the excitement of 2006, 2007 ended up being another one of those off, transitional years that the Korean film industry seems to

sovereignty meant nothing to them. With the support of Korea's trade unions, the film industry was able to get over twenty thousand people on the streets to show their support. Leading filmmakers shaved their heads (back then, it was a powerful symbol of defiance, not a fashion trend). American videotapes were burned in the streets.

Faced with such powerful opposition, the government backed down. Although the various economic- and business-related ministries tried to reintroduce the issue every so often, the film industry had triumphed and the quota was preserved . . . for a time.

By 2003, there was a new president in charge, Roh Moo-hyun—more left-wing than Kim Dae-jung and more responsive to labor issues. However, Roh, too, was eager to sign a trade deal with the United States. So once again rumblings began about the government wanting to cut the screen quota.

This time, though, the reaction of the public was much different. Korean films were no longer dying, they were flourishing, taking in a greater share of the box office each year. In fact, with hit blockbusters like *Taegukgi* topping five hundred screens, some people began to think that mainstream Korean films might be getting too strong, and some suggested an art-house quota to help protect diversity. Furthermore, Korea had rebuilt and restructured since 1998, and had in many ways become the leading economy of Asia. So when the film industry called on Koreans to take to the streets and once again show their support, this time the response was tepid. Despite ceaseless efforts of much of the Korean film industry, in January 2006, the deal was announced—the government would halve the screen quota to seventy-three days, beginning in July. At the same time, the government offered hundreds of millions of dollars

face from time to time. Nothing really exploded until August, when a couple of hits were released (the historical tragedy *May 18* and the truly egregious *D-War*). Despite having a relatively down year, Korean films were still the biggest part of the box office in Korea—around 50.8 percent. And most of Korea's biggest and best directors are just starting new projects, so it it is hard to say when we will see any more ambitious projects that challenge records. Then again, one of the defining traits of all of Korea's biggest successes is that they are completely unpredictable, so who knows what might spring up out of nowhere?

What has really shaped the Korean film industry, more than its record-setting films, are the dozens of mid-sized successes. In 1996, the year of *Gingko Bed*, a film needed less than 300,000 admissions to crack the list of top ten Korean movies. In 2006, it took over 2.2 million admissions. The directors whose movies continued to break records pulled the rest of the industry up with them. Which is where the true power of Kang's achievements lies (along with, of course, the achievements of scores of other talents, filmmakers, and artists who comprise the Korean film industry).

For all of Kang's commercial success, though, critical praise has been much less forthcoming, and one can tell sometimes that it ran-

in aid to the industry. Although most refused to touch the money, others questioned whether or not the quota was really the only way to protect Korean films.

Personally, I have always considered the quota to be a placebo, a sugary pill that tastes good but does nothing real to put more money into filmmakers' pockets (which is, after all, the way you strengthen any industry). People buy tickets to movies they want to see; if there is nothing playing that they like, then they don't buy tickets. Forcing theaters to show movies no one wants to see does not mean more box office, it only hurts the theater owners and distributors.

Also, since the rise of CJ Entertainment, Showbox, Lotte, and the rest, the biggest movie companies in Korea also control all the movie theaters. It would be economic suicide if they kept out Korean movies in favor of Hollywood.

I suppose one can make an argument that in a weak industry, some protection can be helpfu (after all, sometimes placebos are useful, helping the patient's state of mind while he recovers). But Korean films are big business now. The top films in Korea now are all Korean (the biggest foreign movie ever in Korea was *Transformers*, with about 7.3 million admissions, or good enough for the eighth biggest release of all time, compared to Korean movies). The average Korean film does better than the average Hollywood film in Korea. Whatever leverage Hollywood once might have had is long gone. Focusing on consumers, as opposed to the producers, is the key o strengthening any industry. Far more effective than any quota or government protection has been the creativity and ambition of Korean filmmakers, who turned Korea into one of the world's top movie-making countries—and Koreans into a top movie-going populace.

kles. Despite Kang's talk of Korea needing more commercial films and more filmmakers like Spielberg, when people compared *Taegukgi* to *Saving Private Ryan*, he grew quite frustrated (even though the two films have obvious structural similarities—both are war films bookended by a lead character in the present, recounting what happened). I guess he forgets how Spielberg was not really taken seriously either before *Jurassic Park 2* (or was it *Schindler's List* that earned him more respect?). On occasion, Kang claims that critically acclaimed films do not do well at the box office, while panned films become big hits. This can come across as bitter (not to mention wrong, considering how well many of the films of Bong Joon-ho, Park Chan-wook, and other highly praised directors have done).

Kang is proud of his impressive achievements, and was one of the first modern directors to consider himself a celebrity, but I also get the sense while talking with him that he still wants more. More for himself, and more for the Korean movie business. "I want to make Korean movies popular in the United States," he says, taking aim at the biggest movie market in the world.

Kang Je-gyu is still developing his follow-up to *Taegukgi*, spending most of his time in California, working on his scripts and ideas. He likes to keep his ideas fairly secretive, revealing almost nothing about what will come next—besides it being something big and involving science fiction. It might be English-language and it might be made with Hollywood's help, but since he first became famous, Kang has been adamant that whatever he makes will be something of his choice and will be done his way.

The Film Festival

Sure, blockbuster movies are a blast, with high-octane stunts, amazing special effects, and epic stories to suck you in. An intelligent, arthouse film can be interesting and edifying, too. But going to some random movie cannot compare to the fun and energy of a film festival where you gloriously, slothfully squander your days, your hours, in front of the screen, surrounded by thousands of people who understand and approve your choice. Not to mention red carpet premieres, galas, and all sorts of glitz and glamour, plus late-night parties filled with actors and filmmakers, aspiring filmmakers, people who want to hang out with actors and filmmakers, and other miscellaneous riffraff (and far, far down the totem pole, journalists, but perhaps the less said about them the better). And when it comes to film festivals, the Pusan International Film Festival is one of the best.

The origins of PIFF (as the film festival likes to call itself) coincide nicely with my arrival in Korea—both of us date to 1996. When I first arrived, I lived in a smallish city, about a five-hour train ride from Seoul, where the selection of movies at the local cinemas was less than extraordinary. There were plenty of Hollywood blockbusters and the usual local selections, but not much else. Video stores offered slightly more variety, but even when I found a David Cronenberg or Peter Greenaway gem, it was most likely to have been censored into oblivion. *The Cook, the Thief, His Wife and Her Lover*, for example, was about thirty-seven minutes long and quite unintelligible.

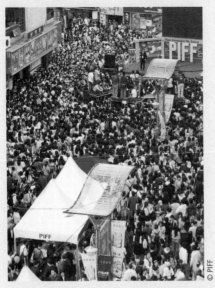

Each year at PIFF, thousands of movie fans gorge the narrow alleys of Nampo-dong.

© PIFF

So when I heard that Pusan (as Busan was spelled back then) would be home to a film festival in the fall, my first thought was how wonderful it would be to see real movies again. Events intervened and I did not get to go to the inaugural PIFF that year, but when I finally did, the event was most wonderfully overwhelming. Uncountable throngs of people pressed tight into Nampo Square, in the heart of Pusan, weaving slowly but patiently through the morass of fellow moviegoers, shuffling between the old, dingy theaters that played host to the nine-day festival. At booths throughout the square, barkers sold a variety of unrelated products or promoted local movie magazines. A stage to one side displayed a steady promenade of actors and directors, talking about their work. Far to the east, in Pusan's beach district, a giant outdoor screen showed a wide array of films from all over the world to thousands of people each night. And in the evenings, a steady run of parties could keep one up until the darkest hours of the night, and sometimes to dawn. Then the whole cycle would repeat the next day.

There probably is not a movie industry in the world that does not dream of launching its own version of Cannes or Venice or Sundance to bask in the glamour of the biggest producers and celebrities from around the world. That is the dream, anyhow. Getting that dream to come true is another matter, and the challenges are legion. Competition between festivals can be fierce, and increases each year all over the globe. The overlapping concerns of economics, art, academia, and entertainment often conflict, spinning dizzying webs of interest for festival organizers.

Did PIFF's founders—Lee Yong-kwan, Kim Ji-seok, and Jay Jeon—have any idea what they were getting themselves into when

they first started bouncing the festival idea around way back in the early 1990s? They could not, of course, have anticipated all the obstacles that would block their way—ignorance, apathy, bad prints, and botched subtitles. Even rats. But they also could never have guessed how important the Pusan International Film Festival would become to the growth of the Korean film world. By exposing Korean movies to the world and developing connections between producers and filmmakers all over Asia, PIFF played an integral role in the rise of Korean movies.

Preceding PIFF

Korea's port city of Pusan, located on the country's southern coast, 450 kilometers from the nation's capital, Seoul, could not be further from any such movie glamour, especially back in the early 1990s. Pusan was a rather dreary port city then, dominated by its mammoth wharves. Mountains of cargo containers stretched for miles along the quays, like giant steel bricks in some sort of mysterious metal labyrinth. Over 80 percent of all container cargo coming to and going from Korea passes through Pusan's five ports and six terminals, which stretch for 202 kilometers across the city's undulating shoreline. It is the world's fifth-busiest port (down slightly from third-largest, a high it reached back around 2000 to 2002), with over 462 million square meters of cargo passing through on fifty thousand vessels each year, and it continues to grow.

Inland of the ports, a sprawl of roads, overpasses, apartments, and redbrick homes navigate the twisting valleys between an elaborate snarl of forested mountains. Pusan was almost the only place in South Korea that did not fall to the North Koreans after their invasion in 1950, and that salvation from destruction meant the city's post-War development would forever be constrained by its centuries of chaotic, natural growth.

Ji-seok, Yong-kwan, and Jay were more academics than entertainers, all more comfortable writing essays and researching in the archives than schmoozing with celebrities. Yong-kwan was the oldest, born in 1955 in Gyeonggi Province but raised in Pusan. After graduating from Chung-Ang University in 1985, he immediately

took up a junior professorship at Kyungsung University in Pusan, which is where the three would meet.

Ji-seok was born in 1960 in Pusan and attended Pusan National University, the most prestigious school in the region, in the early 1980s, where he majored in mechanical engineering. But engineering was not in his heart, and after a couple of years as a part-time lecturer, he suddenly announced to his parents one day that he had to pursue his real passion—movies. As an undergraduate, Ji-seok joined a movie club, but grew frustrated at the lack of information and availability of world cinema in Pusan at the time. He earned his Masters degree in film criticism at Chung-Ang University in 1990, then returned to Pusan to try to make a modest living in this impractical pursuit, eventually teaching at Pusan Arts College.

Only Jay was from Seoul (and his family originally from North Korea), but he joined the Pusan gang when he began lecturing part-time at Kyungsung University. Born in 1959, Jay had more experience actually making movies and had produced several films. He had also spent more time outside of Korea than the others, having studied film at the University of Warwick in the United Kingdom.

The three of them met at Kyungsung University in the mid-1980s, and soon after were meeting weekly just to talk about movies. It was a dire era to be a cinephile in South Korea, as the authoritarian government of the time kept the country in the dark about much of the world. Sure, there were plenty of Hong Kong and Hollywood crowd-pleasers, in addition to the local movies of the time, but very few films arrived that were different, thought-provoking, or from independent production companies. Japanese culture was completely banned. The nation's two major movie magazines looked only at commercial movies and celebrities, with little in-depth criticism. On occasion, the French Cultural Center might show some old French movies. And a few underground movie clubs were springing up, where the truly dedicated movie fans could watch smuggled videotapes with homemade subtitles. But overall, the options were few.

Hungry for more serious cinema, the three founded a film criticism journal called *Film Language*. Published quarterly ("It's all we could afford," Ji-seok told me, with one of his typical hearty laughs), *Film Language* depended on newsstand sales and the patronage of

Lee Yong-kwan ("He was the only one with any money") to get by; it had no sponsors, only partly by choice. It was a small publication, but it was enough to get the three of them noticed by the international film festival network. Jay had been invited to the Yamagata International Documentary Film Festival in 1989, and Ji-seok followed the next year. Hong Kong beckoned next.

The big idea for a film festival of Korea's own came in 1992, when the three of them were invited to the Pesaro Film Festival in Italy. Pesaro, a small city of ninety thousand people, perched on the edge of the Adriatic Sea, hosts a surprisingly large film festival. Founded in 1965 with an academic and critical focus, the Pesaro Film Festival soon developed a major interest in world cinema. It featured Chinese movies in 1978 (right after the Cultural Revolution) and Korean movies for the first time in 1983. Korea was again in Pesaro's spotlight in 1992, and the festival's organizers approached the Korean Motion Picture Promotion Corporation for help selecting movies and finding local critics to write about them. Lee Yong-kwan had worked for the Promotion Corporation, and recommended Jay and Ji-seok. The three of them traveled to Italy for the festival, along with filmmakers like Bae Chang-ho, Ahn Sung-ki, and Lee Chang-ho, where they got to introduce Korean cinema to a wholly new audience.

It was at Pesaro that Ji-seok, Jay, and Yong-kwan began to talk more seriously about starting a film festival in Korea. They were captivated by the charm of the small city of Pesaro and the laid-back, low-key atmosphere of the festival, where filmmakers, guests, and audiences could mingle easily and naturally, and just enjoy their love of movies together. The talk was just general, about the role of film festivals in nations' movie industries, but it soon led to a simple question: Why not Korea?

Finding a Patron

For years, people in Korea had tossed around the idea of a major film festival, but nothing had ever come of it. Such talk invariably centered around Seoul, home of the Korean film industry and 20 million of the nation's 48 million people. But the Seoul-based film industry had a habit of devouring any potential festival, trying to take over and

co-opt anything as soon as it got started. And as soon as a project found traction, it would immediately face incredible competition from within the industry, as everyone wanted to be the one to have his or her name attached to the capital's big film festival. Perhaps a solution was to make the festival far from the politics and egos of Seoul?

Then, from out of nowhere, their Pusan plans got a huge and unexpected boost: the beachfront Paradise Hotel wanted to host a small film festival, and (most importantly) was willing to pay for it. With the promise of 500 million won (then about $640,000), suddenly they had money to play with, enough to get started for real.

At this point, Ji-seok, Jay, and Yong-kwan realized they had money and momentum, but were still missing one of the most important pieces of the puzzle, especially in Korea—a patron. Because of Korea's Confucian culture, relationships are incredibly important. Everyone exists in a complicated network of juniors and seniors, extended family, and friends of friends. When you want the powers-that-be to take you seriously, you need a representative that they take seriously. While the three of them were well known within their academic circles, they had no real clout in the government. That is, no heavy hitters in the nation's senior bureaucracy would open doors and help them navigate through the Byzantine corridors of power. Several names were floated, and finally they decided to approach Kim Dong-ho.

Kim Dong-ho is a curious force in the Korean cultural world. Born in the mountains of Gangwon Province in 1937, Kim spent twenty-seven years at the Ministry of Culture, eventually climbing the government ladder to vice minister. He also served as the head of Korea's Performance Ethics Board and the Korean Motion Pictures Promotion Corporation, the president of the Seoul Arts Center, and many other culture-related positions. Over the years, he established a singular reputation for honesty. In Korea, a never-ending series of "presents" (and outright cash) for superiors, juniors, and anyone you need to curry favor with or just work with is just part of the system. Everyone I have talked to, though, says Kim has never accepted anything from anyone. Expensive televisions, golf clubs, you name it, always get promptly returned. At first, that kind of behavior probably struck most people as anywhere from eccentric to annoying.

Kim Dong-ho, for years the festival director of PIFF, has been a key part of the festival's great success.

But after decades, that honesty built Kim a huge amount of moral capital, which translates into a power base beyond what his resume might indicate.

I should also add that despite Kim Dong-ho's age and small stature, he could still, until very recently, outdrink most people I know (although he pretty much swore off alcohol in 2005). Over the years, it was a common sight at PIFF parties to see Kim making the rounds, bottle in hand (or in the hand of an assistant), making a point to have a drink of *soju* or whiskey with everyone at the party. Sometimes the parties were quite large, and a single round would involve a lot of people. Sometimes he then went around again. But no matter how excessive and late into the night a party may have gone, Kim was inevitably up early in the morning, back to his many duties.

On a hot Friday afternoon in August, Ji-seok, Yong-kwan, and Jay met Kim Dong-ho at the Plaza Hotel in the middle of Seoul and told him all about their plans to create a film festival in Pusan—and asked him to be their festival director. He said yes.

With Kim Dong-ho on board and $640,000 promised, it was

time to get serious about planning. What kind of festival would they create? When should it be held? How much will it cost? Where will the money come from?

Ji-seok and the others thought it was a surprisingly good time to be examining and promoting Korean movies. The era was strong for Asian film in general. Iranian cinema was going through a vogue, the Fifth Generation Chinese directors were still exciting, and Hong Kong cinema had yet to collapse. In Korea, although times were hard commercially, with box office numbers dropping steadily year after year, there was a sense that something good was in the works. Now that Korea had made the transition from military government to civilian, the nation was beginning to open up, look around, and think more freely. A new generation of filmmakers was shaking things up, including Kim Ui-seok (*A Marriage Story*) and Kang Woo-suk (*Two Cops*), and the first wave of foreign-educated filmmakers was already returning from America or wherever else they had studied, bringing with them new ideas and techniques.

They started to research film festivals, especially those around Asia. Many in the region had long been established. The International Film Festival of India dates back to 1952. The Hong Kong International Film Festival has been going strong since 1976. The Tokyo International Film Festival kicked off in 1985. Even the Pyongyang Film Festival of the Non-Aligned and Other Developing Countries has been held biennially since 1987.

Eventually, they decided the Hong Kong Film Festival would be their main model: non-competitive (because they thought fighting with Tokyo, Cannes, or Berlin for top films to be foolishly unrealistic) and focused on Asian movies. They wanted to choose movies that people in Korea could not usually see, underground and art-house fare. The plan was to screen about one hundred movies that first year, in four or five theaters in downtown Pusan. They would call it the Pusan International Film Festival. It would cost about 2 billion won ($2.5 million at the time).

They had barely gotten started, however, when the festival organizers got hit with their first major setback. The Paradise Hotel pulled its money, just three months after making the offer. Surprisingly, the hotel did not know what a film festival really was. That turned out to be a common problem back then. Most people in Korea, when they

heard "film festival," actually imagined glitzy award shows, like the Oscars. The Paradise wanted to host a gala night of celebrities and hoopla, not a bunch of nobodies watching strange movies in the darkness of dingy theaters.

Still, the organizers pressed on. Quickly, Kim Dong-ho proved his worth. The vice mayor of Pusan, Oh Se-min, was a friend of his, so Kim arranged a meeting between them in December. They made a good impression, and the next week met with the mayor himself, Moon Jung-soo. At the time, Mayor Moon already had a vision of building Pusan's reputation as a cultural center. He was working on a cultural festival called "Asian Week" (modeled on the month-long Asian cultural festival held each year in Fukuoka, Japan), and a film festival dovetailed nicely with his plans. Suitably impressed, Moon promised at least 300 million won in funding, almost enough to off-set the withdrawal of the hotel. But the festival organizers still had to raise more money.

It was also time to set a date. With 1995 almost at an end and the festival organizers determined to get started in 1996, they had to pick a date later in the year, just to have enough time to get every-thing planned. There were the existing international film markets, like the European Film Market and MIFED (the international film and multimedia market) to avoid. By November and December, the weather could be too cold. And each fall in Korea, the harvest festi-val of Chuseok pretty much shuts down the entire country. It is the biggest movie-going time of the year, so there was no way theaters would give those dates up to book a bunch of strange, artsy flicks, so Chuseok had to be avoided. The exact date of Chuseok, which is

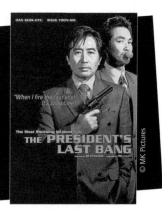

Those Days, Those People . . .
In early 2005, just two days before the release of *The President's Last Bang*, Im Sang-soo's extraordinary and darkly satirical take on the assassination of President Park Chung Hee, a Seoul court ruled that the film could only be shown if four minutes of historical footage was removed. Im replaced those scenes with blank black foot-age. The court decision was reversed in 2006.

linked to the lunar calendar, changes every year, and in 1996 fell on September 27. With the calendar quickly filling up, they decided the inaugural Pusan International Film Festival would kick off on September 13, to synchronize it with the mayor's "Asian Week." Friday the thirteenth.

The First PIFF With the start of the new year, festival organizers moved into high gear. Together, Ji-seok, Jay, Yong-kwan, and Kim Dong-ho set up a small office in the Suyoungman Yachting Center, in Haeundae Beach, on the east end of Pusan. The initial office was tiny, with just three desks everyone shared. Kim Ji-seok brought in his own fax machine and supplied his home phone number for everyone to use. A basic division of labor evolved, with Kim Ji-seok in charge of Asian film programming, Jay Jeon in charge of American and European films, and Lee Yong-kwan getting Korean films. But in truth, everyone did a little of everything, as they worked their way through the film festival's complex logistics.

Around this time, the festival brought in another new face, Paul Yi, the director of the San Francisco Asian-American Film Festival. With his experience running a festival in America, Paul's contribution was essential. He helped set up the basic organization of PIFF and assisted the team to understand the thousands of vital minutae. Paul had them create a detailed timetable, showed them how to prepare a catalog of the festival's films, and brought the festival in touch with his considerable international contacts.

Although the festival was operating on the barest of shoestrings, its organizers were beginning to rack up expenses. Pusan City's money was a good start, but only a start, so fundraising stepped up. The organizers, together with the Pusan City government, started approaching businesses all over Korea, looking for sponsors. But from the beginning, two huge questions loomed large in the minds of all potential sponsors: "Why Pusan?" and "What's a film festival?"

To overcome the first problem, the PIFF team set out to build relationships with all of Korea's Seoul-based movie associations. Kim Dong-ho and Mayor Moon met with many of those organizations, with the mayor even promising the use of Pusan's City Hall for

filmmakers who might want it for their movies. The charm offensive worked, and they even managed to earn a pledge of 100 million won from the Seoul Theater Association. But Korea's movie industry was very small and weak at the time and had little money to give to an unproven, abstract event like a film festival. Corporate support would be essential to making PIFF a reality.

The first major company to come aboard was the jaebeol Daewoo. Daewoo Chairman Kim Woo-jung and his wife Chung Hee-ja (herself the then head of Daewoo's hotel division and a museum) promised a hefty 300 million won. JungAng Industries (whose owner, Cho Kyu-young is married to the actress Chung Yun-hee) also donated 100 million won.

With those big names on board, PIFF was beginning to be taken seriously. A fundraising dinner with two hundred Pusan entrepreneurs raised 200 million won. Small companies, wealthy individuals, and successful celebrities added another 200 million won. Conglomerates with movie-related affiliates chipped in, too. All told, around 1.5 billion won was raised through various sponsorships and donations, nearly the festival's whole budget. Even Pusan Bank signed on, teaming up with PIFF to create an online and phone ticketing system (well before the Internet revolution hit Korea).

All the money in the world, however, is not much use without actual films. Getting the movies to Pusan turned out to be an even bigger challenge than raising money. Around Asia, Ji-seok and Jay and the others had built a good reputation from attending other film festivals and movie-related events. But in the West, few distributors or other film people had any idea where Pusan was, let alone who were these guys trying to create a new festival there. Its overlap with the nearby Fukuoka Film Festival annoyed many European critics who had already grown ties to that festival. Kim Dong-ho decided that the PIFF programmers would have to hit all the big festivals that year to spread the word and convince the world it was worth attending Pusan.

So various combinations of the PIFF team ranged out to festival after festival—Hong Kong, Singapore, Berlin, and, of course, Cannes. Together, they cut a striking and very Korean image that impressed and confused, swirling into town in conservative blue suits (way more formal than what one usually sees at such artsy events), handing out

stacks of business cards (as East Asian businessmen always have in endless supply), to market a film festival that did not yet exist. But it was at Cannes they made their biggest splash. Kim Dong-ho hosted a lunch that featured fifteen major figures from the international film festival circuit. Unlike similar events, the intent of the Cannes luncheon was to gather information, with a minimum of speeches and pomp. "From the beginning, they were pleasantly ambitious," recalls Wouter Barendrecht, co-chairman of Fortissimo Films. Barendrecht says it also helped that most of the PIFF organizers were from the film industry, not just from a tourism authority or a local mayor's office. "There was a real feeling of excitement. People felt like Asia truly needed a major event with a regional focus." Gradually, they spread the word about PIFF and built up a selection of films and guests for the debut festival.

With money taken care of and a decent selection of movies coming into focus, PIFF faced one more major hurdle, one potentially bigger and more intractable than any other—bureaucrats. In particular, those on Korea's film review board. Korea had once been rather liberal regarding movie content, especially in its golden age in the 1960s. But as the Park Chung Hee era continued, Park increasingly

Dueling Film Festivals

With Hollywood action films dominating screens all over the world each summer, most fans of art-house cinema would welcome any alternative to the loud, dumb world of the blockbuster. In summer 2005, Seoul had two such alternatives—two fantastic film festivals running at the same time—but the nation's film community was still not very happy, thanks to a collision of art and politics that has engulfed one of the most popular movie events in Korea.

With PIFF solidly established in Busan, soon other regions in Korea got into the act, setting up their own film festivals, often with specific themes. In 1997, the Seoul International Cartoon and Animation Festival began. In 2000, Seoul got a stop on the international RESFEST tour (the San Francisco-based digital film festival), and Jeonju started the Jeonju International Film Festival, which also concentrates on digital films.

The city of Bucheon, however, created the most successful spinoff, kicking off the Puchon International Fantastic Film Festival, or PiFan, in 1997. (Much like Pusan/Busan, it has one of those P/B confusion things going on in the city's spelling). PiFan was a big hit from the start, in many ways more relaxed and fun-oriented than the sometimes too-cool-for-school PIFF. Its midnight screenings were an instant and huge hit, as all-night, edgier line-ups quickly sold out, thanks to energetic young people eager to see different and strange films. Over the first seven years, thanks in large part to a team of Ellen Kim, Creta Kim, Michelle Sohn, and PiFan festival director Kim Hong-joon, PiFan steadily built up its reputation both in Korea and abroad, becoming the biggest fantastic film festival in Asia.

Then, at the opening ceremonies for the

cracked down on threats to the public morals and order. The govern-
ments of the 1980s had continued those restrictive policies. After
the 1988 Olympics and Korea's move to democracy, the rules had
begun to loosen, but all movies screened in Korea still had to be
reviewed beforehand by the Korea Public Performance Ethics Com-
mittee (unless the festival involved more than three other countries
and, in a typically Korean catch-22, had been going for more than
three years). The review fees alone would have been far too expen-
sive. Sending all the movies to Seoul (where the review committee
was based) would have been far too time consuming, considering
how prints often arrive just one day before their screening. But more
importantly, the whole point of the festival was to bring new and
challenging ideas to Korea. What good would PIFF be if government
scissors could edit out all offending ideas before anyone saw them?

Korea's government bureaucrats have long been a heavy-hand-
ed, controlling bunch, fond of using onerous regulations for their
own sake—not surprising when one remembers that thirty-three
years of military rule came to an end only in 1993—an era preceded
by the Korean War and thirty-six years of Japanese rule (not to men-
tion several hundred years of the Confucian civil service). The point

2004 PiFan, Kim Hong-joon made a mistake that
changed everything: during his opening address,
he briefly forgot Bucheon's newly elected mayor's
name (for two seconds, according to Kim). A seem-
ingly minor gaff, but the damage was done. Mayor
Hong Gun-pyo was livid. In the quiet break be-
tween Christmas and New Year's, Mayor Hong had
Kim fired, citing Kim's busy schedule as dean of
the film school at the Korean National University
of the Arts. Later, the mayor's office also said it was
displeased with the festival's emphasis on strange
fare, much of it inappropriate for families and a
family-heavy suburb.

Mayor Hong probably expected Korea's art
community to react how it usually does when a
politician flexes his muscles and forces changes—a
few angry letters to the editor in newspapers, may-
be a petition or two, and within a few months, it
would all be forgotten. He could not have been
more wrong.

Kim and others saw the mayor's move as petty
politics. Hong had, after all, run on the slogan "Bu
cheon—More than Just Culture," and the mayor's
conservative ties did not mesh well with the libera
bent of the PiFan organizers. Whatever the truth
Kim was out. His programmers and nearly all the
major staff of the festival insisted the mayor rein
state Kim and promise not to interfere with the
festival any more or else they would all leave, too
Soon they were all gone.

Usually, Kim Hong-joon is a remarkably polite
quiet man, low-key to the point he almost looks
sleepy. But Kim, as a festival director, head of the
film studies department at KNUA, and a forme
filmmaker, also knows how to get things done anc
how to make a point. Instead of rolling over, Kim
and the Korean film community fought back. Kim
and his programmers created the Real Fantastic
Film Festival (RealFanta), scheduled for the exac
same period as PiFan in mid July. Then, using his

is, Korea has a long history of its leaders using the law against art and unconventional thinking. No one was about to suspend those rules for an unruly bunch of film industry upstarts.

Once again, having Kim Dong-ho as the festival's head would pay off. Kim had been the leader of the Performance Ethics Committee from 1993 to 1995 and knew his way around the bloody-minded organization as well as anyone. So he came up with a novel two-prong strategy—drink and delay. Kim met often with review board members, and, while consuming more than a few alcoholic beverages, asked for some leniency and understanding. While Kim played nice by night, the rest of the PIFF staff did their best to gum up the works, holding off answering the Committee's questions for as long as possible and backlogging the whole process. The idea was to create so many inefficiencies and headaches for the government reviewers that it would become practically impossible for them to do their jobs properly.

It may seem like a passive-aggressive resistance strategy, but it worked. The Committee's reviewers agreed to go down to Pusan to prescreen the movies. But by the time they got to the festival's headquarters, there was too little time to review them all. PIFF's general

considerable weight in the film community, he got the motion picture producers association's support, ensuring no Korean films could be screened at PiFan. Local newspapers and film magazines followed suit.

The city chose a man to replace Kim, and that man resigned days later thanks to vocal opposition from the movie community. Then, the movie director Zeong Cho-sin took the thankless task of trying to put together and run the two hundred-film slate with only five months to prepare. But Zeong, best known for his *American Pie*-style sex comedy *Wet Dreams*, was only given the title of programming director, not festival director, greatly tying his hands.

Most years, PiFan pulls in around 80,000 people to its ten-day run of movies and events. In 2005, though, just 30,000 attended (although PiFan has since re-estimated that year's attendance, retroactively eliminating the downturn). The open-ing and closing nights were heavy with local city officials, and celebrities nearly absent. In contrast, RealFanta received heavy industry support, with such Korean heavyweights showing up as directors Kim Jee-woon (*A Bittersweet Life*) and Im Kwon-taek (*Chihwaseon*), actors Lee Byung-hun and Ahn Sung-ki, and many producers. Working on a shoestring budget of barely $200,000, RealFanta sold over 11,400 tickets over its ten-day run.

Back in Seoul, RealFanta found a home in the Seoul Art Cinema, an imposing, forty-year-old concrete box that actually spans a major roadway in downtown Seoul. Until recently, this cinema was called the Hollywood Theater, at one time more notable for discreet male encounters than great films. Next door, the 1-2-3 Cabaret, one of the oldest cabarets in town, added a curiously elegant touch of kitsch to the occasion.

"It was amazing," said programmer Creta Kim. "We had 11,400 people come to our festival. We

manager Oh Seok-geun did his best to distract the reviewers whenever sex and nudity showed up on the videos, and to keep the most controversial films out of sight as much as possible. The distributor of David Cronenberg's *Crash* ended up submitting an expurgated version to the festival, but most movies made it to PIFF without censorship, and many avoided being pre-screened altogether.

Despite the many obstacles and trials that littered the way, PIFF was now on the verge of its debut. Though overwhelmingly busy with thousands of details, everyone was still extremely nervous about how the festival would be received. Would anyone show up? Pusan's Mayor Moon, one of PIFF's biggest backers, appeared more concerned with his Asia Culture Week. Although this predated the era of online sales, PIFF began to ratchet up the presales, eventually selling fifty thousand tickets before the festival even began.

Actually, while everyone was nervous about opening night, they were confident that it would at least be well attended. The setting was picturesque and impressive, with the opening film playing on a six-story-high outdoor screen at the Haeundae Yatching Center. At 6:50 that evening, Friday the thirteenth of September, the Pusan Philharmonic Orchestra began to play "Come Back to the Port of

had no money and no government support, but still the people chose us. One Internet site full of our supporters raised money to buy eggs to feed people at the midnight screening. You could really see our support on the Internet bulletin boards."

PiFan, on the other hand, suffered greatly from the negative publicity, with theatrical attendance dropping to just 30,000 (60,000 when counting the outdoor screenings). "I said I would take all the criticism and apologize for any inconvenience," said Zeong, as he went on to apologize about ten times in his short, five-minute speech that closed the festival. "I promise to do better next year."

But many in the foreign media thought Zeong and PiFan had nothing to apologize for. "He's done an excellent job, and it's a shame how he's been treated," said one trade journalist with a long-time interest in Asian film. "The Korean film industry really showed their unprofessionalism on this one."

In the end, you cannot fight City Hall, as the saying goes. RealFanta was held only that one year, unable to secure enough financing to continue. But the Jung-gu district government (the neighborhood the Korean movie industry traditionally called home, in the heart of Seoul) approached Kim Hong-joon, requesting he create a new film festival. So October 2007 saw the birth of the Chungmuro International Film Festival, or CHIFFS in Seoul.

As for PiFan, it rebounded solidly. By 2006 the Korean film industry was back, attending the festival in force and participating in full. It helped that the PiFan organizers recognized just about every major politician and senior movie figure in its opening ceremonies, which stretched on for an incredible ninety minutes to accommodate all the kissing up. Regardless of how the maneuvering took place, PiFan was back, with its eclectic roster of weird and entertaining movies, more popular than ever.

Pusan." Actor Moon Sung-keun and actress Kim Yeon-ju hosted the evening. And five thousand people watched as Mike Leigh's *Secrets and Lies* became the first film ever to play at the Pusan International Film Festival.

Early the next day, it became apparent that the opening night was no fluke. The downtown theater area of Nampo-dong was packed with thousands and thousands of people, pushing their way through each other, filling the square with a tangible energy. Not only were the crowds enthusiastic, they were also young (many film festivals attract older audiences), giving the festival even more of a jolt. PIFF was well on its way to being a huge hit.

That is not to say the festival was free of problems. It had lots of problems. Despite the relatively few guests that first year, organization broke down badly. Guests were stranded at the (very distant) airport, accommodations went missing, and there were countless last-minute changes and cancellations.

Subtitles were another headache. At the time, there were no subtitling projectors in Korea (and printing subtitles onto fresh prints was way too expensive), so PIFF had to rent the projectors from a company in Japan. Even then, much of the subtitling was done so quickly that the Korean subtitles did not get done in time, or were not properly synchronized to the movie. Many prints were damaged, and sometimes projectionists showed the wrong reels.

Some problems were more exotic. The old theaters in downtown Pusan were *very* pre-multiplex, and had a particular kind of, er, "liveliness" that the PIFF organizers and audiences did not want at all—that is, they had rats. When guests complained about this unwanted bit of local culture, PIFF organizers responded by setting a few cats loose in the theaters. Creative, out-of-the-box thinking that one would expect from such creative, out-of-the-box people. Unfortunately, mangy alley cats turned out to be noisier and more distracting than the rats they were supposed to catch, forcing festival volunteers into a comic hunt for the feline predators.

Some of the problems were, in a way, good. The sheer overload of audience demand created much of the chaos, as overwhelmed volunteers tried to keep track of what seats were still available and what seats were sold out. Frustrating, sure, but far better than having empty theaters.

Artistically, the first PIFF was a big hit, too. That year saw the debuts of Kim Ki-duk (*Crocodile*) and Hong Sang-soo (*The Day a Pig Fell into the Well*), filmmakers who have become two of Korea's most reliable art-house favorites around the world. Kang Je-gyu (then calling himself Jackie Kang), who later revolutionized the Korean film industry with his impressive blockbusters, screened his first film, the special-effects-filled melodrama-action hodgepodge *The Gingko Bed*. Future stars Kwak Kyung-taek and Daniel H. Byun both screened short movies that year. Veterans had a strong showing, too, with Im Kwon-taek screening *Festival*, Park Kwang-su showing his *A Single Spark*, Bae Chang-ho with *A Love Story*, and Jang Sun-woo presenting one of his most important films, *A Petal*.

Perhaps most significantly, the Japanese selections were a big hit, too, especially Japanese animation. Japanese popular culture had been banned in Korea since Korea's liberation from colonial rule, and some Korean nationalists and older people took offense at the screening of movies from their onetime oppressors. But, for the most part, those films were among the most popular that year, selling out within hours of going on sale.

In fact, it did not take me long in Korea to realize that the alleged blood feud between the two countries had been greatly overblown, mostly by politicians and newspapers for their own purposes. Among my Korean friends, there was a real interest in Japan as a source of movies, music, and culture. In black markets around Korea, one could easily find copied videocassettes and smuggled magazines from across the water. But the success of Japanese movies at PIFF was a more tangible, undeniable proof of how Korea was ready to open up, even to Japan.

Making the critics and academics happy is one thing. But PIFF would need popular support to continue to receive government and film industry support. Going into the festival, Ji-seok and the other programmers thought that if PIFF could pull an attendance of 50,000, the festival would be a solid success. Attendance was 184,000.

Looking back, it is impressive how much of PIFF has remained the same since that first year. The basic organization of the movie sections has changed little, with a small competitive section for new Asian filmmakers called New Currents. Korean Panorama looks at modern Korean movies, and Korean Retrospective looks at films

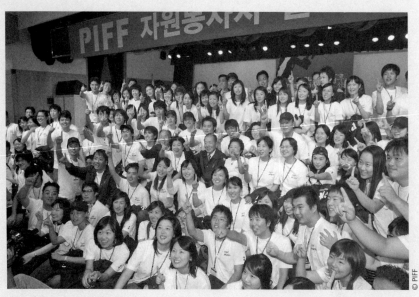

One of the most memorable parts of PIFF each year is the myriad of enthusiastic volunteers.

from the past. Wide Angle focuses on short films and documentaries. Window on Asian Cinema takes a broad look at filmmakers from around the continent, and World Cinema is a general overview of films from the rest of the world.

Another distinctive part of PIFF on display that year was the volunteer staff. Every year at PIFF, the movie sites are flooded by helpers, mostly (but not all) young film fans, in distinctive, bright T-shirts, on hand to take tickets, help the confused, point the way to the lost, and in general just create a presence. That first year, 360 volunteers helped over the course of the festival; ten years later, the festival needed over 600.

Changes would come, of course. The city of Pusan city suddenly found its name spelled "Busan" in 2002, after the Korean government changed the official way hangul is transliterated. However, the festival stuck to tradition and refused to change PIFF to BIFF (although, personally, the thought of a "Biff" Film Festival is pretty amusing).

More seriously, censorship and government control faded, thankfully. In the festival's second year, the Wong Kar-wai film *Happy Together* was banned to the general public because of its homosexual themes (only journalists and film professionals were allowed

to watch it). But from 1998 on, the festival became exempt from the Performance Ethics Committee and prescreening.

Even after that, on occasion, the heavy hand of government appeared. In 2002, when the festival secured seven old movies from North Korea, the South Korean government decided that two of those films violated the National Security Law and could only be viewed by foreign guests. It was a bizarre decision—I saw both films that year and am almost certain that neither turned me into a raving-mad communist. One was a 1948 film about a mistreated peasant, Kwon Jin, who flees to the mountains to join Kim Il-sung's revolutionaries. Its production values were surprisingly adept, especially a scene in which revolutionaries dynamite a bridge as a train is speeding across. In the end, Kwon Jin returns to his hometown and his girlfriend, and as he embraces his true love she exclaims, "Thanks to Kim Il-sung for making our freedom possible!" The other, a Romeo-and-Juliet story from 1987, titled *Snow Melting in Spring*, featured brief nudity and the theme from *Shaft* on the soundtrack—not your typical agitprop.

From Film Fans to Film Making

The biggest change, at least in atmosphere, began in 2002, when PIFF started using a newly opened multiplex in Haeundae Beach, on the eastern edge of Busan. A thirty-minute drive from Nampo-dong (and a good hour by subway), Haeundae had actually been in the organizers' minds since the beginning, a natural home for the festival, with much more room to grow than the cramped confines of the old city. The Haeundae Beach district stretches for twelve kilometers along the coast, contrasting dramatically with the grey industrialism and ports of central Busan. The beach itself curves in a gentle, two-kilometer horseshoe shape, lined with upscale hotels and simple seafood restaurants. When the festival started in 1996, the beach area was much more seedy and underdeveloped, with gaudy love hotels nestled between the hills and the ocean. But development radically reshaped the area, as it does everywhere in Korea. Developers built luxury condominiums on the waterfront, nicer hotels, new apartments in the hills, and plenty of shopping areas

(and more movie theaters). Today, some people prefer the openness and modernity of Haeundae, while others prefer the character and crowds (and even smells) of Nampo-dong. Luckily, there is plenty of festival to go around in both locations.

Despite the kinks, which were worked out as the festival developed, PIFF was clearly a big hit, with 160,000 to 198,000 people flocking to Busan each year to see a wide array of movies they normally would not be exposed to. Those are nice numbers, and it is good for Korean audiences to get a regular dose of diversity. But what made PIFF into something bigger, something more significant for Korean movies, was the way it folded business into the art of filmmaking. And that addition traces back in large part to filmmaker and long-time Busan resident Park Kwang-su.

Park joined the PIFF team as deputy festival director in its earliest days, in December 1995. An accomplished director, the then-forty-year-old Park brought considerable connections to the festival, and it was also his idea to sign on Paul Yi. But Park's biggest contribution was the creation of the Pusan Promotion Plan, PPP, a premarket designed to help cultivate new filmmakers and bring together creators, investors, distributors, and importers.

Park had taken his movie *To the Starry Island* to CineMart at the Rotterdam Film Festival in 1994. CineMart was a venue that offered filmmakers the opportunity to pitch their ideas to the international film industry, gaining connections to get their projects financed. Park was impressed with how the market helped promote and develop independent films. Although Asia had plenty of film festivals, Park noticed how the region lacked a central place where filmmakers across the region could get together to talk and work on projects. He thought a mart like the one in Rotterdam would greatly benefit Asian filmmakers. In 1997, at the second PIFF, Park organized a series of workshops and meetings to set up the Pusan Promotional Plan, with the official premarket (PIFF's version of CineMart) launching the next year. This PPP premarket formed the creative core that made PIFF far more than just a presentation of a bunch of movies, expanding the festival's scope and helping to transform Korea's movie industry.

PPP started out modestly enough, with eleven Asian directors and five Korean directors selected to bring their in-development proj-

ects. For four days, PPP presented seminars about filmmaking. Some 290 film investors and distributors also attended, and PPP arranged interview times for them to meet the filmmakers. Each year thereafter PPP grew, as more directors, producers, and executives attended. Further helping PPP was the growing buzz Korean movies earned on the international festival circuit, and the fact that Korea was considered a hot market for imports. International buyers and sellers were really struck by the youthful audiences at PIFF, as most film festivals in the West skew to an older crowd. After a few years, PIFF began to offer several prizes, most around $10,000 to $20,000, not much by Hollywood's standards, but a real shot in the arm for an art-house moviemaker. In 2002, the PPP premarket and related events moved to Haeundae Beach, giving them plenty of room to grow. And grow they did, from sixteen projects in 1998 to thirty-six in 2006.

Each year it seems like something new gets added to the professional side of PIFF. The festival created a location market (for filmmakers looking for sites to film their stories), headed by Park Kwang-su, which grew into the Asia Film Commission Network. Alongside the premarket, an informal market began to spring up, with more and more international sales agents attending. In 2003, organizers formalized this growth and launched the Asian Film Industry Center, which in turn grew into the Asia Film Market in 2006. PIFF even started a film school, the Asian Film Academy, in 2005. The academy brought together over twenty aspiring filmmakers from around Asia to study with professionals for six weeks and put together a couple of short movies. In 2006, the Asian Film Academy added several special events featuring actors from around Asia.

Admiral Yi Sun-sin
More than three centuries after the Koreans, Chinese, and Mongolians tried to invade Japan, Japan decided to return the favor. Toyotomi Hideyoshi led over 150,000 battle-hardened soldiers to invade China via Korea. But Admiral Yi Sun-sin and his small but deadly fleet of "Turtle Ships" (or *geobukseon*) saved the day.

GNU license.

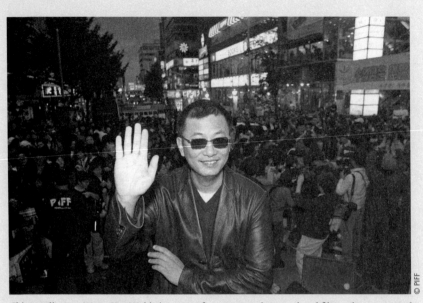

Chinese director Wong Kar Wai is just one of many great international filmmakers to attend PIFF.

Many of the market's most important effects were informal, happening outside the official meeting areas, when movie folks got together at various parties and events and just began talking. Hur Jin-ho's second film, *One Fine Spring Day*, would famously (or apocryphally, depending who you ask) find Korean, Hong Kong, and Japanese funding after a night of heavy drinking. Ironically, Park Kwang-su was one of the first to find success at PPP, when he signed a deal with a French distributor in 1999 for his next movie, *The Uprising*. Over the years, many of the biggest filmmakers from around Asia have participated in the various markets and activities, including Iwai Shunji, Stanley Kwan, Kim Ki-duk, Lee Chang-dong, Hou Hsiao-hsien, Michelle Yeoh, Wong Kar-wai, Kiyoshi Kurosawa, and Hur Jin-ho. Hollywood film studios and international talent agents also come out in force, and *Variety* magazine started printing a daily magazine at the festival in 2006, followed by *The Hollywood Reporter* in 2007. Once a tiny gathering of art-house filmmakers, PIFF now hosts thousands of film industry professionals from all over Asia each year.

Today, film market-related events dominate the festival parties and special events. From Thursday, opening night of the festival, un-

til the close of the film market (usually the following Wednesday), there are a plethora of dinners, parties, mixers, and other events to attend. After the parties, those with energy to spare usually head off to one of the *odeng* bars that lurk on the small street behind the Grand Hotel, just off of the beach, to continue eating and munching (and sometimes even working) until 4:00 or 5:00 a.m.

As for what is next, the biggest change will come in 2012 (or so), when the 430,000 square-foot PIFF Cinema Complex is scheduled to open (although, as the $40-million price tag soars and construction waits to begin, who knows when it will actually be completed). The undulating, gorgeous hall, designed by Vienna-based architecture firm Coop Himmelb(l)au, will be a home for the festival and a testament to Korea's love affair with the movies—and to the huge unexpected success of PIFF. It will contain not only six cinemas, an exhibition hall, a canal park, a red carpet zone, and a walk of fame, but also the Korean Film Council and Korea Media Ratings Board. In addition, Busan continues to create a name for itself as an entertainment center. MGM Studios signed a deal with a Korean investment company and the city of Busan to open a large theme park not far from Haeundae Beach. Although that deal fell through, Busan continues to try to develop a movie-themed amusement park. Regardless, the irony is stil strong–the festival that could never compete with Seoul succeeded precisely because it was not Seoul, and now the Seoul movie world is migrating to Busan.

As I finish this chapter, Kim Dong-ho has just seen his responsibilities cut back. He continues to be the face of PIFF, especially internationally, but Ji-seok, Jay, and Yong-kwan now do most of the heavy lifting. Yong-kwan in February 2007 was appointed co-director of PIFF, Jay became deputy director (along with actors Ahn Sung-ki and Ahn Byung-yul from the MBC television network), and Ji-seok is now program director. This year there will be seven programmers, well up from the original three, as PIFF continues to grow and demand more resources.

They will need all of their combined resources, with competition around the region growing tougher as many countries have eyed PIFF's successes with jealousy. Hong Kong stepped up its film market in 2005, combining it with the city's biggest film festival and several other entertainment-related markets to create one giant three-week

buzz of art and commerce. Many film industry types now consider the Hong Kong Film Market to be the biggest and most important in Asia, especially for mainstream filmmaking (PIFF skews more to art-house films). Bangkok, however, has not had as much luck, despite spending upwards of $8 million a year on a major film festival for several years. The Thai festival was organized by the people who once ran the Palm Springs Film Festival in the United States. They did their best to create another regional film market, but little business ever made it to Thailand. Finally, in late 2006, the Thai organizers saw their budget cut and then cut ties to the American organizers.

Tokyo, too, has made periodic efforts to step up its Tokyo International Film Festival and accompanying market. Japan has the clout to bring in the major Hollywood premieres (such as *Titanic* and *Letter from Iwo Jima*) to TIFF, but because it falls each year in the narrow space between PIFF and the American Film Market, TIFF has never been able to gain much traction with the region's film-makers. Tokyo also faces the very problem that PIFF was designed to avoid—the industry politics that necessarily come from being held in the nation's capital. And because Japan is such an economically powerful country, many in its film industry think it does not really need the rest of Asia, not in the way Korea does. Instead, Japan's eye looks more to the West.

Despite all of PIFF's successes and importance over the years, it faces ever more challenges. Not only from the competition, but from within. As the festival's staff has grown, it has lost some of the close, family feeling the organizers used to have. The volunteers have changed, too. Where once they used to be purely film fans, to-day PIFF makes an impressive reference and attracts a lot of young people just looking to build their resumes.

But the most troubling aspect of PIFF is how it failed in its prima-ry mission: to promote alternative and daring content in Korea. Al-though PIFF has been instrumental in the rise of Korea's commercial movies to their great heights around the world, in the twelve years since the festival began, art-house cinema has actually declined in Korea. *D-War*, *The Host*, and *Transformers* can occupy over 800 screens at a time, while many of the world's most interesting alter-native fare struggles to get more than four or five screens (or to get released at all). The first year of PIFF saw the first films by many of

Korea's top filmmakers today. How many big names have emerged from the festival in more recent years? Very few.

PIFF was originally conceived as a way to bring alternative and daring content to a country where decades of oppressive governments had kept out ideas that challenged the status quo. But it turns out that the Korean people themselves were just as adept at keeping out those ideas, only instead of using police batons and the censor's scissors, they use their wallets. Even Ji-seok laments how interest in retrospectives and documentaries at PIFF has been fading year by year, as the tastes of young people grow increasingly commercial, uninterested in difficult fare.

Of course, getting film festival movies into the regular theaters is not a problem unique to Korea. In fact, Fortissimo Films' Wouter Barendrecht calls it "the film festival disease," when movies that are hugely popular at a festival do absolutely no business when released into regular theaters. People are free to watch whatever they like, and Korea has always had a preference for the mainstream, from all the way back to the 1930s. But it is still a bittersweet irony that the festival that has done so much for Korean and Asian cinema (and PIFF undeniably has been hugely beneficial) has had so little impact in the very area it was designed to help the most.

The Actor
and the TV Drama

Smoke fills the dark karaoke room salon as the action begins. A gangster curses as his minions get ready for combat. But Lee Byung-hun's character is unconcerned. A bottle breaks, and Lee quickly leaps onto the table, sliding a sharp kick at thug No. 1. Standing on the table, he disarms another tough-guy with a kick, then swings his foot back around for another boot to the head. In a moment, the action is over and a voice calls out "Cut." Everyone ambles over to monitors to check out how the scene looked. It looks good, but the director wants a few changes, and everyone prepares for yet another take.

It's just another day in the life of Lee Byung-hun, for over fifteen years one of Korea's most popular actors. While some have made their name on the big screen, and others their reputations on the small screen of TV, Lee is one of the few actors to have been equally successful on both. Since making his acting debut in 1991 on the KBS series *Asphalt My Hometown*, he has gone back and forth between the media forms, winning awards and praise for both.

Handsome, with sharp eyes, a square jaw, and a big smile that hovers mysteriously between confident and mischievous, Lee is certainly a charmer. For public events, he usually sports elegant suits, but in private or in his office, he prefers a more casual, preppy style. He comes across measured and image-conscious, although not in a vain way—more like professional. And as an actor, his image is his

profession. He talks to me in careful, well-enunciated English. He sounds good, and obviously has practiced long and hard to get good, but it is not his native language, and it still slows him down, makes him careful. Whenever he switches to Korean, his voice takes off like a stampeding herd, racing with ideas and anecdotes and energy.

I also want to say that, at 5' 10" and 70 kilograms, he looks quite slight—except that when we met most recently, he had suddenly bulked up noticeably, several kilograms at least. Turns out he had been working out seriously for much of the year, getting in shape for some revealing scenes in a couple of upcoming movies. No rice and little kimchi for months, just protein. No rice and kimchi for a Korean man? That is dedication. That is professionalism.

Such professionalism was not exactly innate. He went into acting on a whim, much as he went to university on a whim, even chose his religion on a whim. But in the 1980s, much of Korea's entertainment industry was pretty whimsical, too (in form more than content, which was usually quite weepy and serious). Lee has grown into his role as one of the most representative actors in Korea, much as the television business has grown into its role as industry leader around Asia. His career grew up alongside the entertainment industry and modern Korean society, from the simple, low-budget, and strictly local days of the early 1990s, to the complex, big money, international heights of today.

French, Religion, and Other Whims

Born in the summer of 1970 in northwestern Seoul, Lee Byung-hun was the son of a construction company owner, Lee's mother a stay-at-home housewife. To this day, he still lives with his mother and sister (his father passed away in 1998). In Korea this is not at all odd, rather, it is the sign of a devoted and respectful son. He says his mother was extremely strict when he was young, not afraid to get physical with him when she thought he needed correction. But, he assures, she was not overbearing, and one day she simply changed, granting him instead much more independence.

Lee calls himself Buddhist, but the route to Buddhism was surprisingly complicated for someone who considers himself not es-

pecially religious. He says his mother was Catholic, so he naturally followed her lead. He was even baptized as Johann (John). But in middle school, a friend of his father pushed the family to convert to Protestantism. That lasted only one year, though, because when his father's mother died, the family suddenly realized that she was Buddhist, so everyone felt they needed to convert again. Obviously, religion is not a core issue to the Lee family or Lee Byung-hun himself. "Maybe I'll be Hindu next," he jokes.

When he was young, Lee remembers being captivated by the movies, even before he had ever seen one. The local Seongnam Theater displayed its posters across the street from his home, and he remembers always begging his family to take him to a movie, any movie. Finally, when he was four years old, a cousin agreed to take him. The movie was Steve McQueen's *Papillon*. Hardly the stuff for young children, but Lee just wanted to go. It was an overcrowded, old theater, without seat numbers, so he sat on his cousin's shoulders for the whole film. Lee does not remember much about the movie itself—just McQueen eating the cockroach and falling into the sea—but what really stayed with him was the environment of the theater, the darkness, even the smell.

Television, however, did not leave such a deep impression. One of the earliest shows he remembers liking was the old *Tarzan* series. And, like most young kids, he enjoyed his cartoons. But for the most part, the television was just the box sitting in the living room.

Lee says he was a solid if unspectacular student, not a troublemaker, and had good leadership skills. When he dreamed of working in entertainment back then, it was as a director, not as an actor, because he suffered from stage fright and did not like to be in front of groups.

He made it to the respectable Hanyang University, where he chose to study French Literature on a whim. "Most kids at that age are so serious, but I wasn't. I had never thought about French literature before, and when I selected it for my major, it was just an impulse. It sounded cool," he said, adding, "It wasn't." That first semester, he found himself in a French language class taught by a native speaker from France. She did not know any Korean. He did not know any French (usually in Korea, one does not get a native speaker for a teacher until after the introductory semester). The results were un-

surprisingly bad. Lee says he was the class joke, totally embarrassed by his inability. Sometimes he even took to drinking a little rice wine before the morning conversation class, just to cope with the stress of it all.

Then in his second year, through a friend of the family, he met a TV producer who convinced him he should apply to be an actor on KBS. Once again thinking "Why not?" he gave it a shot.

Making Airwaves— TV Begins in Korea
To provide a little background: Television in Korea got started on May 12, 1956, when the American RCA company launched HLKZ-TV, a tiny 100-watt channel located on a downtown Seoul corner, across from the famous Hwashin Department Store. (North Korea would have to wait until 1963 to get its own Central TV Broadcasting System). Because there were no televisions in Korea, RCA also installed forty 21-inch and 24-inch television sets in twenty-two public locations around Seoul. By the end of the year, there were three hundred TV sets in the country, but the broadcasting business was a money loser and was sold off in 1957 to Chang Key-young, president and founder of the *Hankook Ilbo*, who renamed the channel DBS (for Daehan Broadcasting System). The DBS studio burned to the ground in 1959, but the station was allowed to use the studio facilities at the American Forces Korean Network (AFKN), which had started broadcasting in September 1957. AFKN was designed for the tens of thousands of US soldiers serving

A Director for All Seasons
Kim Jee-woon is one of Korea's most versatile directors, having tackled black comedy (*The Quiet Family*), horror (*Tale of Two Sisters*), film noir (*Bittersweet Life*), and the spaghetti western (*The Good, the Bad, the Weird*).

© CJ Entertainment

in Korea, but was watched by many Koreans, further influencing life in the capital.

Local TV picked up on Dec. 31, 1961, with the founding of the Seoul Television channel (pretty much the successor to DBS), which would grow into Korea's main state-run station KBS (Korea Broadcasting System). TBC (Tongyang Broadcasting Corporation) would start in December 1964, founded by Lee Byung Chull of the Samsung conglomerate, and MBC (Munhwa Broadcasting Corporation) expanded from radio to TV in August 1969. Such diversity and independence would not last long, however, as the military regime increased its control over life in Korea. TBC was forced to merge with KBS to form KBS-TV2 in 1980, and MBC became a *de facto* public broadcaster in the 1980s as the military government of the 1970s and 1980s sought to keep broadcasters in line. Color TV arrived in 1981. KBS gained an additional channel dedicated to educational content in 1981, which was spun off in 1990 to form EBS. The only privately owned TV station in Korea, SBS, would not hit the airwaves until 1990.

As in most of the world, once television got its start, it spread rapidly—from 300 sets in 1957 to 30,000 in 1962, to 6.3 million in 1980, and to 8.7 million in 1987. Along with the growth in TV sets and stations came growth in programming. The seventies are often regarded as Korean television's first great era, as daily dramas (such as *Asshi, My Lady*), detective mysteries (*Susa Banjang, Chief Investigator*), and historical dramas (too many to count) all flourished, even as censorship and harassment by the government was destroying the movie industry. Imports accounted for one-third of all programming in 1969, but just 16 percent by 1983, and then 10 percent by 1987. Today, the free-to-air channels broadcast very little foreign programming, leaving it instead to the cable channels.

Point being, by the 1980s, television was firmly established in Korea. As in most countries, it quickly became the focus of most families' entertainment, devastating the movie industry in the process. Korean TV was still young and poor and finding its way, but the foundation of the drama industry was in place. There were several different styles of dramatic programs—long, ongoing dramas, miniseries, and *sageuk*, or historical dramas. Overall, the general look and structure of the industry was most similar to Japanese televi-

sion (certainly much more so than to American TV), with KBS taking many of its cues from NHK (if NHK had an orchestra, so would KBS; if NHK had X-number of reporters around the world, so would KBS).

Despite all the similarities, Korean dramas were evolving in significantly different directions than Japanese dramas. In Japan, most television series are twelve weeks long, and are broadcast in four "seasons" throughout the year. Korean series are much more staggered, coming at more random intervals. Korean shows typically air two days a week, back-to-back—Monday and Tuesday, or Wednesday and Thursday. The idea is that back-to-back dates make them easier to follow (in case you miss an episode, you can get caught up the next night), giving them an advantage over once-a-week shows. In addition, the length of Korean dramas has evolved a lot over the years. In the 1980s, dramas were usually shorter than Japanese series, typically four or eight weeks long. But then they started growing, to 12 episodes and then 16 or more. Today, the biggest miniseries are usually between 16 and 24 episodes, but there are many longer series, too, that go on for 60, 80, or over 100 episodes.

Trying Out Into this mix, in 1991, Lee Byung-hun decided to apply to become an actor. Back in the early 1990s, it is amazing how different the entire Korean entertainment business was, particularly television. It was rare for an actor to have a manager. Most people handled their own careers, answered their own phones and pagers, drove themselves to work, and negotiated their own salaries. Not that there was much to negotiate. Most actors were basically staff workers, paid a monthly wage on a scale according to seniority. Acting certainly was not some cool, highly sought after profession. Most parents despised the thought of their children going into show business (although Lee says his parents were surprisingly comfortable with his decision from the beginning).

Those who wanted to become actors applied for a job in the annual auditions the two networks offered, much the same as other big companies in Korea hired office workers. Back then, there were only two choices, MBC or KBS (SBS was just getting started). Actors

auditioned for a channel, and when passed, then belonged to that channel (kind of like the Hollywood studio system of the 1930s to the 1950s). Even though MBC was the king of TV dramas throughout the 1980s, Lee went with KBS, joining the station's fourteenth annual open auditions. Becoming a TV actor was a three-step process. First, an actor filled out an application (and sent photos), then did a reading, and finally a camera test. From a few thousand initial applicants, perhaps 200 would be called in for a reading, and only 40 would be chosen to become actors.

Lee made the first cut and was called back for an audition. He was given dialogue from some long-forgotten TV series and waited his turn with the scores of other hopefuls in the old KBS Hall. Along with the reading, applicants were expected to present some sort of skill or talent. He had been practicing taekwondo for years, and thought that big, showy kicks would impress the producers. Unfortunately, the guy right ahead of him had the same idea. Even more unfortunately, the man's kicks ended in disaster, as a mistimed kick caused him to wipe out and split his head open on the floor. He was taken away from KBS in an ambulance. So when Lee got in front of the judges and said he wanted to demonstrate his martial arts abilities, they called out "No!" Forced to think on his feet, in desperation he told the judges he could make funny faces. Not the world's most unique talent perhaps, but it got him through the audition.

He passed the audition, but was not yet out of the woods. The first three months, all new hires were on probation and took acting classes. Each month at least one person was cut. Early on, a producer approached Lee and gave him some dark news—Lee had in fact been the last person chosen to make the application cut. Dead last. The producer said his acting was unimpressive and sounded like someone reading a book. Knowing his job was in danger before it had even gotten started, Lee got serious for one of the first times in his life, and threw himself into the classes. When the three months were up, he had risen all the way from the bottom to graduate at the top of his class. For the first time, he began to feel confident about his future.

Becoming a KBS actor was far from instant glamour or fame. Actors signed a two-year contract for very little money, and were expected to come to the office every day, from 9:00 a.m. to 5:00 or 6:00

p.m., and just sit there, in a plain, unadorned office, waiting to be selected. Every so often the room's phone might ring or a producer would amble in, looking for someone for a program, usually an extra or a minor part. Every time someone was selected, his fellow actors would applaud and try to look supportive even though they were all totally envious. Day by day, Lee's colleagues were chosen for a variety of projects, but he was passed over. On top of it all, he was still a student, and was supposed to be studying. It was a miserable time.

Then one day, something remarkable happened: a producer selected him. Not only that, he was chosen for a supporting role, not as an extra, in the sixteen-part miniseries *Asphalt My Hometown*. The series was set in the 1960s, and Lee played a cousin to the lead actress' character, someone with romantic feelings he could not show. For a first role, it was quite meaty. True to form, his classmates were bitter, and accused him of having used connections to get the role.

From there, the roles kept coming. His role as the son of a rich man who becomes the delivery boy at a Chinese restaurant in *Day of Sunshine* was the first to put his name on the map. In the beginning, he had mostly supporting roles in miniseries, and once even a daily drama called *Wild Chrysanthemum*. But slowly he built his name and reputation.

Then, in 1992, he was cast as a university student on the long-running romantic series *Tomorrow Love*, which proved to be a big step up. *Tomorrow Love* was unusual in that it had two directors, each with a very different style—Jeon San, a story-centered director, and the visually inclined Yoon Seok-ho. It was an odd combination, as the tone of each episode varied wildly depending on who was at

A Movie to Remember
Of all the Korean movies to make it big in Japan, none was bigger than *A Moment to Remember*, a remake of a Japanese TV series about a young woman who gets early-onset Alzheimer's disease. *Moment* made $30 million in the autumn of 2005, marking the peak of popularity for Korean pop culture in Japan.

One of Lee Byung-hun's first roles was a
university student in Tomorrow Love.

the helm (as, too, did the rat-
ings.). Even more strangely,
neither director had created a
character for Lee to play; they
just wanted him to play him-
self. At the time, Lee was much
shyer and more self-effacing
than the confident charm he
typically exudes now. Between
the university-campus setting
for much of the series and the
natural style of the program,
Lee says the memories he has
of his fake university life on the
show are stronger than those
of his real university days.

Even though acting was a
full-time job, Lee still had his
studies. But, truth was, school
was slipping by the wayside.
Lee was never much interested in his major, and he was already
building a career. For most Korean students, the struggle is making
it into university. Once in, the classes are not so important. Many of
Lee's professors understood his predicament and were willing to let
him coast on through. "Don't worry," he remembers one professor
telling him, "You've already succeeded."

Out of the Frying Pan

Lee's college professor may have considered
him a success, but the producers at KBS did not
care. KBS was organized like most of Korea at the
time—hierarchical, based on Confucian ideals of seniority and age.
It mattered little if you were a great actor or a lousy one, if your
shows got high ratings or low ratings. Your pay was instead tied
more to how long you had been at KBS. Which is a good strategy for
keeping things orderly, regular, and safe, but it is a poor way to get
the most out of people or to make the best shows possible. So long

as everyone kept playing by the same rules (and with just two networks, there was little competition), this conservative system could just keep on going.

But then one day, someone changed the rules. Struggling upstart station SBS TV made Lee a big offer to jump ship—100 episodes at 2 million won per episode (about $2,000 per episode at the 2008 exchange rate). The numbers may seem small by today's standards, but in 1994 they were stunning. The nine o'clock news reported on the record-breaking amount. At first Lee actually said no, wanting to stick with KBS. But it was such a huge raise over his then salary at KBS, he approached his boss to ask for at least a small bump in pay. Although raising Lee's pay level would have cost the station very little, the mere request caused the director to fly into a rage. Lee thought his boss was about to throw an ashtray at him, so he ran out and went to SBS.

SBS TV got started in 1990, the first private broadcaster in Korea in decades. With TBC out of the picture (folded into KBS), MBC spent the 1980s unchallenged as king of TV dramas. So when SBS began, it started throwing money at many of Korea's top television talent—veteran writer Kim Soo-hyun, the hot new team of Kim Jong-hak and Song Ji-nah, and many others all jumped at the chance to work for the new station. And in 1994, Lee was one of the stars SBS captured. "The SBS offer was a bit of a mystery," says Una Beck, editor-in-chief of *T*, an online television-drama magazine. "Lee Byung-hun was popular, but he had never been in any of the really big hits. Despite that, he really is one of Korea's classiest actors."

Despite the record-setting money and the great opportunity, Lee calls the move "one of the biggest mistakes of my life." It is not like SBS was making bad TV (in fact, the signing of Lee coincides with one of SBS's most successful stretches of programming). But the record-breaking contract soon began to feel like a weight. One hundred episodes might go quickly if you were in a daily drama (and it paled beside Choi Jin-shil's monstrous 300-episode contract), but he mostly starred in miniseries, of sixteen or twenty episodes at a time. One hundred episodes represented a lot of TV acting he had committed to, and the months and years started to drag on.

In addition, he soon discovered, the SBS producer's promises of flexibility amounted to nothing. When he had signed with SBS, he

made sure that he would be able to return to KBS to work on one more series, *Son of the Wind*, which was being made by his friend. When he approached his boss at SBS to arrange for time to work on the drama, he was told he would not be allowed to participate. "He told me he lied to me, just to get me to sign the contract," Lee said. But Korea being Korea, contracts are one- or two-page outlines with plenty of room for "interpretation," not the giant, detailed tomes typical in Hollywood. In this case, interpretation meant Lee would have to extend his lengthy contract for even more episodes in exchange for permission to act in his friend's series.

The problems in the Korean television industry, of course, extended far beyond how actors were treated. The rest of KBS was run similarly, as was the rest of the entertainment industry. In fact, the entire broadcasting sector in Korea had been tamed under the watchful eye of the government. Throughout the military governments, first under Park Chung Hee and then Chun Doo-hwan, the authorities had taken many steps to ensure the media stayed in line. The Chun government even took over all television advertising, put-

All-time Top Twenty Korean TV Dramas

The figures that follow are from AGB Nielsen. They are average ratings—the percentages refer to how many households with televisions in the nation viewed a particular program.

1 *What on Earth Is Love?* (MBC, 1992)
59.6%

Written by Kim Soo-hyeon, *What on Earth Is Love?* is a most Korean drama, all about family, patriarchy, and cultural clashes. It is the lighthearted story of Choi Min-su, who grows up in a very conservative, patriarchal family, and Ha Hee-ra, who grows up in a progressive, matriarchal family. When they get married and Ha moves into Choi's home, their radically different backgrounds lead to an array of conflicts and misunderstandings. No worries, though: eventually they live happily ever after. Writer Kim Soo-hyeon infused comedy into the story and dialogue, creating a huge factor of the series' success. Series star Lee Sun-jae was later

elected to the National Assembly, while Kim Kuk-hwan made a hit song, "Tatata." The show even found recent success in China, where it has aired several times.

2 *Sons and Daughters* (MBC, 1993)
49.1%

Written by Park Jin-suk. Starring Kim Hee-ae, Chae Shi-ra, Choi Soo-jong, Han Seok-gyu. Another drama critical of Korea's patriarchal culture, *Sons and Daughters* told the story of a twin brother and sister born to a conservative Confucian family. The mother wants her son, Gwi-nam (literally, "precious boy"), to grow up to become a judge, but is shocked and disappointed when it turns out her daughter Hoo-nam (literally, "behind the boy") is smarter and more capable. Under the relentless pressure of her family, Hoo-nam eventually runs away to Seoul, while Gwi-nam is never able to become a judge, working in a bank instead. In the

ting it under a monopoly by the Korean Advertising Broadcasting Corporation, or KOBACO. Now this might sound like an abstract sort of problem, but in fact it was very big and very real. KOBACO controlled when stations could show advertisements and how many, how much they could charge, and even who got to advertise. All in the name of "fairness," of course (always a favorite justification for bureaucratic control). The main result, though, was that Korea's TV stations were greatly restricted in how much money they could make from ads. Lower ad revenues meant less money to fund programs. And because a show's ratings did little to influence how much KOBACO charged, there was little incentive beyond bragging rights to create top shows.

In fact, KOBACO still controls much of Korea's advertising markets, much to the dismay of all networks and advertising agencies in the nation. Which is kind of remarkable, considering not even communist Vietnam has such a controlling advertising regime. Although pretty much everyone in TV and advertising would like to see KOBACO killed, it keeps limping along, which has given rise to an

end, everybody reconciles.

3 *Hur Joon* (MBC, 1999)
48.9%

The highest-rated *sageuk* (historical drama) ever in Korea, *Hur Joon* told the story of a man with humble origins in the early days of the Joseon dynasty who grew up to become one of the most famous physicians in Korean history. Although Hur Joon's story has been told many times on Korean television beginning in 1975, none compared to this melodramatic retelling, directed by Lee Byung-hoon and written by Choi Wan-kyu.

4 *First Love* (KBS2, 1996)
47.2%

Two brothers (played by Bae Yong-joon and Choi Soo-jong) fall in love with the same woman, leading to bitterness and schemes of revenge. This sixty-six-episode series featured the first pairing of Bae and Choi Ji-woo, who would later team up for *Winter Sonata*. Although *First Love* ranks as only

the fourth-highest-rated TV show according to AGB Nielsen, the show boasts the single highest-rated drama episode of all time. The episode reached an incredible 65.8% on April 20, 1997.

5 *The Sandglass* (SBS, 1995)
46.7%

A remarkable twenty-four-episode series by Kim Jong-hak and Song Ji-nah about the turbulent 1970s and '80s in Korea, including the Gwangju Massacre of 1980. *Sandglass* describes a love triangle using a well-worn Korean storyline—two childhood friends, one of whom grows up to be a gangster (played by Choi Min-su), the other to be in law enforcement (in this case, a prosecutor, played by Park Sang-won). The Gwangju Massacre occurs over two episodes, mixing actual news footage to heighten the sense of reality. Choi's character is in Gwangju to see a gangster associate, while Park, serving in the military, is sent to Gwangju to quell the uprising. But most of the series takes place after Gwangju, and the characters' attempt to come

amusing nickname for KOBACO—the zombie corporation, "because it just won't die."

The point is, the television industry was full of institutional hurdles and inefficiencies designed to reward the loyal and stodgy, not the innovative and talented. But then even the most torpidly rigid bureaucrats faced a challenge they could not overcome—success.

If the early 1970s were Korean television's first great era, the 1990s were a veritable Golden Age, as drama after drama broke ratings records and enthralled the nation. The rise of SBS helped a lot, creating new, commercial options for creators dissatisfied with MBC and KBS. Suddenly, there was competition again, driving up costs and risks, but also rewards. For the first few years, SBS mostly floundered, at least when it came to producing original dramas. But 1995 changed all that, when SBS presented one of the biggest dramas in Korean history, *Sandglass*. Producer/director Kim Jong-hak and writer Song Ji-nah were already a hot property, after their 1991 epic drama for MBC, *Eyes of Dawn* (about three young Koreans caught in the chaos of life from the end of the Japanese colonial era to the Ko-

to grips with that tragedy mirror how Korea as a whole has tried to understand that same event.

6 *Dae Jang Geum* (MBC, 2003)
46.3%

Lee Young-ae plays the young woman who overcomes her humble origins to become a cook in the king's palace, and later, a royal physician. Also known as *The Jewel in the Palace*, this was probably the most successful Korean drama internationally, pulling in huge ratings around Asia and finding popularity as far away as Iran and Egypt.

7 *Can't Take My Eyes Off You* (MBC, 1998)
44.7%

Yun Hae-young, Jeong Bo-seok, and Heo Jun-ho star in this series written by Im Seong-han, who over the years has become known for plots that stir up controversy. Another family-centered story about culture and clashes, it features two sisters who marry two brothers of another family. However, the young-

er sister marries the older brother, and the younger brother marries the older sister, upsetting the Confucian order and leading to all sorts of trouble.

8 *Eyes of Dawn* (MBC, 1992)
44.3%

Eyes of Dawn is director Kim Jong-hak and writer Song Ji-nah's first big team-up, an epic that ran from the Japanese colonial era to the Korean War. Park Sang-won and Choi Jae-sung play two old friends who fall in love with the same woman (Chae Shi-ra) toward the end of the colonial era. She is taken away during the war to be a comfort woman (a prostitute for the troops), but she escapes and makes her way back to Korea. Any happiness after being liberated from Japanese rule is short-lived, however, as the two friends end up on opposite sides, one siding with the Americans and the other fighting with communist partisans.

9 *Honesty* (MBC, 2000)
42.7%

rean War), became absolutely huge, SBS hired them to create a series about another tumultuous subject, the Gwangju Uprising of 1980. That series, *Sandglass,* ran for twenty-four episodes and peaked with a stunning 64.5 percent audience share—good enough to make it the third-highest-rated show ever in Korea. Its social and cultural impact cannot be measured. Times were good, and station executives were eager to find the next big producer, the next big writer, the next big actor.

The political oppression and other difficulties of the 1980s made that decade a difficult time to explore Korea's rapidly changing society. Top writers, like Kim Soo-hyun, typically responded by turning inwards, exploring the family and "safe" subjects. But as Korea began to liberalize after 1988, writers soon returned to tackling new topics. In addition to Kim Jong-hak and Song Ji-nah's historical epic series, there were plenty of new shows shaking things up and earning huge ratings in the process. MBC's 1991 series *Jealousy* blew people away with its fresh, lively look at young professions in the style of the Japanese *trendy dorama* (and in fact, *Jealousy* was so similar to the 1991

Written by Kim In-young and starring Choi Ji-woo, Ryu Shi-won, Park Seon-young, and Sohn Ji-chang, *Honesty* is a classic example of the Korean convoluted melodrama. A drunk-driving accident is the crux of the series. Shin-hee, the driver, is the only one conscious after the accident, so she switches seats with her "friend" Ja-young (played by the always long-suffering Choi Ji-woo) and tells the police Ja-young was driving. Nice.

 You and I (MBC, 1997)
42.4%

This family-based melodrama was written by Kim Jeong-su and starred Park Sang-won, Choi Jin-shil, Cha In-pyo, Kim Ji-young, and Song Seung-heon. Choi Jin-shil and Park Sang-won play coworkers who get married, but Choi's character gets more than she bargained for when she moves in with her husband and has to deal with his onerous family.

 Lovers in Paris (SBS, 2004)
41.1%

The daughter (Kim Jeong-eun) of a movie director studying abroad and the son (Park Shin-yang) of a rich *jaebeol* family meet in Paris, then face all the usual headaches and obstacles of falling in love. This series boasts one of the strangest endings of any Korean drama, as the couple's whole story is revealed to be a dream at the end—allegedly because writer Kim Eun-sook was annoyed to find the conclusion revealed on the Internet and made a last-minute rewrite.

 Jumong (MBC, 2006)
40.4%

An action-oriented retelling of the story of Jumong Taewang, founder of Korea's ancient Goguryeo Kingdom. Originally slated for sixty episodes, *Jumong* kept growing more popular as its run went on, inspiring MBC to order an extra twenty episodes.

Wish Upon a Star (MBC, 1997)
40.2%

Japanese drama *Tokyo Love Story* that it raised more than a few well-plucked eyebrows). Yoon Seok-ho's tales of pure love were new and intriguing, yet to collapse into repetition and self-parody. And Jeong Se-ho's *M* was a primetime horror-thriller like no one had ever seen (plus starring Shim Eun-ha, just as she was becoming a huge star, did not hurt). Each ratings hit drove up demand for artists who could create such smashes, making it ever more tempting to bypass the traditional, seniority-based system and instead offer proven talent the money needed to secure their services.

Lee was enjoying life as a television star, even if life at SBS was less than ideal. But what had always truly inspired him were the movies. And in 1995, he finally found his first chance to star in a film, in Gu Im-seo's *Who Drives Me Mad?* Luckily, his exclusive contract at SBS did permit movie work. Remember, 1995 was the low point for the Korean film industry, and coming at the same time as the apex of TV's Golden Age made cinema seem like the poor stepchild (at least to many producers).

The transition to movies would not be easy, though. At first, Lee

Yoon-hee (Choi Jin-shil) lived in an orphanage after her father died but later is adopted by one of her father's rich friends. Unfortunately, this puts her in the middle of a nightmare, thanks to an evil stepmother (Park Won-sook) and stepsister (Jeon Do-yeon). Later, it is revealed that Yoon-hee really is the man's biological daughter. And there is a love triangle, of course.

14 *Jealousy* (MBC, 1992)
40.1%

Written by Choi Yeon-ji, Korea's first "trendy drama" (after the Japanese genre), *Jealousy* is a love-triangle story, featuring Choi Jin-shil and Choi Soo-jong. This series is rumored to be a copy of the Japanese drama *Tokyo Love Story*.

15 *Emperor Wang Gun* (KBS1, 2000–2)
39.7%

Written by Lee Hwan-kyeong. Starring Choi Soo-jong as the Emperor Wang Geun, the first ruler of the Goryeo dynasty. Born in 877 to a merchant family, Taejo Wang Geun teams up with a local bandit who rebels against the queen. Wang Geun is a successful commander and, after the bandit becomes king, Wang Geun becomes prime minister. As the bandit-king begins to upset his followers with his cruel rule, they plot to overthrow him and make Wang Geun king. This 200-episode series maintained remarkable ratings for such a long series.

16 *Because of the Affection* (KBS1, 1997)
38.8%

This famous daily drama starring Lee Jae-ryong and Ha Hee-ra and written by Mun Myeong-nam is about a widow struggling to make ends meet for her family. She gets a rude surprise when a woman her late-husband was having an affair with moves into her house.

17 *Tomato* (SBS, 1999)
38.6%

expected film to be just like TV (especially since his recent drama, *Men of Asphalt*, was the first Korean drama to be shot on film instead of video). He quickly found out how wrong he was at an early press conference. Introducing himself to the Korean press, Lee proudly called himself a "movie actor." The press just snickered. In their minds, he was just a TV actor.

Not only was the movie difficult, it was downright frightening for Lee. Back then, grizzled veteran cinematographers typically held all the real power on the set (much as engineers held the real power in the recording studio). And the *Who Drives Me Mad?* cinematographer, Jeong Gwang-seok, was one of the most grizzled, most veteran cinematographers in Korea, with well over one hundred films to his name. Jeong had worked with many of Korea's top directors since his debut in 1962, including Bae Chang-ho, Park Kwang-su, and Kang Woo-suk. Lee spent much of the shoot terrified of the man. Back then, the film industry was so poor that everyone hated to waste precious film, and if Lee did not like a scene, he had to beg for an additional take. The whole process was physically taxing, and when

Written by Lee Hee-myeong and starring Kim Hee-seon, Kim Seok-hun, Kim Ji-young, and Kim Sang-jung, *Tomato* is yet another Cinderella story. This one is about two aspiring fashion designers and the man they love. The Korean Wave star Won Bin makes a short but well-received appearance.

 M (MBC, 1994)
38.6%

Shim Eun-ha stars in this very unusual series about a woman who has magical powers that emerge when she is in trouble, accompanied by cheesy, Incredible Hulk–like special effects of Shim's eyes turning green.

 A Daughter-Rich House (KBS2)
38.4%

This is the story of five daughters and their husbands and boyfriends. There is a Korean saying that a home with a lot of daughters is a rich home, hence the title. But there is also the saying, "Three

women are enough to break a plate," meaning that a lot of women together can be quite noisy and unruly. The daughters are all good young women but always seem to be getting into trouble or otherwise causing craziness for the family. In the end they also bring much happiness.

 Mother's Sea (MBC, 1993)
37.9%

The father of a rich family dies, leaving his family suddenly poor. His wife and four children are forced to move into the home of the wife's sister. For the first time ever, the wife must get a job and the whole family learns what life is like on the other side of the tracks.

Of course, this list only covers average ratings. Plenty of shows have been wildly popular for a time but were unable to sustain over the length of the series. For example *Rustic Period* (which told the life of the famous gangster-turned politician Kim Doo-han) was a huge hit for severa

it was done, *Who Drives Me Mad?* sold only one hundred thousand tickets, a major disappointment.

Lee followed up *Who Drives Me Mad?* with three more movies—*Runaway*, *Kill the Love* (produced by Ilshin Investment and Kim Seung-bum), and *Elegy of Earth*. All three were major failures. There is a saying in the Korean film business that "If you fail three times, no one wants you." Well, Lee had now failed four times. It looked like he was yet another actor who could shine on the small screen, but could not cross over to the big screen, so he returned to television. After all, his giant SBS contract was still waiting for him.

When he returned for his next SBS series, Lee for the first time realized how fast and sloppily TV was done in Korea. Scenes were set up and shot quickly. There were no monitors to review the scene. Even in the bad days of Korean cinema, even when Lee was terrorized by veteran cinematographers, their low-budget, simple movie productions were light-years ahead of television. The limits of television made him frustrated and angry.

Just when his frustrations were about to boil over, however, Lee rediscovered success, thanks to the drama *Beautiful My Lady*. Teaming up again with producer Lee Jang-soo (who had also created *Men of Asphalt*), Lee played a boxer who fell in love with a beautiful young widow, played by Shim Eun-ha, soon after she had become one of Korea's top stars. The show returned Lee to the spotlight and made him a hot commodity again.

Then in 1998, a perfect-looking project came together, *White Nights 3.98*. *White Nights* was the latest epic devised by Song Ji-nah and Kim Jong-hak, once again combining romance and politics in a vast saga, this time involving North Korea and the former Soviet Union, with shoots in Moscow, Kazakhstan, Uzbekistan, and Kyrgyzstan. Kim had most of the series cast, including Shim Eun-ha and Choi Min-su. However, he had been unable to find an actor to play the pivotal role of Gyeong-bin, a former air-force officer. Kim and Song's first project since *Sandglass* looked to be a sure-fire hit, and Lee landed the important role.

Unfortunately, the show was a total failure. With its fanciful storyline (about an advanced North Korean bomber) and heavy use of Russian and English, *White Nights* quickly grew tiresome for viewers. Ratings tanked, in one of the biggest flops of Lee's career. On

the plus side, Lee enjoyed getting to work with Kim Jong-hak, who he says was great at explaining anything, often by telling seemingly irrelevant stories until the actor figured things out on his own. But that did not change the ratings and financial disaster the show was.

Soon after *White Nights*, Lee made what was then a radical step—he got a manager. Although, to be honest, his first manager was not really much of a manager. In fact, he was a friend of Lee's, hired in part because Lee missed his friends and was lonely. During movie production in Korea, all the actors and crew tend to spend a lot of time together, eat together, and become close. But in the TV business, people were much more independent and distant. They would take off at lunch or dinner, and go eat with friends and in private cliques. Of course, Lee switched from having a friend be his manager to hiring a more typical manager a few years after that—Son Seok-woo, to this day still his manager. Today, pretty much everyone in the Korean entertainment industry has professional management of one sort or another. But at the time, getting a manager was a big step.

Despite the surprise disappointment of *White Nights* and failing in movies four times already, Lee found another film role, this time playing an early 1960s Seoul schoolteacher who was sent to the countryside. Directed by Lee Young-jae (not to mention starring a transformative Jeon Do-yeon, morphing unrecognizably yet again, this time into a seventeen-year-old country girl), *The Harmonium in My Memory* was not a huge hit (in fact, it lost money again for Ilshin and Kim), but it earned much critical praise. Two star-studded and quite successful TV dramas soon followed—*Happy Together* and *Sunflower* (particularly *Happy Together*)—further helping his career.

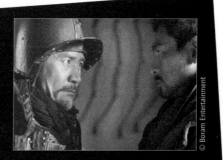

Fifty Years of Hits
Ahn Sung-ki made his acting debut when he was just seven years old, with *Defiance of a Teenager* in 1959. Throughout his fifty-year career, Ahn has starred in many of Korea's biggest hits, including *The Housemaid* (1960), *The Whale Hunter* (1984), *Two Cops* (1993), and *Silmido* (2003).

© Boram Entertainment

It was now 1999, and Lee still had not fulfilled his military service requirement. He had been putting it off for years, for one reason or another, and decided he could put it off no longer. At nearly thirty, Lee says, he was by far the oldest person in his unit to be doing the mandatory service. Although most Korean men serve for about two and a half years, Lee put in only six months. His father had passed away while he was filming *Harmonium in My Memory*, and as the only male heir, his service time was greatly reduced. Nevertheless, it was difficult, tiring, and as far away from celebrity life as one could get. But Lee remembers the time fondly. "At the time it was tough, but now, when I remember it, it was cool," he says. "For six months, I was nothing. A natural person."

Stepping Up Upon leaving the military, Lee was promptly offered a new film role—coincidentally, a military role. A no-name director with two flops under his belt had been selected by Myung Film to make a movie adaptation of the Park Sang-yeon short story *DMZ*, a murder-mystery that took place on the North-South border. The director was Park Chan-wook, and the movie was called *JSA: Joint Security Area* (just another name for the Demilitarized Zone). Lee played a South Korean soldier who patrols the DMZ. He strikes up a surprising friendship with a couple of North Korean soldiers (including one played by Song Gang-ho) after he accidentally wanders into North Korean territory one night. With former democracy activist Kim Dae-jung the new president of South Korea, bringing a Sunshine Policy of goodwill to the North, the movie was perfectly aligned with the mood of the nation, helping turn *JSA* into an even bigger hit than *Shiri* (depending on who is counting), with 5.8 million tickets sold. Made for just $3 million, *JSA* also helped relaunch Lee Young-ae's career (which had been on the skids after the monstrous flop *Inshalla* a couple of years earlier) and showcased Song Gang-ho. *Shiri* had turned the Korean movie world upside-down the year before, but many people worried it was just a one-off fluke. *JSA* proved the potential power of the Korean hit machine. The two films would vie for title of biggest film ever in Korea for a year, until *Friend* bested them both.

Lee would make one more movie, *Bungee Jumping of Their Own*, before returning to television again in 2001. His next show, *Beautiful Days*, would be another hit on Korean TV. But by that point, a huge change was beginning to reshape the world of Korean dramas. Korean dramas were going out into the world, finding fans in some far-flung places. It was a wave of popularity that no one saw coming. The Korean Wave.

For years, Korean TV dramas were little known or seen outside of Korea, basically cheap alternatives to expensive American and Japanese content. The big networks would send people to the major TV markets, hoping to sell a couple of shows here and there, to Taiwan mostly, as well as other areas around Asia, usually for just a few dollars an episode. All three networks together sold just $13 million in exports in 2000. By 2005, that number would top $100 million, as surging demand saw the per-hour price of Korean dramas soar by more than tenfold.

The Korean Wave—*hallyu* in Korean, *hanryu* in Japanese, and *hanliu* in Chinese—had started unofficially around 1997, as the teenage dance band H.O.T. and other bubblegum acts began to catch on beyond Korea's borders, particularly in Taiwan (the term *hallyu* was first used by the Chinese media in 1999 while describing a H.O.T. concert in Beijing). Then, in late 1998 and 1999, television dramas followed. Shows like *What Is Love?* and *Firecracker* did unexpectedly well in Taiwan. But things really took off with Yoon Seok-ho's "pure love" drama *Autumn in My Heart* (also known as *Endless Love* in some territories, and *Autumn Tale* in others).

The thing about Korean dramas is that not only were they cheap, they were also well made. The hits of the 1990s had brought more money into the television industry, raising budgets and production values along the way. Korean dramas also had a lot of cultural elements that people around Asia could relate to—Confucian values, strong (if overbearing) families, and modest sexuality (not to mention the actors were physically more similar to Asian audiences than Western audiences). But because Korea is a notch or two above most of Asia economically (and democratically), the dramas were also aspirational. The pretty young people featured in the Korean dramas, with their nice cars and even nicer cell phones, lived the life that audiences craved, from Bangkok to Beijing. The characters were mod-

ern and forward-looking while portraying people audiences could relate to. These were people audiences wanted to be, living lives they wanted to live.

Not only were the dramas popular in and of themselves, but also many Korean manufacturers were using them to gain access to different markets. Cosmetic companies would tie the release of a series in a country to an advertising campaign featuring an actress from that series. One appliance company paid for a series to be exported to Central Asia in exchange for the program's advertising rights there. It was a steady, somewhat surprising rise in exports that had Korean producers pleased, but skeptical whether it could last or grow into anything significant.

But what really took this "Korean Wave" to the next level was one more Yoon Seok-ho drama that came out in early 2002 called *Winter Sonata*. Another series about "pure love," much in the style of *Autumn in My Heart*, *Winter Sonata* featured Bae Yong-joon and Choi Ji-woo in a dramatic and elaborate tale of a love that overcomes secrets, lies, time, and even blindness.

Summing up the complicated storyline would be nearly impossible, but if I might try: Yu-jin (Choi) and Jun-sang (Bae) are young sweethearts in love, so Yu-jin is crushed when Jun-sang dies in a car accident. Ten years later, Yu-jin has moved on and is engaged to someone else when one day she sees Jun-sang on the street. Only it is not Jun-sang, it is someone who just looks like him. Only it is Jun-sang—turns out Jun-sang did not really die, he just lost his memory in the accident and was raised abroad as a different person. They fall in love and intend to get married, only to find out they are half-siblings—Jun-sang's father is also Yu-jin's father. The two break up, Yu-jin goes to France to study and Jun-sang finds out he has a brain tumor (the operation will either kill him or blind him). Three years later, Yu-jin returns to Korea, only to discover that Jun-sang and she are not related at all, and that Jun-sang is blind but still in love with her. They are together at last. The end.

The show played on KBS in early 2002 to respectable ratings (albeit down from *Autumn in My Heart*), but nothing overwhelming. Choi had developed a bit of a following overseas, thanks in part to her role in Lee's *Beautiful Days*, but she was no superstar. Bae was even less known, already on the downswing of his slight career. Af-

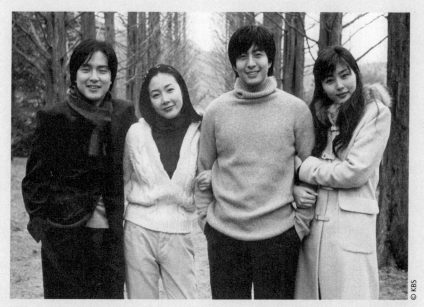

Winter Sonata *took the Korean Wave to incredible heights all over Asia, making stars out of Bae Yong-joon and Choi Ji-woo.*

ter the show's twenty-episode run, that usually would have been it. But something remarkable happened when *Winter Sonata* began to play overseas—people really liked it. A lot. Viewers in Taiwan, Hong Kong, and other Asian territories ate it up. It was even a hit in Uzbekistan. Tourists streamed into Korea, traveling to the locations where the scene was shot, to the hotel featured in some scenes. Life-size cutouts of Bae suddenly appeared in tourist districts and at the airport. Something big was happening.

But the real surprise came from Japan. Following the 2002 Korea/Japan FIFA World Cup, relations between the two countries were generally warm, and talk of cultural exchanges was in the air. Japan's national broadcaster decided to show *Winter Sonata* in April 2003 on its satellite channel NHK BS2. Surprisingly, the show's ratings were strong, and they kept getting stronger week by week. After such an unexpected reaction from viewers, the network decided to re-run *Winter Sonata* on its main terrestrial channel, where the ratings really exploded, topping 20 percent and landing in the weekly top ten. NHK recognized a cash cow and soon pumped out *Winter Sonata* books, CDs, DVDs, calendars, you name it.

The strange thing about the success of Korean programs in Japan, though, is how different the demographic. In Taiwan, Hong Kong, or Bangkok, Seoul seemed modern and hip, and the protagonists of the shows had lives that young audiences could aspire to. But Japan is much richer than Korea, its technology generally more advanced. Korean television in Japan did not take off because it represented the future; it represented the past. The "pure love" of Yoon's drama appeals to older women in Japan, reminding them of the dramas of their youth. It was nostalgia in twenty one-hour blocks. Somehow Korean dramas had managed to walk two very different sides of the cultural fence, appealing to both the forward-looking and the backward-looking. It was quite a trick.

The other strange thing about the success of Korean shows in Japan was the importance the opposite force had in creating that success—that is, the success of Japanese pop culture in Korea. It was fear of what the Japanese cultural behemoth could do to Korea that spurred the Korean government and TV industry to make the changes that helped create the Korean Wave.

Following Japan's colonization of Korea for most of the first half of the twentieth century, Japanese popular culture was completely banned. Japan's music, movies, and television were all off limits, considered too painful a reminder of a difficult time. For decades, it was like the biggest pop culture force in Asia did not exist. (Although, strangely, many animated shows and comic books did make it to Korea. The animation was dubbed, with the Japanese taken out so the show could be presented as Korean. Besides, so much of the work in many animated series was done in Korea by local animation middlemen that the images felt practically Korean.)

Despite the ban, Japan still made its culture felt in Korea, if only unofficially. Black markets in videocassettes and VCDs were common, as were Japanese culture cafes, where people could share their contraband.* Korean producers often gathered collections of the lat-

*I sometimes find myself oddly intrigued by the idea of contraband culture. Japanese culture was available for all who wanted it, but they had to really dig for it, just as they did for many other things banned by the Korean government over the years—good movies, good music, good rice. Most banned things were around, just not readily accessible. While I am certainly no fan of censorship, I rather like the idea that people need to struggle to find their art. No casual viewers.

est and most popular Japanese dramas and watched them together, as a kind of group study session, combing them for ideas. Japan had done well in exporting its dramas to much of Asia—Taiwan, Singapore, Hong Kong—in the 1990s, creating a presence that would indirectly, eventually, trickle down to Korea. For example, the *trendy dorama*, which features "real life" jobs and aspirational stories, took off in Japan in the late 1980s, eventually crossing over to Korea in 1992 with the hit *Jealousy*. Indeed, many of the biggest hits of the 1990s in Korea were derived from the trendy drama format.

Throughout the 1990s, the media in Korea criticized television producers for just copying Japanese content (particularly entertainment programs, but dramas, too), but because so few people in Korea had access to the original Japanese shows, it was hard to make such accusations stick. In 1993, Japan's TBC sent KBS a letter that claimed the KBS show *Racing Sunday* was a copy of *Lucky Zelda*, and demanded $30,000 in royalties. KBS simply cancelled the show, and never responded publicly to the charge. In 1998, MBC cancelled their drama *Cheongchun* after accusations that it was a copy of the 1997 Japan drama *Love Generation*. It marked the first time any Korean broadcaster admitted the problem and took action.

Finally, in 2004, Korea opened fully to Japanese culture (well almost). The change had been brewing for some time. It began in 1998 with three award-winning movies and slowly spread. Many in the industry were dreading that day, certain it would open the floodgates, revealing to Koreans how much of their television was plagiarized from Japan, and how much better the originals were. But it turned out those fears were exaggerated, if not outright wrong.

In fact, producers knew that the changes were coming and had already prepared. They started to license the Japanese shows they wanted to use instead of stealing their ideas, in part because they did not want to get caught, and in part because the industry had more money than ever and could afford to license (not to mention Korean TV producers were exporting more programs than ever—nothing like having intellectual property of their own to sell to make them much more concerned about IP rights). In addition, Japanese dramas had lost much of their cachet with Korean producers, who began to study American dramas for ideas much more heavily.

The government, too, helped get the industry ready, when the

Ministry of Culture and Tourism back in 1998 created a five-year plan to boost the domestic culture industry, encouraging universities all over Korea to create culture and entertainment business departments. Various government groups helped Korean production companies attend the world's TV and film markets. And the government created the Korea Culture and Content Agency (KOCCA) to help promote Korean programs and products abroad.

In short, the opening of Korea's TV and cultural market to a major competitor (Japan) made it stronger. "Protecting" Korea from Japan in fact did nothing of the sort and instead only made the local television industry lazier, less competitive, and less interesting. It is not that Korean producers were looking for shows that would appeal abroad, but by making stronger programs, foreign audiences naturally took a greater interest in the Korea shown.

Regardless, soon all things Korean were all over Japan. The numbers of Japanese tourists traveling to Korea jumped 35 percent in 2004. Bae Yong-joon was the undisputed king of Korean pop stars in Japan, but the media in Japan began looking for other Koreans who might also appeal there. Choi Ji-woo, naturally, did well there for a time. Jang Dong-gun proved to have a decent fan base, too. And Lee Byung-hun was also one of those stars.

Lee's last two television programs were among the most popular of his career. *Beautiful Days*, from the early days of the Korean Wave in 2001, featured Lee as Min-cheol, the eldest son of a music business owner. Min-cheol may have been arrogant and ruthless, but he was also lonely inside, and fell hard for the good girl Yeon-su (played by Choi Ji-woo). Of course there is a love triangle, as Yeon-su is in love with Min-cheol's half-brother. But a strong cast and good pacing lifted this drama above the competition at the time.

After *Beautiful Days* had run its course, Lee made his first work-related trip to Japan, to help market the late release of *JSA*, and was surprised at the media interest in him and things Korean. There were endless interviews, one after the other, like a Western-style press junket (which Korea had not yet adopted, so it added to the oddness of the experience for him). He also found himself promoting his programs in Taiwan, Hong Kong, and Singapore. In addition to press events, there were fan meetings, photo books, and appearances at award shows.

By the way, the "fan meeting" must be one of the strangest parts of the Asian celebrity lifestyle. I am not talking about meeting a couple of people who win some radio contest or visiting a sick kid in the hospital. No, this is something far different. Thousands of fans gather in a stadium, like at a rock concert, only instead of a band, loud music, or pyrotechnics, the star sits there talking to people (and screaming fans). The star will just make small talk, maybe sing a song or two. His manager might talk to the crowd for a spell, telling them frank and candid "truths" about the star (who knows how much of a basis in reality any of those secrets have). In Japan, top stars can get up to 10,000 die-hard fans paying around $50 each, just for the opportunity to see their favorite celebrity, vaguely, in the distance, in the intimacy of a giant stadium.

Lee does only a few fan meetings each year, usually in Korea or Japan, but occasionally elsewhere in Asia. He says he is conflicted about the events. He wants to be generous to his fans, but on the other hand wants to keep enough mystery so that people's perceptions do not hamper his acting. But the demand is huge. In fact, in May 2006, Lee filled the Tokyo Dome with 42,000 fans, the biggest fan meeting ever for a Korean actor, and in July 2007 filled the 10,000-seat Nihon Budokan two times in one day. While Lee is unfailingly gracious towards his hordes of enthusiastic fans (including the ones who jump the security lines and mob him), for an unbeliever such as myself, it all seems quite odd.

Anyhow, following *Beautiful Days*, in 2003 Lee starred in *All In*, playing an orphan who grew up to be a great gambler and card shark (very loosely based on a true story). *All In* was by far Lee's most popular

Red Devils
At the peak of Korea's amazing FIFA World Cup run in 2002, when Korea battled Germany in the semifinals, an estimated 7.5 million red-clad fans took to the streets to support Korea. In contrast, the height of the democracy movement of the 1980s saw just 1.5 million people hit the streets.

television drama, with ratings that topped 46 percent for SBS. Costarring with the popular young actress Song Hye-gyo (one of the co-stars from *Autumn in My Heart*), *All In* found much success around Asia.

For all the different series Lee has been in over the years, there is one genre that he never tried, the *sageuk* (or historical drama). With Korea's long, rich history (and, on occasion, the history of its neighbors), there has always been a wealth of topics and eras to choose from. And from the earliest days of Korean television (as in the movies), the sageuk has been a popular genre. Actually, for much of the 1970s, '80s and '90s, the sageuk was an almost intimidating form, very formal, concentrating on kings and famous generals, even sticking closely to anachronistic ways of talking. Because so many people in Korea know their history very well, producers had to be careful to get the details right or risk a popular drubbing. Even Lee says that the pressure such roles demanded were part of the reason he never tried the genre.

The biggest change to hit the historical drama came in late 1999 with the MBC series *Hur Joon*, the well-known story (to Koreans, anyhow) of a commoner who became a royal physician around 400 years ago. Running for sixty-four episodes, *Hur Joon* was one of the most popular programs ever in Korea, with ratings of nearly 64 percent making it by far the most popular sageuk ever. The difference between *Hur Joon* and the historical epics that came before it (including two previous tellings of Hur Joon's story) was its tone. Instead of focusing on politics and history, it looked at people and personal struggles. Basically, it applied the trendy drama formula to the sageuk genre. After *Hur Joon*, going personal became the way all the sageuk approached their subjects. Daily life—personal looks at the olden days—became their centerpiece.

While *Hur Joon* did incredibly well in Korea, it did not travel well, finding limited popularity in other countries. But in 2003, a sageuk drama that applied the ideas of *Hur Joon* to a young woman who became a royal cook and later a royal physician unexpectedly grew into the next big international hit, even bigger than *Winter Sonata*. Lee Young-ae, who had acted with Lee Byung-hun in *JSA*, starred in *Dae Jang Geum* (or *The Jewel in the Palace*), playing the lead role of Jang-geum, the best chef and doctor in that ancient time, as humble and twice as long-suffering as she was wise.

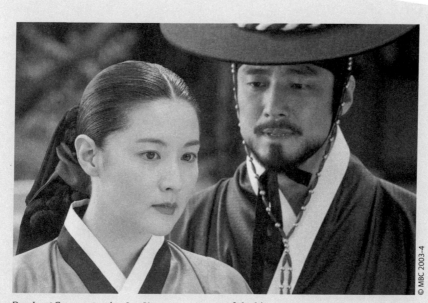

Dae Jang Geum, *starring Lee Young-ae, was one of the biggest Korean TV dramas of all time, all around Asia.*

Set in the early days of the Joseon dynasty (about fifty years before the events in *Hur Joon*), *Dae Jang Geum* was originally planned as a drama-educational hybrid. In Korea, the main networks all have mandates to educate the public and improve public discourse. However, simple lectures are usually pretty boring to watch, so broadcasters sometimes add an educational element to their original dramas. So *Dae Jang Geum* featured plenty of lessons about traditional cooking and medicine from long ago in Korea. It proved to be a gimmick people around Asia found surprisingly addictive. *Dae Jang Geum* was No. 1 in Taiwan, set ratings records in Hong Kong (over 3 million of Hong Kong's 6.5 million people tuned in to see the last episode, including a stunning 97 percent of all the people who were watching Chinese-language terrestrial TV at the time), and has now aired in over forty countries around the world.

As for Lee Byung-hun, though, he left television after *All In*. He starred in the sexy comedy *Everybody Has Secrets*, maximizing his mischievous charm as a mysterious man who seduces three sisters (it is a remake of the Irish film *About Adam*). Then, he followed up that role with a 180-degree turn, reuniting with Park Chan-wook for the dark short film *Cut* (one part of the trilogy *Three: Extremes*).

After a decade of being one of Korea's hottest TV stars, Lee Byung-hun's movie career finally took off.

And in 2005, he starred in Kim Ji-woon's "action noir" film, *A Bittersweet Life*, playing a smooth gangland enforcer who finds his life torn apart over a simple misunderstanding. In 2006, there was the weepy melodrama *Once in a Summer*, which was totally forgotten. As I write this, Lee is teaming up with Kim Ji-woon once again, this time for an "Oriental western," *The Good, the Bad, the Weird* (Kim's riff-off of the famous Sergio Leone film of nearly the same name). Lee is playing The Bad (remarkably, it is the first time in his sixteen-year career to play the antagonist).

It is not that Lee dislikes working in television (although clearly for him movies have the romance), but he is looking for projects that can take his career to the next level. These days, he finds that television in Korea is in a bit of rut. Far from the fresh, new directions it was taking in the mid 1990s, these days a small number of stories seem to be repeated endlessly. Everyone wants to tell variations on the Cinderella story. (I once had a leading producer at KBC complain excitedly, "I tell my writers all the time to go crazy and give me something new and different. But they keep giving me Cinderella.") Yoon Seok-ho keeps making the same pure love stories, to ever decreasing ratings. Kim Jong-hak and Song Ji-nah teamed up with Bae

Lee Byung-hun took the unusual role of playing a bad guy in Kim Jee-woon's blockbuster Western The Good, the Bad, the Weird.

Yong-joon to retell the Korean founding myth in the most expensive television show ever produced, but the feeling among many is that it is yet another Bae project aimed at the lucrative Japanese market. Although television exports did not collapse in 2006 the way the movie exports did, they did drop 15 percent to about $85 million.

The Korean television market has split over the last few years. Cable television, floundering for years after its founding in 1994, finally got its act together recently, as American shows gradually built a major following. American imports were all but irrelevant by 2000, but then *Friends* became a surprise hit in syndication. *Sex and the City* was even bigger, becoming especially popular with young women. Slowly the stodgy TV executives began to take notice. *CSI* became an even bigger hit, and now all manner of American dramas command top dollar on cable. The free-to-air networks are home to the local dramas, leaving cable for foreign programming, which is now considered much more fresh and appealing than the tired local shows. Most everyone recognizes this trend, and top producers have been trying to adapt the newest storytelling ideas from the West (*Grey's Anatomy* alone led to a mini-burst in medical dramas), but to mixed success thus far.

While the world is increasingly intruding into Korea, Lee is beginning to look to the world. He has a role in Anh Hung Tran's new thriller *I Come With the Rain*, for instance, and a small part in the movie *G.I. Joe*, an American production. Lee says he is interested in trying out Hollywood, too, but only if he can avoid relying on the martial arts or any of the usual Asian clichés that Hollywood likes to wallow in. He also is not interested in being the token Asian guy brought into a mainstream movie just to help with marketing in that part of the world. He is not going international because it is the hot thing to do or because he has something to prove. Lee is just looking for the best roles he can find. "You can't think about what will appeal internationally," he says. "I make the stories I would want to see." He is not just trying to grab money as fast as he can. Rather, Lee is building his career steadily and carefully. Professionally.

To that end, like many in the entertainment industry, Lee is taking control of his own career, setting up his own company rather than relying on others. BH Entertainment just opened in February 2007, and, in addition to marketing Lee, it also represents several other actors internationally, including Choi Ji-woo and Shin Hyun-joon, and it represents the Japanese singer/songwriter/actor Hakuryu in Korea. His goal is to help develop a more Western-style management system in Korea, instead of the more controlling and meddlesome version that has evolved over time. BH Entertainment is located inside one of the many new, funky concrete offices that dot the Apgujeong region of Seoul, right across the street from the new CJ Entertainment offices, which are as much a center of power now as any place in the Korean entertainment industry.

These days, plenty of people have gone independent. Not just actors setting up their own private management companies (although several have), but producers and others at all levels of the entertainment industry. When Lee Byung-hun started in the industry, the networks were the only game in town. They hired actors, paid their salaries, produced and financed the programs, and did it all. Over the years, various members of the film community have taken on more and more pieces of the process and set up shop on their own.

Kim Jong-hak was one of the first, establishing Kimjonghak Production in 1998, following his disastrous attempt to move into the movie business with CJ Entertainment. At Kimjonghak, Kim brought

together some of the biggest names in television writing and directing, including his regular writing partner Song Ji-nah, as well as Jang Jin, Lee Byeong-hun (*Hur Joon, Dae Jang Geum*), Kang Eun-kyung (*Hotelier*), Yoo Cheol-young (*All In*), and many more. Some Kimjonghak programs include *Beautiful Days, Full House, The White Tower*, and *Fashion 70s*.

Yoon Seok-ho also created his own company, Yoon's Color. A former actor and composer, Song Byung-joon formed the Eight Peaks Contents Group, which made such shows as *Sorry I Love You* and *The Princess Hours*. Lee Jin-seok (*Love Story of Harvard, All About Eve, Sunflower,* and many more) created JS Pictures. Lee Kwan-hee (*Love of a Thousand Years*) formed LKH Productions. Some spinoffs are even creating spinoffs, as Yoon Shin-ae left Kimjonghak to create Apple Pictures.

All those new, independent production houses are continuing to push the development of the entire industry, but the changes do not come easily. Once again, the industry finds itself in a period of transition, as spiraling costs and salaries are threatening to take another major leap. Epic miniseries can cost $200,000 per episode now—nothing compared to Hollywood, but far more than they used to cost in 1991 when Lee started. Lee shocked much of the industry when he received a 2-million-won ($2,000) per episode contract back in 1995. How times have changed. By 2003, the top rate had risen to $10,000, and, in 2005, stars' pay was climbing past $20,000 per episode. These days, there are thirty actors who get between $20,000 and $50,000 per episode, and four who get over $50,000 (Lee Young-ae, Jang Dong-gun, Bae Yong-joon and, of course, Lee Byung-hun).

If ancillary rights are factored in, those rates can climb even more—much more. Bae Yong-joon is starring in Kimjonghak Production's epic series *Taewangsasingi* (also known as *Legend* and *Four Guardian Gods of the King*, depending on who you ask). The show was originally budgeted for an impressive $10 million for twenty episodes, but after Bae signed on, the budget soared to $30 million (and unexpected overruns have taken costs north of $46 million). This is a very special case (because of Bae and his continuing demand in Japan), but Yellow Films has several projects in the works that similarly push TV budgets to territories never dreamed of. Many producers, like Eight Peaks' Song, say this escalation is killing the TV

industry; but let's face it, if the presence of an actor can turn a $10 million production into a $46 million epic, he is going to get a piece of that action.

Now Lee, too, is poised to star in his own big-budget television series. Called *Iris*, it is a $22-million spy series developed by Korea's top action filmmaker Kang Je-gyu. Like *Taewangsasingi*, *Iris* is being made outside of Korea's traditional TV-network system, relying on international interest to make a profit. It will be Lee's first TV series in five years and a clear sign of how Korean television is increasingly following the lead of the movie industry (more ambitious, high-risk, high-reward projects).

These big-budget series are still an exception, though. For most dramas bought from outside production companies, the networks can afford around $100,000 to $150,000 per episode. But a network can easily have a drama in which the top two actors get $20,000 per episode each, as do the writer and the producer—that is $80,000 per episode just to get started, or around eighty percent of a $100,000-per-episode budget. Product placements and international sales can help, but clearly the economics are out of whack, especially as outside production houses get ever more aggressive, raising rates to snap up the biggest names.

As budgets soar, foreign sales grow ever more important for producers to break even. But even as international money grows more important, it also grows more uncertain, as the Korean Wave has faced a growing backlash for a couple of years now. Government officials in Taiwan, China, and other Asian countries have talked of putting quotas on Korean content or otherwise restricting it if Korea does not import more of their programs. Some in Japan considered the whole Korean Wave to be an artificial trend, manufactured by the nation's leading advertising firm Dentsu (I have seen no evidence to back up that accusation, and believe that evidence suggests otherwise, but nevertheless, the feelings exist among some people).

In fact, Lee and his managers balk noticeably at the word hallyu, preferring not to use it at all. After all, a defining trait of a wave is that for every peak there is a corresponding valley. Business is up, business is down, and nothing really changes. Lee prefers to think of his career and the industry in general in terms of growth, not waves. Globalization, not a Korean fad. Acting is acting, and all the other

stuff does not matter to him very much. He is trying to be professional. For Lee and his team, the Korean Wave cannot die because it never existed in the first place.

So if the success of Korean television dramas around the world is about globalization, does that mean success is just a business development, unrelated to the content of those programs? Of course not. What one says is as important as how one says it. And if there is a theme that runs through Korean television drama, it would be the great and ambiguous emotion called *jeong*, a kind of empathic love. The idea of jeong exists around much of Asia, as the Chinese character is the same in Japan and China: 情. However, the word's meaning in Korea is bigger, broader, and more powerful, as well as more ambiguous (the Japanese *jyo* is more about sentimentality, while the Chinese *qing* is more about loyalty). Jeong is like kindness or love, but it also means sympathy, attachment, and obligation. Jeong is not just an emotion you feel, it is a condition that possesses you. Jeong is not just your emotion, it is a relationship, an interaction of emotions between two people, a denying of the self in favor of the bond.

For Lee, jeong used to be an integral part of television dramas. In *Beautiful My Lady*, jeong meant Lee's character, Jun-ho, standing by his love for Sun-young, despite repeated rejections by her unsympathetic family, as well as secretly visiting his estranged mother without ever revealing who he is. *Fragrance of Love* looked at three love relationships in a single mother's family, examining the various combinations of complications and joys in their lives. In *Beautiful Days*, Lee's character Min-chul's arrogance and hard exterior

A Night at the Opera
When coloratura soprano Sumi Jo recorded Verdi's *Un Ballo in Maschera* with Herbert von Karajan in 1988, the performance made her one of the first Asian opera singers to become a genuine hit in the West, releasing forty-six albums that have sold over 4 million copies.

Photo by Cho Sei-hon

Stepping Up • 131

crumbles before the gentle and giving Yeon-soo. His movies, too, show signs of jeong (although in general, jeong is not as central to film as it is in television). *Harmonium in My Memory* was very much a jeong tale, of a schoolgirl's crush on her teacher and the ways she expresses her feelings, and *A Bittersweet Life* can be summed up as jeong betrayed.

These days, jeong is less fashionable a topic, as television shows prefer the thrilling affairs of doctors and the sinful thrills of affairs. "Old dramas used to show jeong all the time, but modern society does not feel the need for it so much anymore," Lee says. "Jeong is the opposite of individualism, and as Korean society modernizes, jeong is slowly disappearing."

From unknown to one of Korea's biggest names, from modest minor characters to charming heroes, Lee's career has followed Korean's entertainment industry over the years. Whether looking abroad for new opportunities or tackling ambitious new television series at home, Lee gives off the sense of someone seeking a bigger stage, of someone looking how to take his career to the next level. Just like the Korean entertainment industry.

The Music Mogul

Take a walk through Seoul's trendy Apgujeong district, continue past the flashy video walls of the Galleria Department Store and up the slight hill. Just next to the posh shopping center you will come across a nondescript doorway to a faded, unassuming four-story yellow building that is home to the biggest music machine in Korea. On most days you can find packs of high school girls lurking here, abuzz with energy as they mill around the sidewalk and side alley, coordinating movements through their cell phones, eyes darting up and down the road on the constant lookout for minivans with heavily tinted windows that signify the approach of their favorite singing stars. This is the headquarters to SM Entertainment. "SM" as in "Lee," as in Lee Soo-man, former pop star, former star deejay, former computer engineer, and founder of the most successful music label in Korea. The names of the SM Entertainment singers and groups are some of the most famous from Korea. H.O.T, BoA, Shinhwa, Dong Bang Shin Gi, Fly to the Sky, and SES were all huge in Korea and around Asia, with their catchy, high-energy pop songs and/or rich ballads.

Music anywhere can excite the passions like no other art form, particularly among young people. If people prefer a different style of painting than you do, most people can overlook that. If they have different tastes in literature, well, different strokes for different folks. These are subjects we can debate. But if someone does not like your

favorite singer? Sacrilege! Infidel! It is a strange dichotomy. On the one hand, pop music (particularly the Asian brand) strikes many as saccharine and derivative; on the other, people like what they like, and just because one person might not like something does not make another person's passion for it any less strong or real.

Even by the powerful standards of music, however, young South Koreans have long been some of the most intense, crazed fans around. When a few hundred schoolgirls start shrieking in unison, the sound can make you want to lash yourself to the mast of a ship like Ulysses (what a shame there are not more ship masts lying around). Fans surround the stars' apartment all day and night, singing their favorite songs, disregarding neighbors' pleas to quiet down. And woe to the poor woman who dates one of these young heartthrobs, as she earns the deepest hatred of the stars' thousands of fans. More infamously, when New Kids on the Block came to Seoul in early 1992, around 100 girls were hurt and one even died when fans rushed the stage forty minutes into a concert.

Lee Soo-man has for nearly twenty years been Korea's most consistently successful pop music mogul—although I'm not sure whether that is a compliment or an accusation. With his short, well-gelled hair, nice clothes, and big toothy smile permanently etched on a tanned face, Lee looks every inch the success. Even now, in his mid-fifties, he is confident and fit enough to wear his shirts a couple of buttons open, a thin gold necklace peeking out. He is relentlessly positive about nearly everything SM—the past, the present, the future, all are going great. SM Entertainment is the most important and successful entertainment company in Korea. Maybe all of Asia, who knows? Lee Soo-man is a confident man, with a lifetime of experience to back him up. In fact, all the way back in the 1970s, long before he ever even thought of starting a music label, Lee was already winning awards and filling the pop charts with hits.

Schoolhouse Rock

Lee Soo-man was born in Seoul toward the end of the Korean War, in 1952. He moved to mountainous Gangwon Province with his family when he was just two years old, before returning to Seoul for

high school. Lee grew up in a musical family, his father a high school math and science teacher, his mother a classical pianist. Although his mother disapproved of folk and rock ("What kind of melody is that?" he remembers her asking derisively) and other newfangled musical styles emerging in Korea in the 1960s, Lee enjoyed them all. From America, he liked Bob Dylan and Peter, Paul, and Mary. From Korea, he liked Shin Joong-hyun (the godfather of Korean rock music) and remembers seeing Kim Choo-ja sing at his high school. "When I saw The Pearl Sisters, with their singing and dancing," Lee told me, "I thought that was the style for me."

He learned guitar and played it in church. One of Lee's earliest public performances came in his second year of high school, when a nearby girls' high school asked him to play there. "It was hard for girls to meet boys," he said, explaining the invitation. At that first show, he played "Crying in the Rain." "These days, friends say they remember me drinking and smoking cigarettes," he said. "But I never did. I only studied and went home. But because I was popular, that is what people think."

In 1971, Lee Soo-man entered Seoul National University, the best university in Korea, to study the very unmusical field of Agricultural Machinery Engineering. But soon after starting school, an older friend of his, Baek Sun-jin, asked Lee to form a folk duo. They called themselves April & May and were quite a hit on the university music scene (which is kind of like its own genre in Korea).

With the success of the band, however, Lee's grades suffered, and he barely passed his courses that first year. He had originally wanted to travel to the United States to study, but back in the 1970s, Korea had many restrictions on going abroad, including at least a B+ average. More seriously, his parents disapproved of his singing ambitions. Getting into SNU has long been considered the key to success in Korea, especially back in the 1970s, and anyone who passed the insanely difficult application procedure was not supposed to fritter away the opportunity playing silly songs for silly young people.

So Lee left the duo, took a year off from school due to health reasons (which also kept him out of the military, fulfilling his service obligation with an office job instead), then returned with a dedication to study hard. His newfound focus on his studies paid off, and his grades were strong enough to earn him a scholarship for both

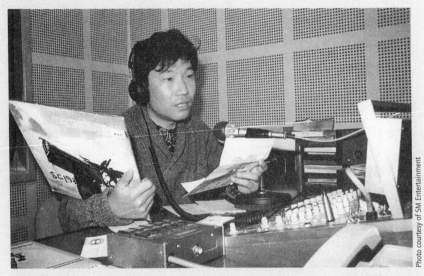

Lee Soo-man was a popular singer and TV and radio host in the 1970s and 1980s before he became Korea's most successful music mogul.

sophomore and junior years. Unfortunately, those good grades were not enough to offset the lousy grades of freshman year, and his plan to travel abroad came to an unceremonious end.

Incidentally, Baek Sun-jin would continue the band, bringing in a new singer, Kim Tae-poong, to take Lee's place. The new April & May did quite well for several years, before a marijuana scandal in 1975 forced the band to break up. Actually, 1975 was a huge year for pot scandals. In fact, marijuana had long been part of Korean culture—fibers from the hemp plant were used for clothes, and the fun parts were smoked for Korean traditional medicine. But Korea's three decades in the American sphere of influence were adding up, until President Park Chung Hee decided it was time for his own war on drugs (well before the war on drugs was cool in America). Over fifty celebrities were rounded up over several months, including the godfather of Korean rock music Shin Joong-hyun, effectively derailing his career. Many people said they had no idea it was even illegal in Korea at the time. Both Baek and Kim soon left Korea to study abroad and get away from their problems. Both are also successful businessmen today.

Lee now faced a difficult decision to make about his future. If he stayed in academia, he could do all right, but who dreams of a career

in agricultural machinery? Traveling abroad was out, given his me-diocre grades. And his parents did not approve of singing.

But then, in 1975, during the summer vacation period, the TBC radio station offered him a deejaying job, hosting the music show *Viva Pops*. At first he turned down the position, but after a little re-thinking changed his mind and took the job. The show was a big hit. Back in the mid-1970s, radio was huge in Korea. Television was too new and expensive and many people did not have TV sets, but ev-erybody listened to the radio. Succeeding on radio could make you a major figure on the national scene, fast. Certainly the money was better than in academia. And just like that, Lee was back in show business.

He began singing again, sometimes with a band, sometimes sing-ing folk by himself on guitar. In 1976, he won a university singing contest on the MBC television station, winning the Best New Singer award. The next year, he was selected by MBC as one of the top ten singers in the country, and won Artist of the Year by the show *Monthly Pop*.

He graduated from SNU in 1979 with his Bachelor of Science de-gree. It had taken him nine years to get through university, but that is what military service and a big singing career can do to your studies. For a year, Lee did basically nothing, but people began to push him to record again. This time, though, his style changed. Seeing that folk was on the way out, he tried a more rock style.

Nineteen seventy-nine was also an important time because that was the year Park Chung Hee was assassinated. Park had led Ko-rea through an amazing economic revolution, changing the country from one of the poorest in the world to a rapidly rising economic tiger, but in the process had increasingly turned up government op-pression. With his death, for a time the mood in Korea lightened and the rules loosened.

For a year, Lee had done nothing. With government rules loosen-ing, he was able to apply for and receive a visa to study abroad, but Lee was not convinced that was what he wanted to do. Then MBC made him an offer he found intriguing—host his own television talk show. Kind of a TV version of his old radio show, *Together With Lee Soo-man* aired on Wednesdays at 10:00 p.m. and was quickly an-other hit to add to Lee's resume.

But the flowering of openness in Korea was all too brief. In 1980, military officer Chun Doo-hwan declared martial law and disbanded the National Assembly, making himself president. He soon began to crack down on dissent and the media once again. As part of his campaign to tame the media, he told broadcasters to reduce the number of talk shows. Quickly, the number fell from eleven to three. After just ten episodes, *Together With Lee Soo-man* was taken off the air. For a couple more months, Lee continued with a Saturday night show, but that too was removed, and soon after, Lee's TBC radio show also got the axe. It was a stressful time for him, as he began to worry that he was in the government's sights. He stopped eating properly and got sick. Clearly, Lee could not go on like that.

Living in America

With things looking bad for him in Korea, Lee decided it was a good time to use his student visa, so he moved to the United States. At first he went to Melbourne, Florida, to study electrical engineering at the Florida Institute of Technology but found the culture shock too intense. His English was too poor and the stores were so different from Korea's that he could not even figure out how to shop. So he transferred to California State University at Northridge, where he studied computer engineering, working on an early computer optics project that he says eventually turned into part of the Patriot Missile guidance system.

Despite the hard work and the culture shock, Lee liked his life in California. He felt free—free from the government and free from people, too. In Korea, he was a celebrity. In California he was not. Nobody knew who he was.

Free, yes, but he was also lonely. Fortunately, music would once again be his solution, as it helped him to meet his wife. She had been born in Korea, but her family had emigrated when she was quite young. Later, she became a design student at the University of California, Los Angeles. The Korean student association at UCLA learned that Lee was attending graduate school at Northridge and invited him down to perform. Lee's future wife was a friend of the woman who organized the event, and although she was nine years younger than Lee, he was right away quite smitten. He did not get

a chance to get to know her then, though, and after his concert returned to Northridge. Time passed, and during the summer vacation a few months later, he returned to UCLA to use the library, where he bumped into her once again. This time they hit it off, and after dating a few months were quickly married.

As Lee finished off his master's degree, he thought about what direction he would like his life to go. Although he liked his life in the United States, he also realized that there were plenty of Koreans with PhDs, many of them from better schools and with better prospects. A career in engineering would probably mean a life in America, and he wanted to return to Korea.

And, after all, how many young singing stars graduated from Seoul National University? "There was no one in Korea like me," he thought. So Lee decided to return to Korea and the entertainment industry.

Lee's five years in the United States coincided with one of the biggest changes in popular music since the Beatles—MTV. The music video channel (back when it still played music videos) was new, fresh, and exciting to Lee. It made him look at the entertainment industry with a fresh perspective. It certainly says a lot about the state of the Korean music industry at the time that anyone could look at the U.S. pop market and think artists were treated better in America. It was the age of the *Solid Gold* lip-synched TV show (and, of course, the Solid Gold Dancers), skinny ties, big shoulder pads, and bigger hair. It was the age of tinny bubblegum pop and cheesy lite metal bands. It was the age of Michael Jackson. Lee soaked it all in and decided that there was a lot Korea could learn.

Prelude to a Revolution

Despite his background in folk and rock music, Lee had dance music on his mind when he returned to Korea, The flashy clothes and dance moves of American pop stars made for exciting television, and Lee thought the combination had huge potential. However, the music scene had changed during the years he had lived abroad, and those changes would greatly affect Lee's plans for the music business.

Lee just wanted to make music, but quickly realized that in order to do so, he would need to become a manager and have a nice studio

of his own. Both would require a lot of money. After five years study-ing in the United States, and not working, money was not something he had a lot of. So, in yet another professional zigzag, he opened a restaurant. Much as the conglomerates behind CJ Entertainment and Showbox started in confectionary, then used their knowledge of consumer tastes to move into the movie business, Lee used his experience in show business to move into food. Called Hemingway, the restaurant opened in what was then a dilapidated part of Wol-mido, at the edge of Incheon by the sea. Today Wolmido is a popular tourist location, but back then, it was dusty and unpaved. The only restaurant in the area that did not sell fish, Hemingway became yet another hit for Lee. He has long since sold the restaurant, but it is still there today, under different ownership.

In addition to money, Lee knew he would need to rebuild his connections. Right away he resumed deejaying on the radio, which helped reconnect him to the local scene. In addition, he began host-ing TV shows from time to time. In 1988 he was soon able to open a studio (called SM Studio) in the then-distant southeastern Seoul area of Jamsil, but it would take several years before his budding music company would burst on the scene and return Lee to prominence

The Golden Age of Korean Rock

n the cluttered basement of his home, in the quiet countryside an hour south of Seoul, practices a white-haired man who just happens to be South Ko-rea's greatest rock star. Or, at least, he used to be.

In the 1950s, '60s, and '70s, Shin Joong-hyun was pivotal in introducing his countrymen to rock'n'roll, writing many of the nation's most popu-ar songs for the most popular stars—but after he an afoul of Park Chung Hee and Korea's military government of the 1970s, by the 1980s, music trends had passed him by.

Shin has the quiet confidence of a man with nothing to prove to anyone. The cocky, almost Johnny Cash-like swagger he once carried in his heyday has mellowed with age, his long, dark hair now white and crew-cut short. His style is casual. The studio behind his house is handmade ("My band members are good builders," he jokes). After

I became horribly lost and rather late trying to find his out-of-the-way home, hidden among rice fields and tiny roads in the middle of nowhere, Shin just laughed into his cell phone and said: "Whenever you can get here is fine."

Shin was born in 1938 in Korea. His mother died when he was quite young, and his father, a barber, soon remarried, to a Japanese beauti-cian. When Shin refers to her as "that woman," he sounds neither affectionate nor bitter: it's just the way things were. The family spent several years in Japan and Manchuria before returning to Korea, to the Chungcheong Province countryside after World War II was over. The family was not a musical one, although Shin fondly remembers their old, hand-cranked, German-made phonograph.

His father died in 1952, and "that woman" soon after in 1953. Orphaned, Shin sent his brother to

again. In the meantime, the industry was continuing to change. Nobody knew it, but there was a musical revolution coming.

For years, the studios had dominated Korea's music scene, doubling as the music labels, too. The studios controlled the stars, the songs, and the hits. The dominant company at the heart of the industry was Seoul Studio. Seoul Studio was founded by Choi Sung-doo way back in 1946 and for years had been *the* place to make music, famous for its thumping bass and kick drum. It defined the Korean music sound, especially in the 1980s, creating sounds that were instantly recognizable, even on someone's cheap radio or market sound system (thanks in part to the Solid State Logic compressor the studio installed in 1984, the only one in Korea at the time).

Under the studio system, the engineer actually controlled the sound. Producers were more like "executive producers," concentrating on business and promotion, less involved with creating the music. As the 1980s went on, producers were growing in importance, but that reflected changes in the music business, not a producer's say over the music itself.

As for the music itself, the late 1980s were beginning to show signs of life. The oppressive Park Chung Hee and Chun Doo-hwan

live with relatives, then moved to Seoul. The post-War years in Seoul were tough. Shin woke up at four o'clock each morning to work in a pharmacy, then went to night school in the evenings. At night, in between, and any chance he got, he taught himself guitar.

Soon Shin was good enough at the guitar to find work teaching at a music institute in Jongno, the center of old Seoul. His reputation grew quickly, and someone suggested he audition to play for the U.S. Eighth Army.

In 1957, he started playing rock music for U.S. Army bases (under the name "Jackie Shin"), where he would continue for ten years. The American Army circuit was a godsend for musicians then, with plenty of clubs (jazz standards for the officers clubs, more country music for the NCOs, and rock for the enlisted men) and decent pay.

"The American bases are where Korean rock developed," Shin says. "At the time, Korean clubs

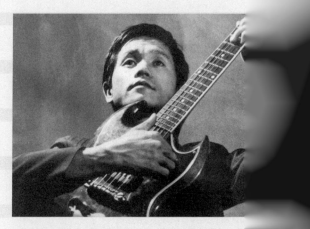

only played 'trot,' tango, music like that." Shin still remembers the music he most liked to play then: "Bill Haley's 'Rock Around the Clock,' 'Guitar Boogie Shuffle,' Duane Eddy's '40 Miles of Bad Road.'" He was a big fan of Elvis, and after seeing the movie *Love Me Tender*, Shin bought a denim jacket

eras had done much to destroy the best of Korean music, as the government censored and banned music for threatening national security, "thoughtlessly following foreign trends," or being too depressing or immoral. Basically, anything that rock stars like to sing about. Inoffensive ballads and trot (*enka*, called *ppongjak* in Korean) were the main music genres for much of the 1980s. But when Chun Doo-hwan left power in 1987 and the 1988 Olympics introduced Korea to the world, the environment at home began to change. Politically minded singers, like Kim Min-ki, were gradually unbanned. And, much the same way the movie business enjoyed the first signs of a comeback, the music industry also began to wake up. Singers like Kim Hyun-sik, Shin Seung-hun, and Park Jung-woon were beginning to sell in bigger numbers than ever before—2 million, even 2.5 million copies. Some of the first graduates from the Berkelee School of Music were returning to Korea, bringing a top-notch knowledge of music, production values, and the like.

One Berkelee grad, Koh Young-whan, almost stumbled into the local scene. Fresh from working at the famed Clinton Studio in New York, helping out on projects by the Count Basie Orchestra and George Benson, Koh came to Korea for a little backpacking vacation

and practiced shaking his legs and playing like the King. "But I could never get it right," he says. "I was very disappointed in myself."

Gradually, rock music spread from the army bases to the rest of Korea. In 1961, Shin formed Korea's first rock band, Add 4, but Korea still was not ready to embrace the rock sound.

Mainstream success eluded him until 1968 when he produced an album for two high school girls who called themselves The Pearl Sisters. That album, *Nima*, was a huge hit, and soon made Shin a star, too. Over the next seven years, Shin and the singers he produced released many hit records, usually with his signature "fuzzy" guitar style, spacey organ sounds, and a healthy dose of the psychedelic.

In 1972, near the peak of his fame, however, he received "the phone call"—it was the president's office on the line. Asked to write a song glorifying then-president Park Chung Hee, Shin refused. "I

was young and I didn't like the president," Shin explains. "I was upset he never returned the power to the people, like he said he would when he came to power. I think I did a good thing, not writing that song. If I did, I could never have been here now."

The president's office did not ask again, and when Shin then wrote the song "Areumdaum Gangsan" (Beautiful Mountains and Rivers), officials considered it blatantly disobedient and impudent. Soon after, police officers and government agents began following and harassing him. First they said he could not wear his hair long, then they began to censor and ban his songs. "Mi-in" (Beautiful Woman) got the censor's axe for being "too noisy" and "vulgar."

Finally, in August 1975, Shin was arrested for, in Shin's words, "being involved with marijuana" (part of the same busts that took out Lee Soo-man's old music partners in the band April & May). "Yeah, I experimented with marijuana in the 1960s, but

in the summer of 1990. He stopped by one small studio in south-western Seoul to say hello to a friend, but at the studio he met the great Korean rocker Kim Hyun-sik, in the last throes of cirrhosis of the liver. It brought Koh to tears, to see such a legend in such terrible shape, dying while sitting with a bottle of soju. Right then, he called home to tell them he would need another month to work on Kim's album. Koh spent several nights working on the studio's equipment, figuring out how to replicate Seoul Studio's thumping bass on the cheap console. He also got the musicians playing together (partic-ularly the rhythm section), instead of locked in individual booths playing from scores like a machine. The changes worked and helped create a lively new sound that worked especially well with dance music. As the sales of Kim's album took off, Koh suddenly found himself in high demand, and before he knew it, he had a thriving career as an engineer and producer in Korea.

Then came the pivotal moment that changed everything—Seo Taiji. It would be difficult to exaggerate how huge the Seo Taiji phe-nomenon that hit Korea was, bringing a dance/hip-hop hybrid to the screaming masses. It was fresh, exciting, and different from any-thing Korea had ever seen before. During the Seo Taiji phenomenon,

just for the music," he insists. "After getting high, I could see, 'Oh, that's where this music came from.' I could see how it looked bad on the outside, but I didn't care. I just wanted to learn about the music. But I could see how a lot of reporters and critics might say I'm the reason for the fall of Korea."

Following his arrest, Shin was banned from per-forming in Korea for years. Sympathetic fans on the military bases helped ensure he always had a place to play, even if it was just a small, solo show, but still, it was tough for Shin to make a living.

Only with Park Chung Hee's passing, in 1979, was the ban on Shin finally lifted, but he discov-ered a greater obstacle in his path—time. The rock trend passed by in the late 1970s to be replaced by a curious blend of disco, modern synthesizers, and a return to the old trot tunes that Park Chung Hee had enjoyed—it was the start of the bubble-gum pop and syrupy ballads that have ruled Korea ever since. "It was all, 'Let's work hard,' and 'Let's be

happy' kind of stuff," Shin says, with a soft, matter-of-fact bitterness. "It was completely physical, with no spirit, no mentality, no humanity. That trend has carried over all the way to today, so people are deaf to real music. They don't know because they are never exposed to it."

Shin tried to update himself, making disco ver-sions of his old hits, but his era was gone. In the 1980s, he opened a live music club that did well in the foreigners' enclave of Itaewon, but he was forced out by his partner. In 1986, he opened anoth-er bar, Woodstock, in the southeast edge of Seoul and based there for twenty years. When Shin's son met Seo Taiji at Woodstock, Shin helped to usher in Korea's second great age of music. He released a few albums that sold modestly, toured from time to time, and taught at a local university, but Shin has for the most past, spent recent years quietly.

"I will never leave music behind. But I want to find my own direction. Something new."

hordes of young girls would surround Seo Taiji's family home in Yeonhui-dong, in western Seoul, scribbling praises to their idol on the outside walls and shouting out, "We love you, Seo Taiji!" Even today, the house still stands there (although the singer moved long ago), its thick coats of paint testament to the constant battle with his fans' graffiti. "There were two eras," Koh told me, "Before Seo Taiji and after Seo Taiji."

Seo Taiji was born Jung Hyun-chul, and had been into music from a young age. He was in several amateur bands while still a student, starting when he was just fourteen. When he was sixteen, he started hanging out at Woodstock, a bar in the southeast of Seoul owned by Shin Joong-hyun—yes, the same godfather of Korean rock music whose career had been killed in the marijuana crackdowns of the 1970s. It was there that Jung Hyun-chul met the veteran metal band Sinawe (lead guitarist Shin Dae-chul is a son of Shin Joong-hyun), sometimes jamming with them on bass. The next year, he was asked to join the band. Soon after, Hyun-chul dropped out of high school (about the most rebellious thing a teenager can do in education-obsessed Korea). He grew his hair long, changed his name to Seo Taiji, and for two years rocked with Sinawe, until the band broke up (for a time) in 1991.

Seo Taiji had for years been fascinated with electronic music and hip-hop but never had a chance to explore those genres in Sinawe. But around the time he left the group, he met a couple of young aspiring dancers, Yang Hyun-suk and Lee Juno. They shared an interest in hip-hop and dancing and decided to form a new group, Seo Taiji and Boys. Seo Taiji wrote all the songs himself, arranged everything, and did most of the recording at home, by himself, and finished it off in the studio. Just like that, at the end of March 1992, the first Seo Taiji and Boys album hit the stores.

The first album was called *Vol. 1, Nan Arayo (I Know)*, and it was quickly a big hit. On April 11, Seo Taiji and Boys performed the title track from the album on the MBC music program *Teukjong! TV Yeonye (Scoop! TV Entertainment)*, where singers would perform and a panel of judges would review and make comments. Kind of like *American Idol*, but without the, uh, everything. The show was squarer than *America's Funniest Home Videos*. At the time Seo Taiji had cut his ridiculously long hair to an almost respectable length, just

a few inches long (gelled plenty high, of course). He wore a simple black and grey outfit while Yang and Lee wore these strange green ensembles that looked like something out of an MC Hammer video. The audience sat in silence, somewhere between shock and confusion over the whole thing (which would be just about the last time any Seo Taiji audience was quiet). After the performance, the middle-aged judges sedately critiqued the bizarre spectacle they had just seen. "The rhythm is good, but the melody is bad," said one judge. "There's too much dancing, and the song is weak," said another.

Seo Taiji and Boys might not have won over the MBC judges, but they soon won over South Korean teenagers. The hip-hop rhymes and beats had a strong energy, while the group's soft, androgynous looks were both attractive and safe, non-threatening. That first single created the template for all of Korean pop music to come—hip-hop verses with guitars in the bridge and a melodic chorus. But even Seo Taiji was unhappy with how the album sounded, and that fall he returned to the studio to rerecord and remix the album. Koh Young-whan helped with the engineering on several tracks and was deeply impressed by the young star. Seo Taiji came to the studio carrying an old PC computer to sequence the songs, then just sat in the studio and remastered the whole thing. "He knew exactly what he wanted to do," said Koh. "His first album was already famous. The remake was about pride."

That first album may sound more Milli Vanilli than Timbaland to modern ears, but it is important to remember how new and important Seo Taiji was in Korea (also, it is important to remember that 1992 in America was the era of Kris Kross and Boyz II Men, so let's

Anarchy in the Hongdae
Crying Nut, the most famous example of "Chosun Punk," the local variation of punk music, built their name at the small, now-defunct Drug Club, which once called the western Seoul neighborhood of Hongdae home.

© Drug Records

not be hypocritical here). Seo Taiji struck a truly deep chord with Korean young people in a time of much social change. His comments about the failings of the school system and society were exactly what many people believed but seldom heard anyone in popular entertainment mention. Also, Seo Taiji backed up his words with his style as an artist. He maintained his independence. He wrote nearly all of his songs himself, rarely appeared on television, and never signed his life away to any manager or record label.

Seo Taiji's remix album came out that November. His second new album in June 1993 only increased his popularity. With each album, Seo Taiji added more guitar and metal influences, moving his sound away from dance and more toward industrial/hardcore, like a pop-ish Rage Against the Machine. But his controversial content kept the band in the spotlight and enormously popular. By early 1996, the group had released four studio albums, three live albums, and a best-of compilation. And then they broke up. Just like that, the Seo Taiji

The Reign of Rain

He's sold millions of CDs all over Asia. He has sung and danced in front of tens of thousands of screaming fans in Seoul, Bangkok, Hong Kong, Tokyo—even in Las Vegas and New York. As an actor, he has starred in hit television shows and a movie by art-house favorite Park Chan-wook, not to mention his appearance in the Wachowsky brothers' *Speed Racer* blockbuster. He has even "feuded" with Comedy Central mock newsman extraordinaire Stephen Colbert. He is the performer known as "Rain," and he is the biggest international star yet to emerge from the Korean entertainment industry.

Born Jung Ji-hoon in 1982, Rain grew up in a lower-class maze of concrete streets and redbrick, two-story buildings close to Shinchon, in western Seoul. He spent his days learning how to dance like the stars in the music videos, like Seo Taiji and the rest, neglecting his studies, and hanging out with other young kids who were also obsessed about dancing and were neglecting their studies.

A producer found Jung almost by accident when he was still in high school—caught him danc-

ing with friends—and asked him to join the boy-band FanClub. After two underwhelming albums, FanClub broke up, leaving Jung on his own, looking for a new record label. Throughout 1999, Jung auditioned for ten music labels, but no one was interested in the tall, slightly awkward-looking teenager. At the time, the main look for male singers in Korea was cute, like young boys who looked like they stepped out of the pages of a Japanese comic book. Jung did not fit the mold. Some producers even told him to come back after he had double-eyelid plastic surgery.

Jung's music career appeared over before it had barely begun when he finally caught a big break with JYP Entertainment. JYP was founded by singer Park Jin-young, who had several big hits in the late 1990s, mostly in the R&B/dance music genre, with a distinctive funk sound noticeably more soulful than most of the Korean pop scene. But Park was growing a little old to be a pop star and was looking for artists he could help develop. Unlike all the other music label scouts, Park actually liked Jung's

revolution was over. Yang Hyun-suk started a hip-hop record label, YG Entertainment, which continues to do quite well. Lee Juno has also produced various acts over the years and hosted radio shows. Seo Taiji moved to the United States, returning periodically to release a solo album, but he was hardly the dominant force he had been in the early 1990s.

Seo Taiji mania might have lasted only a short time, but the effects of his music would resonate for years throughout the Korean music industry. But precisely because Seo Taiji broke all the rules, it made turning his music into a formula very difficult. Geniuses and zeitgeist moments, while exciting, are not things you can build a business around. For the music industry to prosper and thrive in the long run, it would need a steady supply of hits and superstars. It would need a system. Which is what brings us back to Lee Soo-man.

Almost. Before I get back to Lee Soo-man's story, there is one more revolution that was taking place at the same time as Seo Taiji

look, especially his eyes. He said they looked like a tiger's eyes. For five hours, Jung danced for Park in a marathon audition, performing moves over and over again until he was on the verge of collapse. When it was all over, Park was impressed, and Jung had found a new home.

Passing the audition, however, was just the beginning. JYP Entertainment runs a tough level system for its star wannabes. After passing the audition, a prospect is at Level A. At Level B, the prospect moves into one of JYP's dorms and gets a manager, and the training gets even harder. The highest level is Level C, and after that the prospect becomes a full-fledged singer. At first, everyone learns the same subjects, but as prospects develop, they get individual training programs. JYP also insists that all its students attend university. Each month JYP holds private tests and showcases, and once a year hosts a public showcase. It is a long, grueling process, and it costs JYP up to half a million dollars for each student to work through the two-to-three year system.

For two years, Jung toiled relentlessly, working on his dancing and singing. At one point, he won

© J.Tune Entertainment

an unprecedented twelve monthly showcases in a row, which deeply impressed the bosses at the music label. He was clearly a rising star. Because Jung already had a strong background in dance, he focused more on his singing. But it was all tough. The whole time Park was very demanding. He rarely gave compliments, and told Jung, "If you don't do such-and-such, you can't make an album," and Jung would do such-and-such. Park even made the not-so-book-inclined Jung study and get into university (quite a task—Jung is a relentless trainee, but apparently not at all a fan of reading). "I

that absolutely needs to be remembered—karaoke. In Korea, karaoke does not take place in bars, in front of strangers. Rather, a person sings in a small room, with friends or coworkers or whomever. Koreans call these places *noraebang*, literally "song rooms." Ever since I came to Korea, I have been impressed by the omnipresence of the noraebang. Rare is the street corner without one. At some noraebang, you just sing with a plate of snacks, but usually you can order alcohol and more elaborate foods. At others, there are young women to entertain the men (and at a few very special places, young men to entertain the women). There are cheap little noraebang in residential neighborhoods, with faded furniture and depressing interiors. There are ultra-chic noraebang in the hippest neighborhoods, for big-business executives and celebrities and the like. They come in all styles and sizes, and they are everywhere.

Given the ubiquity of the noraebang, it is strange to realize just how recent the phenomenon is. With Korean music's centuries-old

thought if I could satisfy Park Jin-young, I would be able to satisfy anyone in the world," Jung recalls. Eventually, Park thought Jung good enough to at least begin as a back-dancer, both for Park and for female singer Park Ji-yoon. After a few months, Park even made Jung the choreographer for Park Ji-yoon. And the nonstop practice continued.

Finally, in May 2002, after three years of training, JYP was ready to launch Jung as a solo artist. In fact, Park had been preparing the album for some time before he told Jung about it, so once the decision was made, Jung's life changed quickly and radically. Park rechristened him under the stage name of *Bi*, Korean for "rain." Park had suggested the name, and Jung immediately took to it, finding rain evocative and a good fit for his style. The rain soaks you right through, envelopes you completely, and Jung liked the thought of having that kind of total impact on people.

His debut album was less than a smash hit, though, at least at first. It hit the shelves just a month before the 2002 Korea/Japan FIFA World Cup, and the hearts and minds of most Koreans were focused on the colossal event and their favorite sport. Sales were slow, but that fall, with the release of Rain's second single, he had a real hit, and began to grow into a major star. His first album sold about 180,000 copies, and while not overwhelming, it was a solid debut. His second album, released in 2003, did even better, and the third, made in 2004, was best of all.

Even as his singing career grew, Rain was also finding fame as an actor. Like many singers, he promoted his albums with many appearances on television and variety shows. He MCed events and starred in television commercials. In 2002, he was in a small show called *Orange*, but in 2003 he starred in a bigger hit called *Sang-doo! Let's Go to School*, and in 2004 he had his biggest hit of all, *Full House*. *Full House* really put Rain on the map, becoming something of a hit all over South Asia. The TV show and his third album reinforced each other, helping Rain sell over 1 million copies of his third album throughout Asia. Suddenly, Rain was not just another Korean pop star—he'd become one of the hottest acts around the region. Advertisers started calling, asking him to endorse products. MTV made him their star of the year on the MTV

emphasis on improvisation and personal interpretation, Japanese Daisuke Inouye's karaoke machine never really caught on here. Instead, most entertainment facilities featured live accompaniment, usually a guy on guitar, playing along with a synthesizer.

This changed in a huge way in early 1991 thanks to Hyeon Chung-dan, the enterprising owner of a video game arcade (*oraksil*) near Donga University in Busan, the southernmost city in Korea, the closest to Japan. Hyeon was an enthusiast for electronic gadgets of all sorts, and he used to travel to Japan frequently in search of new toys. In April 1991, he returned with a karaoke machine, figured out by himself how to put Korean songs into it, and then installed it in his arcade in a small glass booth with room for two or three people. Then, together with Yeongpung Electronics, he figured out how to display Korean lyrics on a monitor, so singers could read all the words. To say it was an instant hit does not begin to describe the impact. Within months there were hundreds of noraebang all over

Asia Awards, MTV Video Music Awards Japan, and MTV China Awards.

Rain has also moved into movies. He starred in Park Chan-wook's *I'm a Cyborg, but That's Okay* late in 2006, and in summer 2007 he headed over to Germany to participate in *Speed Racer*.

But more recently, Rain has been through some more challenging times. He left JYP Entertainment in May 2007, trying to make his own way, out from under the wing of Park Jin-young. But he discovered the path was more difficult than he imagined. He was sued in the United States by a Beatles tribute band also called Rain. Concerts were cancelled in Hawaii, Los Angeles, and elsewhere, harming his reputation.

© CJ Entertainment

Gradually, though, Rain and his team have been gaining a better understanding of what is needed to operate independently (and the true scope of all that JYP Entertainment did for him over the years). He signed up with Hollywood agent William Morris and has been courted by major music labels.

Despite his rising fame, Jung is a surprisingly gentle, low-key star. No drunken rampages through hotel rooms for him or his entourage. He has a shy-ness about him that is more quiet teenager than international pop star. Executives at his former music label called him the best star they ever had, a polite young man who would automatically do whatever was asked of him—practice, travel, fan events, anything—without complaining or asking why. Even though Jung is now twenty-five years old, he is clearly still figuring himself out, asking who am I? and what am I about? The answers to those questions will be the most important part in determining just how high Jung's star will rise.

Busan. By November, the government was encouraging their development, as a form of "healthy-minded" entertainment. The noraebang quickly spread, to Masan, Daegu and, by January 1992, they made it to Seoul.

The noraebang piggybacked off of Korea's ancient love of singing, but transformed it from freeform into the strictly regimented, regular world of electronic beats. The noraebang, combined with the new pop sounds filling the airwaves, plus the Seo Taiji revolution, created a whole new world for Korean music. But these elements were all just floating around chaotically and disconnected. Something big was happening, but what exactly was it? Enter Lee Soo-man, who brought all of these elements together and created the modern age of Korean pop music.

The Rise of SM Entertainment

From 1988 on, Lee had been trying to get back into the music industry. He had a radio program and hosted TV shows sometimes, and even recorded a couple of albums, but the music itself proved more elusive. He opened his first office and studio in 1988, in the basement of a new building in Jamsil, close to where much of the Olympic games were held that year. Soon after opening, however, a flood washed out much of the studio. "It was a total failure," Lee said, laughing at the memory.

But he quickly regrouped and set up the studio all over again. He decided that digital was the way to go: it was cheaper than analog equipment, and he thought the sound quality was the same (at least theoretically), so he filled the new studio with Akai equipment. Akai Electric had just started a professional studio division in 1984, called Akai Electronic Musical Instruments (Akai Professional today). After Lee stocked his studio with Akai equipment, he was surprised when the president of the Japanese company sent two more sequencers for free, even though the two had never met. This soon led to a relationship between the two companies. Lee says he used his engineering background to make suggestions to Akai on how to improve its machines.

The brand-new SM Studio in place, Lee decided to concentrate

on the bigger picture. Rather than write the songs himself, he hired a couple of classically trained composers who both had an interest in synthesizer-based music, one a Julliard graduate, the other a graduate of Kyung Hee University. Lee provided the direction, with a firm belief in the future of electronic dance music. He credits his deejaying job for keeping his musical tastes broad and in step with what audiences liked. First on MBC radio, then on SBS radio, he tried out different songs and types of music. He discovered that some songs that were not big in the West got a big reaction in Korea. Slowly he built up an understanding of what Koreans liked to listen to.

At the same time, he went looking for potential artists to promote. Ironically, one of the first performers he found was a young, dance-obsessed man named Lee Juno—the same Juno of Seo Taiji and Boys. Juno had spent much of the 1980s dancing in various clubs in Itaewon, then the center of foreign life and culture in Seoul. From the beginning, Lee knew that strong dance moves would be integral to promoting dance music, and Juno was a very good dancer. However, Lee never had much luck getting Juno's career started, and they parted ways in 1991.

Lee tried working with several other young singers, but his major find was Hyun Jin-young. Hyun was the first pop star to emerge from the back-dancing ranks. Lee discovered Hyun before he had yet turned twenty, a slightly built young man, just 5'6" tall. Hyun's first album in 1990, *Sad Mannequin*, had a very synthetic sound, somewhere between early Madonna and Paula Abdul, and did less than overwhelming business. But Lee kept on refining his techniques, confident he could find the right formula for his young protégé. He

First Korean-American
After a failed coup attempt in 1884, Seo Jae-pil moved to the United States and became the first Korean person to take American citizenship. Under the anglicized name Philip Jaisohn, Seo obtained a Western medical degree and became a leading proponent of Korean independence.

switched Hyun into baggier, more hip-hop-like clothes, raised the music tempo, and added a stronger rap feel. Released right on the heels of Seo Taiji's debut, this new effort struck a chord with teenagers and became a serious hit, especially the single "You in My Vague Memory." Unfortunately, SM was just producing music at the time, not distributing it. So when the album's distributor Seorabeol Records went bankrupt, SM ended up losing a lot of money.

Luckily, Hyun's third album, in early 1993, looked like it was going to be another big success: 400,000 copies were printed and selling well. Lee's career as a music mogul was taking off, and nothing could stop him now.

Nothing that is, except for marijuana. Like a blast from the past, once again weed would derail a promising music career, this time Hyun Jin-young's. At first, Lee was just confused and concerned for his young singer, who was suddenly snatched off the street. Lee worried that he had been kidnapped or something similar but then got in touch with a contact at the police station and learned about Hyun's drug charge. If the war on drugs was a new idea in 1975, by the 1990s it was a major taboo, firmly indoctrinated throughout Korea. Lee says he was shocked by the charge.

Just like that, Hyun's career was pretty much over. He completely disappeared from the entertainment scene for four years before trying his first comeback (with no help from SM Entertainment), this time as part of a hip-hop duo, but few broadcasters were ready to play his music. Depressed, he returned to drugs and has struggled with addiction on and off for years. In 2001 he finally released his fourth solo record, followed by a fifth solo project in June 2006.

Lee, however, was devastated. The loss of Hyun Jin-young nearly meant the loss of his company. He could not go through the endless promoting and developing of a new artist only to have it crash and burn around him. So Lee decided it was time to systemize his pop-star business. From then on, personality and character were as important as an artist's voice and dancing ability.

Not that voices and dancing were not still important. Lee put together the total package. He worked out a whole system for training and developing young people. He held auditions all over Korea and even outside of Korea, in the United States, Japan, and wherever large numbers of hip Korean teens were found. If a student passed

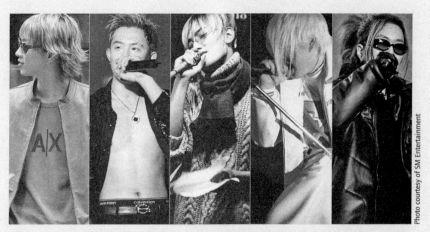

SM Entertainment's biggest group was undoubtedly H.O.T, or "Hi-five of Teenagers."

the auditions, he or she was brought into SM for training, taught to sing, to dance, to act like a star. Some students learned languages, too, to help their marketability in other countries. And, of course, he hired songwriters and producers to create the music upon which their stardom was based. In February 1995, he changed SM Studio into SM Entertainment, and his idea for a grand music promotion enterprise was really on its way.

Throughout 1995 and 1996, Lee worked on these ideas, refining his ideas, until at last he was ready to create the greatest pop package Korea has ever known. That group was, of course, H.O.T—which stands for Hi-five of Teenagers, in one of the most impressively forced anagrams ever (although there would be much competition for that category over the years). If Seo Taiji was the start of modern K-pop, H.O.T was the apex. They sold more albums than any band in Korean pop music, they had some of the wildest styles, and they had the most fanatical fans. Born between 1978 and 1980, all members had the looks and personalities that drive young girls wild.

An Chil-hyun came first, discovered at a Seoul amusement park when he was just fourteen years old. SM convinced his parents to let them develop their son into a star. Lee saw star potential in the young talent, but started him as a back-dancer for other performers. He took the stage name of Kangta, and soon became the face of H.O.T.

Moon Hee-jun came along next, having taken the more direct route of scheduling an appointment with the SM Entertainment

managers and auditioning. Like Kangta, he also began as a back-dancer, before getting the chance to front H.O.T. The oldest member of the band (if only by a few months), Moon began as the group's main rapper and was generally considered their best dancer, too.

Next to join the band was Lee Jae-won, the youngest member. Then came Jang Woo-hyuk, referred to SM Entertainment after winning a dance contest. And finally, An Seung-ho (better known as "Tony"), who attended high school in the United States, where he was discovered in a Los Angeles audition.

Their album was released on September 7, 1996, and immediately took off, selling 800,000 copies in the first 100 days of its release. "Candy" was the biggest hit, filling the airwaves for months with its catchy tune. In their early shows, H.O.T typically wore baggy hip-hop clothes in bright primary colors, often in a fuzzy plush, like a rainbow of teddy bears. Over time, they took on a more industrial edge, with dark leather and capes like out of a science fiction movie.

Like many SM Entertainment acts, H.O.T would release an album each year, usually in September (their second album was their only studio album to be released outside of September, in the summer). They also put out two live albums, a greatest hits package, and a movie—before disbanding in 2001. All told, they sold over 12 million albums in Korea alone, plus singles and albums around Asia.

The end of H.O.T, however, was almost as explosive as their life. The group's fans were among the most enthusiastic Korea has ever seen, and when the members decided to part company, those fans exploded with anger. Some egged SM Entertainment's headquarters. Bitter, even threatening, phone calls flooded the offices. They blamed Lee directly for the breakup. Word soon got out that the root of the breakup was money. The band members received as little as 10 won (about a penny) for each album sold. Even though they were the biggest selling act at the peak of the K-pop era, the members were receiving a pretty meager take-home pay.

Much is made of the artists' tiny royalty rates in these pop groups. But in SM's defense, we are not talking about musical artists in the Western sense. These are not singer-songwriters who started in small clubs and coffee shops and slowly built up a following. These are performers who were created by the labels—the labels (SM and others) discovered the performers, trained them, groomed them, produced

their albums, managed them, chauffeured them, and pretty much took care of everything. The labels have to do this not only for their stars, but also for the hopefuls. SM Entertainment alone has around seventy people in training at any moment, only a small number of whom will become genuine stars. In short, developing stars is expensive work.

On the other hand, stars are still stars. They have the power, and they drive the entertainment machine. And once their contracts were up, Jang Woo-hyuk, Tony (An Seung-ho), and Lee Jae-won all bolted to Yejeon Media, where they formed another alphabet band named JTL (after a combination of first-name and last-name initials). That band has since dissolved, but the three of them are still heavily involved in the music industry, whether as solo performers or in running other entertainment companies.

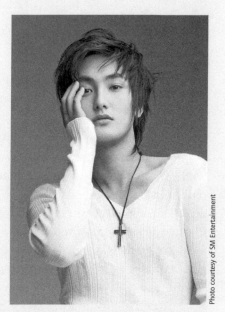

Singer Kangta released four solo albums and numerous duets and wrote scores of songs

Kangta and Moon, however, stayed with SM Entertainment, each getting much more lucrative contracts in the process. Both moved away from H.O.T's dance music focus, Kangta to more R&B ballads, and Moon toward guitar rock (albeit guitar rock with choreographed dancing still). Moon finally left SM Entertainment in 2005, creating his own label.

While many people disrespect boy bands, both in Korea and in the West, for being "artificial," it is surprising to note just how creative the guys in H.O.T are. As they grew up, all became more involved in the creative process. Kangta has written scores of songs, for himself and other singers. Several of the H.O.T alumni have also completed the cycle started by Lee Soo-man, starting up music labels of their own.

But SM Entertainment was about more than just H.O.T. Excited

by the success of his first big hit group, Lee kept producing new acts. In 1997, he moved the company to a large new headquarters in Paju, just outside of Seoul, with dance studios and music studios (the Apgujeong office opened later, in 1999). First came an all-female trio called S.E.S. in 1997. Then in 1998 came the boy-band Shinhwa, followed by the duo Fly to the Sky in 1999. And in 2000, the female singer BoA made her debut.

For years, Lee was painfully aware of how small the Korean market is. Even before Internet file-sharing hurt the music business, Korea's music sales were surprisingly small—just $300 million in 2000, versus $6.4 billion in Japan, and $14 billion in the United States. China was very small then, at $78 million, but with Hong Kong ($108 million) and Taiwan ($244 million) added in, Chinese-speaking territories' sales were quite substantial, and mainland China was growing quickly.

So Lee began thinking about acts that might translate to overseas markets. He opened branch offices in China, then Japan. In fact, SM Entertainment's official timeline immodestly states, "February 2000—"H.O.T China concert in Beijing (Korean Wave starts)." China was the big goal, the giant market just waiting to open, but the more immediate market was Japan. Even a moderate hit in Japan, whose music market is twenty times larger than Korea's, could mean some impressive revenues coming SM Entertainment's way. SM Entertainment had pushed S.E.S. in Japan, and H.O.T and Shinhwa had both performed abroad and had some success there. But no one would compare to BoA.

When Kwon Boa was eleven years old (by the way, I am stopping the capital "A" thing from here on), she accompanied her brother when he went to an SM Entertainment audition. He did not make it, but something about Boa caught the eyes of the audition judges and Lee himself. SM Entertainment convinced Boa's parents to let her go into training. In August 2000, her first album came out. It peaked at the No. 10 spot in Korea, selling a decent 220,000 copies—not H.O.T numbers, but not bad.

Then Lee began to concentrate on getting her ready for the Japan market. Boa started studying Japanese intensively, even living in Japan for a time to get full immersion in the language. He made a deal with the Japanese music power Avex Entertainment, one of the

biggest music labels in Japan, especially known for its 1990s dance music.

Boa's first Japanese album, *Listen to My Heart*, came out in March 2002, in the months leading up to the 2002 Korea/Japan FIFA World Cup, an international soccer tournament cohosted by Korea and Japan. The timing was excellent to introduce a Korean singer to the Japanese market. Boa's record was a hit, a million-seller, making her a bigger star in Japan than in Korea. Since then, five of her six full-length albums in Japan have gone No. 1, and all save the first were number ones in Korea (sales

Since making her debut at the age of thirteen, Boa has sold millions of albums and been Korea's biggest singing star in Japan.

for the young star have begun to decline over the past couple of years, though). She has also released two best-of collections, two remix collections, and thirty singles, many of which were hits on the Japanese pop charts (the singles market pretty much does not exist in Korea).

SM Entertainment's connection with Avex also had a surprising affect on Lee's company, quite apart from album sales. Lee credits Avex chairman Tom Yoda with the idea to take SM Entertainment public, which it did in 2000. Lee says the Japanese music mogul told him that being listed publicly is an important way to be taken seriously, to get credibility. It is a sign of size and steadiness, as well as a way to promote transparency and make sure the books are clean. Indeed, SM Entertainment was the first Korean entertainment company to be listed on the local stock market.

Since 2000, SM Entertainment has released many more acts, like Dong Bang Shin Gi (which is aimed more at the Japanese market) and Super Junior (with a startling thirteen members). However the year 2000 turned out to be a pivotal one for the music industry. The

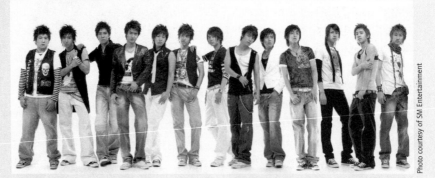

SM Entertainment's latest hit band Super Junior is so big (thirteen members) that it has sub-groups specializing in trot music, international touring, and more.

golden age of pop turned, and sales figures began to decline. Sharply. From $300 million in 2000, Korea's retail music sales dropped to less than $100 million in 2006 and less than $75 million in 2007. Most people in the music business blamed Internet file sharing and CD piracy. There is, however, much more to the decline than that simple explanation.

SM Entertainment, while a successful factory for creating new stars, has found it difficult to hold on to its top stars over the years. H.O.T broke up, with four of the five members going to other management companies. S.E.S. also broke up and went to other companies. Shinhwa and Fly to the Sky stayed together, but took their entire groups to competing labels. The years 2002 and 2003 were particularly hard on SM Entertainment, as top acts left and new acts were not performing as strongly as the old ones. The company's share price tumbled.

SM Entertainment's strategy for the future was twofold. One, to increase its international standing, and, two, to diversify beyond the music business. Music sales may have been poor in Korea, but movies and television were stronger than ever. SM Entertainment has merged with or bought out several media companies over the past couple of years, including a DVD distributor, a karaoke machine distributor, a music video channel, new media platforms, and more. SM Entertainment has become an all-around media conglomerate, with affiliates in just about every part of the entertainment industry.

Facing the Music Over the years, the pop music industry has come under heavy criticism on more than one occasion. Rumors of corruption and influence peddling plague the entire business. As the market leader, SM Entertainment has taken no small amount of criticism, too. It has even been raided by prosecutors, its computers and files hauled away (although no charges have ever stuck).

Such criticisms are, I think, too cynical and tend to miss the point. Has SME played hardball? At times, sure. Has the company made mistakes over the years? Certainly. But it is a mistake to blame SM Entertainment for failings that are structural and endemic to much of Korea.

For example, one popular complaint leveled at Lee over the years is that he used his role as deejay and television MC to excess to promote his own acts. Indeed, he continued hosting radio and television programs up until 1997, well after H.O.T and S.E.S. had become huge. The scandal here, however, should not be that he had influence over which stars were features on those programs. The real scandal is the system, which put so much power into the hands of the television networks in the first place. Lee successfully navigated a broken system, but he was not the one who broke it in the first place.

Another popular complaint against SM Entertainment (and the rest of the pop music industry) has been its lack of diversity. Nothing but bubblegum pop, all the time. But when it comes to diversity, the labels are chasing popular trends as much as they are shaping them. When Korean audiences begin to demand more sophisticated music, someone will step in to fill the void. Look at Japan, where, despite a huge J-Pop music industry, there is still a thriving live music culture, a healthy jazz scene, and more.

One huge reason for the lack of diversity in Korea is the decline of the live club scene. In the 1960s and '70s, the era when Lee became a singing star himself, the hip parts of Seoul and the rest of Korea had places one could see live music, particularly folk singers. Not many places, granted, but at least there were some. Government oppression and changing tastes led to the death of most of the live scene in the 1980s. The lack of a live music scene led to a further decline in catalog sales of older music, which in turn led to a greater emphasis on modern pop, the music of young people, and television

shows. Imagine what the Western music scene would look like if people had no interest in old Rolling Stones records or Jimmy Hendrix or whatever. Imagine if they only listened to current hits. While the latest pop hits seem to dominate the airwaves in the West, the fact is that selling well over many years is just as important to the financial survival of the music industry as having this week's megahit. More important even. While no one can guess what the next big hit will be, catalog sales remain consistent over time. And accountants especially like sources of steady revenue over the long term. Catalog sales are the foundation for the business. Starting in the 1980s, the Korean music industry became a house without a foundation. Its cornerstone was the idiot box, and it was laid on a bed of sand.

That decline in the live music scene further boosted the power of television in Korea. With just a handful of channels (cable TV would not begin until 1994), the free-to-air networks had enormous power. If you could play on a network's music show, the whole country would know who you are, so there was incredible pressure to get onto one of the precious, scarce media slots. Whenever a small number of people control the gateways, controlling so much power, there is an invitation for bad things to happen. Demand was high (many people wanted to do the same thing Lee did), and supply small (less than twenty music-related TV shows), causing relationships with the

Lucky Breaks: B-Boys and Dancing in Korea

Dancing has long been an integral part of the K-pop scene in Korea—Seo Taiji and Boys, H.O.T, Rain, and everyone in between is expected to have well-practiced moves to highlight their music. Usually these moves look vaguely derived from American and Japanese music videos, like what you might see from the boy bands popular in the late 1990s. Hardly at the cutting edge of choreography.

But something amazing happened around the turn of the millennium—Koreans got good at dancing. Really good. And not just those music video-esque moves. We are talking the real thing. B-boy dancing. Also known as breakin' and breakdancing. Koreans began winning b-boy competitions in Japan, Europe, and all over the world.

That's right. Breakdancing did not disappear in the 1980s, although the mass-marketed fad died a sad, ugly death. But b-boy dancing itself continued and grew, spreading to Europe in the late 1980s, and then to Asia and the rest of the world.

Breakdancing began in Korea in Itaewon and the parts of the country with a heavy American presence (mostly around military bases) back in the 1980s. It was there that Lee Juno and Yang Hyun-suk, of Seo Taiji and Boys, learned the art, and it was from their band that hip-hop-style dancing found the masses (albeit in a rather watered-down style). Since them, all major pop music acts in Korea were expected to perform some sort of choreographed dance.

Dancing became a true grassroots obsession for many around Korea in the 1990s. In the parks and

top media producers to become key to access. Drinks, girls, and cash payoffs were common throughout the Korean music industry. Golf trips to Bali and Thailand were not unknown, either.

For the record, Lee Soo-man adamantly denies ever taking part in that kind of corruption. Prosecutors cracked down on the music industry several times over the years, including 1995, 1999, and most seriously in 2002, when over thirty music promoters and TV producers were indicted or arrested. SM Entertainment's offices were raided a couple of times by prosecutors as part of much wider industry clean-ups, but the company itself was never found guilty of breaking any laws.

Radio, by the way, has had little power in Korea for a long time, since television overtook it as the center of most households in the late 1970s and early 1980s. Broadcasting regulations ensure that none of the nation's radio stations ever become too competitive with its neighbors. With no dedicated pop-music radio channels (all the stations in Korea have a mixture of programming), there were few outlets for pushing the musical envelope on radio. Basically, radio took its cues from television.

Adding to the problems in the music industry was the lack of reliable music charts. There never really were any vinyl or CD singles in Korea, so one could not measure their sales. Instead, people tried

shopping malls around Seoul and the rest of the country, packs of young people listened to music and practiced their moves for hours each day. That is the scene that Jung Ji-hoon, or Rain, came from. But it was all an abstraction of an abstraction, many steps removed from the source.

The big change came in 2000, when two Korean-Americans visited Korea, John Jay Chun from Seattle and Charlie Shin from New York. They were b-boy dancers themselves. They saw what all the young dance fans were trying to do and decided to help them. They taught steps and the real nature of b-boy dancing. And, perhaps more importantly, they left behind some videos of top dancers from around the world.

Two years later, those videos had been copied and recopied, thousands of times, forming the basis of b-boy dancing in Korea. In 2001, the Korean

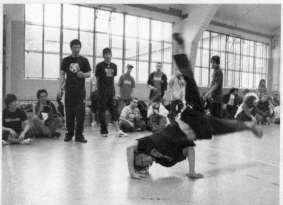
© Jay Lewis

b-boy crew Visual Shock won a show award in the Battle of the Year breakin' championship in Germany. The next year, another Korean crew, Expression, won the championship. Ever since, Korean teams

measuring TV appearances, call-ins, radio requests, and album sales, but the results were highly dubious, easily manipulated, and ever more reliant on television. It was like the music industry was creating a kind of feedback loop—what was popular was what was on TV, and what was on TV was what was popular.

Ironically, the revival of the music industry in the early 1990s in many ways hurt it further. Because albums began to sell well, a lot more money flowed through the system in general. Dance acts made for better TV, which fueled the trend still more. Although the money was increasing, the number of television networks was fixed at three. More money and more popularity with no additional outlets for that money and popularity put ever more pressure on those existing music programs, making them ever more lucrative and exclusive and vulnerable to pressure.

So people in the music business had to find stability elsewhere. Without catalog sales, they needed a nonstop supply of new hits, which moved the music business toward teenager music, to the fun, high-energy, low-calorie music of youth.

This trend in turn put more power into the television producers and music managers. No live music meant there were few outlets for singers and musicians to develop their craft, no places for people to discover new sounds, no room for experimentation and alterna-

have been winning breaking tournaments all over the world. Another Korean crew, Gamblerz, won the Battle of the Year in 2004, then another, Last to One, won in 2005, and yet another, Extreme Crew, in 2007. Last to One also came in second in 2006. Last to One were not even a big city crew, coming instead from the smaller Jeolla Province town of Jeonju.

Korean music companies were among the first to catch this wave, bringing on the top dancers to teach and dance with their acts. Advertisers quickly came calling too, using the dancers to promote everything from mobile phones to sneakers. Even the stodgy Korean government caught on after a while, and has turned into an enthusiastic promoter of the dance form. Now, Korean b-boy shows tour all over the world, like musicals.

So why has Korea become so successful when it comes to the modern world of b-boy dancing? It is something of a mystery, although people see several possible reasons.

Of course, there is the innate Korean nature to obsess and study and practice slavishly, traits that serve dancing well. And Koreans have a long history of succeeding at many kinds of dance. The Universal Ballet, based in Seoul, is generally considered one of the top dance troupes in the world.

But of more significance were the videos left behind by Chun and Shin. One of them featured the German dancer Storm, who is famous for his power moves—his flips and headspins and windmills. Not knowing any different, Korean dancers assumed that Storm's style was normal, so power dancing became the foundation of much of Korean dance.

Benson Lee, a documentarian who made *Planet B-Boy (2007)*, a movie about the Korean breaking

tives. Again, Korea was not always like that. There was a thriving live music scene in the 1960s and 1970s, but it was deliberately and systematically snuffed out. In the absence of live music, television became ever more important in discovering and popularizing music. Lee, as a television host, a radio host, and a music manager, had a great advantage when it came to linking up music and TV. Which is hardly his fault, and it is not even necessarily a bad thing (although jealous rivals have long liked to gripe otherwise).

Today, the Korean music industry is at once the same as ever, and quite different. The pop music machine of SM Entertainment and its rivals still controls much of the music industry. However, that industry has shrunk much from its peak in the 1990s—to less than $75 million in retail sales in 2007, down from over $500 million in 1996. Given the changes in exchange rates and inflation, perhaps those numbers are a little misleading, so consider units sold—from over 90 million in 1991, to 61 million in 1996, to 45 million in 2000, to just 15 million in 2004. Most of that decline is from the disappearance of LP records and cassette tapes. In 1991, Koreans bought 29 million records and 56 million cassettes, but those formats have disappeared in our modern, digital age. Even CD sales are down significantly these days from their peak in the late 1990s.

Once again, 1996 is such a significant date in Korean pop his-

phenomenon, thinks it boils down to military service. All able-bodied Korean men must serve in the military, taking nearly two and a half years out of the prime of their lives. In the arts, especially music, this can be devastating. Just as a band is beginning to get some traction and popularity, members may have to disappear, losing all that momentum (and often a good chunk of any counter-cultural ideas they might have had). But for b-boy dancing, the effects of military service can paradoxically be the opposite. Learning breakdancing at the highest levels takes years, and it is definitely a career with a short shelf life, given the pounding it puts on the joints and bones. Taking a two-to-three-year break for military service means losing those hard-earned skills, and having to start nearly from scratch all over again. As a result, the window of opportunity for Korea's b-boys is incredibly brief, so the danc-

ers respond by going all-out, pushing themselves without regard for the long term.

Whatever the reason, Korea's thrilling b-boy dancers remain one of the greatest surprises and success stories in Korean pop culture.

tory. The Pusan International Film Festival launched that year, and the first portable MP3 player made its appearance (from a Korean electronics company). For music, 1996 was the apex. The year that H.O.T launched marked the peak of the music business, at least for revenues and CD sales.

When the Asian financial crisis hit the following year, most entertainment industries in Korea were so weak they were forced to change, to modernize, to grow transparent. But the music industry was already strong and full of energy, creativity, and confidence. It did not need radical reform, or at least some thought. For SM Entertainment, Doremi, Yedang, and the rest, their industrialized pop music system was still making them plenty of money. More money each year, in fact. Little did anyone suspect that their booming industry was in fact in trouble. Teenybopper pop music will always be there because there are always new teenagers. It is a constantly replenishing market. But what worked so well for the teen-pop market did not apply to the rest of the market, and adults lost interest in the sparkly enthusiasms of the young.

Since 2000, much of the damage suffered by the industry has been covered by exports and by the growth in acting and commercial endorsements for musicians. Once again, in both areas, SM Entertainment was a leader. Lee was brilliant in getting advertising campaigns and acting roles for his stars, helping to increase their fame and sources of revenue. He led the way in spreading the popularity of Korean stars around Asia, so that, today, Korean stars sing to packed houses from Bangkok to Tokyo.

While sales suffer badly at home, there are signs of hope. Tastes are broadening, as the Internet has helped give Koreans of all ages access to more kinds of music than ever before. The worst of the TV-music abuses of the 1990s have been, if not eliminated, quelled. And online music has created a new source of revenue that no one could have predicted a few short years ago.

Through it all, Lee Soo-man has not changed. He remains as boldly confident as ever, as convinced as ever that SM Entertainment is the apex of the Korean music and entertainment world. SM Entertainment had the biggest acts in Korean music history. SM Entertainment started the "Korean Wave," the popularity of Korean culture around Asia. Not that he is necessarily wrong in these assessments,

but they obscure a bigger, more remarkable accomplishment that he has been a part of. "When singing in the 1970s, I think Western pop was around 80 percent of music back then," Lee told me. "I never thought that Korean audiences would one day prefer to listen to Korean-language songs." Thanks to Lee, though, that is exactly what happened.

The Music Thieves

Sean Yang and his brother Il-hwan never set out to destroy the South Korean music industry. It just sort of happened. Fresh out of university, Sean and Il-hwan just wanted to combine their knowledge of computers and love of music and create a better music player that worked well in the Korean language. Along the way, they led a wave of Internet file sharing that swamped Korea more than any other country on Earth, devastating the nation's music industry. Sales on CDs and cassettes plummeted, music stores closed by the thousands, and the entire music business nearly died.

Jump ahead a few years and an amazing thing happened. The same Internet that ravaged Korea's music industry rebuilt it. Thanks to Internet music sales, ringtones, and other music services for mobile phones, Koreans now spend more money on music than they ever have before. And the digital music market only continues to grow. The turnaround is nothing short of stunning.

This story is, in my mind, one of the most remarkable in Korean entertainment since I first arrived here, over a decade ago. The tale of the Yang brothers and their company Soribada is also, in many ways, the story of Korea—the story of determination, chaos, and unintended consequences over vested interests, old ideas, and central planning. The Yangs have spent more time in court than either thought possible. In the ten years since they graduated university in the United States, the Yangs have been sued or faced copyright

infringement charges five times, not including many other minor actions. The music industry has called Sean and Il-hwan reckless criminals, two people with intent to destroy music in Korea.

Sean and his brother hardly come across as criminal masterminds. Sure, they have a big, spiffy office in a ritzy part of town these days, but Soribada just moved there in 2006. Before that, Sean and Il-hwan mostly ran their two-man operation from home. Sean gives off almost a "gosh-gee" personality, like he is vaguely embarrassed to be the front man for such a big business. In one of their first interviews, with the AP newswire in 2001, the two of them looked quite boyish and nerdy, each wearing white T-shirts and shorts.

Cyber Simmering

Long before gaining infamy, Sean and Il-hwan (along with a third brother, Moon-hwan) were just typical kids, with a bit of a geeky streak. Born in Seoul, they all grew up in the upper-class Gangnam region, loving computers and heavy metal music, much to the consternation of their law professor father Yang Su-san and stay-at-home mother, Gil Hang-young. When Il-hwan left Korea to study computer science at Virginia Tech, his mother and brothers came along, too.

At one point, Il-hwan's love of heavy metal even got him kicked out of the house. It would not be the last time his passion for music and computers got him into trouble. He was so into his music that he was missing classes, so one summer his dad gave him the boot. Fortunately, it was summer vacation, so Il-hwan crashed in Los Angeles with his brother (who had studied electrical engineering at the Univesity of Virginia before moving out west). While staying with his brother, Il-hwan got a job at a computer gaming company, and took up residence in California.

Sean, also a metal fan, was never so rebellious. He studied hard and got into Columbia University in New York, where he also studied computer science. After graduating, he went to live with Il-hwan in LA. Il-hwan's computer gaming company had just gone bankrupt, but he still had some software he wanted to continue working on, so Sean joined him.

At the time, instant messaging was the big thing in computers,

with programs like ICQ and Microsoft's MSN Messenger catching on quickly, which is what Sean and Il-hwan originally explored. But soon another application caught their eye—Winamp, a music-playing software designed for the computer.

Way back in the 1990s, getting music onto your computer was a chore. Most hard drives had just a gigabyte or two of memory, so they could not hold many songs. Plus, one had to copy songs from a CD to the computer, which could be rather time and resource consuming, too. It was not at all a convenient time for digital music.

Change is, of course, the only constant in the world of computers. Hard drives were getting bigger, and people were catching on to the Internet as a way of sharing information and even music. The invention of the MP3 (which is basically a way of condensing a music file by chopping off the bits that most people cannot hear anyway) helped put more music into a smaller space, but it needed to be decompressed for it to play. Then came Winplay 3, the first MP3 player, in September 1995. Quickly, the MP3 format took off, and music files in that format spread across the Internet. Winplay was pretty basic, though, and could not do much. Winamp, which features a more sophisticated and user-friendly interface, was released in May 1997 and quickly caught on, spreading the MP3 format.

Sean and Il-hwan were big fans of Winamp. But the player could not handle files with hangul, the Korean writing system. So they started working on a Korean-language MP3 player for the Windows operating system. The result was Sorinara, which translates to "Sound Nation." Sorinara could play files with Korean writing in them, but it suffered from the same major drawback as did Winamp—no business model. Also like Winamp, Sorinara was a free download, with no obvious ways of making money from it.

Then in 1999, Sean found an opportunity. An online music business in Korea asked them to customize a music player for the company. It was a pretty simple job, basically just creating a new skin for the same player, but the Yangs received $15,000 for their work. At that moment, Sean saw they would have far more business opportunities in Korea, so he moved back. A few months later, in early 2000, Il-hwan followed.

Working out of their parents' eighth-floor apartment in the dull suburb of Bundang, Sean and Il-hwan started brainstorming for ideas.

By this point, Napster had become the next big thing in computers. Launched by two university students in June 1999, the file-sharing service exploded into the popular consciousness largely from the ease with which one could find music. By early 2000, it had over 1 million subscribers and would peak in February 2001 with 26.4 million users. It was obvious to everyone that something big was happening here, and Sean began to explore.

Just as quickly as Napster became a phenomenon, however, it also became a target of the music industry. The Recording Industry Association of America filed their first lawsuit against the P2P (peer to peer) service in December 1999. As intrigued as Sean was by Napster's potential, he was equally worried by the legal dangers. "I spent a lot of time wondering about it," Sean says. "I knew people would really like something like that, but I had no money to defend us." Despite the legal problems, people were already creating similar systems in the West, so after some thinking, Sean's idealistic, computer-geek side won out. "I thought, how can you stop the Internet?"

Korea's first Internet service kicked off in 1982 (it was the first in Asia), when a computer at the Computer Science Department at Seoul National University was connected to a computer at the Korea Institute of Electronics Technology. In January the next year, a whole third computer was hooked up at the Korea Advanced Institute of Science and Technology. Three university computers wired to each other, hardly the stuff of revolutions, but everything needs to begin somewhere. The first email editing program that could handle hangul, the Korean writing system, was developed in 1985. Just like in

Pro Wrestling—North Korean Style
Kollision in Korea, the largest pro wrestling match ever held, took place in North Korea, on April 28 and 29, 1995. 150,000 people attended to see wrestlers like Ric Flair, Antonio Inoki, Chris Benoit, and the Steiner brothers. Day two brought in 190,000. Even boxing great Muhammad Ali took part in the festivities.

the West, the Internet was then the reserve of computer geeks at universities, little known by most people.

The World Wide Web brought the Internet to the mainstream in the West in 1994 and 1995, with a flurry of dorky articles in the mainstream media (each one painfully and didactically spelling out "what is the Internet," over and over again). In Korea, the online evolution lagged slightly. The Internet had been restricted to universities and research institutions until around 1994, when several commercial services, like Kornet and Dacom, got their start. The *Joongang Ilbo* and *Chosun Ilbo* newspapers went online in 1995, the same year the first Internet café (called Net) opened in Seoul, and online shopping began in 1996. But for the most part, the changes came slowly. When I first arrived in Korea in 1996, to Gwangju in the nation's southwest, I can still remember harassing the nice receptionists at a small Dacom telecom office (very fun, back when I had zero Korean skills) so I could access the Unix computers in the lobby and check my email account back in the United States. Even then, I was impressed by the speed of my connection.

Once the Internet boom began in Korea, though, it transformed the entire nation incredibly swiftly. The boom really began in 1998 with *StarCraft*, the online computer game. Koreans went absolutely crazy for *StarCraft*, like nowhere else on the planet. Koreans were responsible for about one third of the game's 3.5 million worldwide sales. At the same time, broadband Internet launched in Korea (thanks to Thrunet), and the combination of high-speed Internet and an addictive multiplayer game proved explosive. At first, most people got their *StarCraft* fix from Internet cafes (called *PC bang* in Korean), rather than at home. From just one Internet cafe in 1995, there were 15,150 Internet cafes around Korea by the end of 1999, most of them dedicated to the great war of Zergs, Protoss, and Terrans.

Parents—perhaps believing the endless hype about the digital future, perhaps just missing their children, gone weeks at a time in dark, smoky PC bang—soon began signing up for broadband connections at home. Because so many people in Korea, from all walks of life, live in high-density apartment blocks, it was relatively easy for the Internet service providers to connect huge sections of the country to broadband fairly quickly. At the start of 2000, less than

half a million households in Korea had either a DSL or a cable Internet connection. By the end of 2000, that number was close to 4 million (and by 2002, it was over 10 million, or around 70 percent of all households in Korea, compared to less than 20 percent in the United States at the time). This amazing change quickly moved beyond online gaming to transform everyday life. Banking and shopping quickly shifted online. Online communities flourished. In 2000, the online newspaper *Oh My News* launched, turning tens of thousands of everyday readers into writers, deeply shaking the traditional and stuffy mainstream media.

Let the Sea Make a Noise It was in this digital tumult that Sean and Il-hwan created Soribada. For three months they worked on reverse-engineering Napster and other sources, using the wealth of information already disseminated on the Internet. Il-hwan concentrated on the core of the software and getting it to function on people's computers. Sean focused on the server side. Soon they found themselves changing vast chunks of the Napster architecture, creating something greatly different inside. Napster was basically like a search engine, only with a server keeping tabs on all the files people were sharing. But Sean and Il-hwan did not have the money for the hundreds of servers such a system would require, so they worked on modifying the underlying program, to make it leaner, in Sean's words, "more like a phonebook," using a central server only to manage the list of available files.

Soribada launched on a portentous day—May 18, 2000, twentieth anniversary of the Gwangju Uprising. In 1980, thousands of students and activists rose up in the southwest city of Gwangju against the ruling military government. When the military retook the city, 207 Koreans were killed and nearly a thousand people were seriously injured, according to official estimates (unofficial numbers are much higher). It was a ghastly, bloody crackdown, but in many ways signaled the start of a new era in Korean history, the rise of a democratic movement that would lead to free elections in 1988. Soribada, too, was leading the way toward another massive change, but Sean had little interest in any of the grandiose parallels or metaphors I

offered. "It's just my birthday," he explained with a sheepish laugh and a shrug.

Of course, compared to lost lives and the violent struggles of the 1980s, listening to pop music over the Internet may seem trivial. But oftentimes the seemingly trivial contains seeds of significance, which can grow to unexpected importance.

Certainly it did not take long for the Yangs' Soribada to catch on. Relying only on word of mouth (they had no money for advertising campaigns), Soribada grew, and grew quickly. After one month, 100,000 people had signed up. In less than three months, the count passed 1 million, and grew from 500,000 to 700,000 new users each month thereafter. After one year, Soribada had five million registered users. By the end of 2001, user count reached 8.1 million, and by the end of 2002, 15 million.

Sean had no specific business model in mind when they launched Soribada. "We knew that once we had over a million people as our base, we would make money somehow." And he was right. In less than six months, advertisers were calling. Not much interested in the high life, Sean and Il-hwan put their energies into developing and improving their P2P service. They simplified the system so their one server suffered less of a load, and they added a real-time keyword chart function, which showed users what songs and artists were currently popular. Il-hwan concentrated on the nuts-and-bolts programming that kept Soribada running. Sean took charge of the business, website, and pretty much everything else. Despite the millions of users, Soribada worked from just one central server. Individual users paid for most of the heavy bandwidth required to trade all those songs. The Yangs had no employees (and would continue to have none until they incorporated in 2003). They worked from their parents' home. With monthly expenses of less than $300, they were soon taking in about $50,000 each month.

Of course, it was not long before the Korean recording industry took notice of Soribada and moved to shut it down. On April 21, 2001, four local music labels (Daeyoung A&V, Woofer Entertainment, Donga Music, and Sinchon Music) complained to the prosecutors' office. The Recording Industry Association of Korea (RIAK), a lobby of 133 local music labels, claimed that Soribada had caused $154 million in losses the previous year. Finally, on August 12, 2001,

Soribada was indicted for copyright infringement. Prosecutors asked for five years of jail time and a 40 million won ($43,000) fine.

Surprisingly, Sean says that he and his brother were not too worried by this move. Earlier that summer, they had been called by the prosecutor and asked to come in for questioning. All told, they visited the prosecutor's office four or five times before the indictment came down. "We were expecting it," he said, adding that they took the whole legal case "really calmly." They hired lawyers at Bae, Kim & Lee, one of Seoul's bigger law firms, and, confident the courts would recognize the unstoppable reality of the Internet, proceeded to see what the Korean courts would say. "We really thought we would win," said Sean. He was wrong.

In fact, big changes were already rocking Korea's music scene, even before Soribada came along. The pop wave that Seo Taiji ignited and Lee Soo-man perfected was losing its freshness. Television ratings for music programs were falling. The number of retail stores was already collapsing, dropping from 5,200 in 1999 to 2,400 in 2000. Strangely, though, despite RIAK's complaint of having lost so much money because of Soribada, the Korean music industry actually *grew* in 2000, reaching $315 million in retail sales, up from $292 million in 1999. Even Cho Jin-bae, the then head of EMI in Korea, admitted in the local media that there was no evidence of sales declining. Clearly, there were bigger forces at work than just Soribada.

In fact, the seeds of the music market implosion were planted back in 1997, when Saehan Information Systems came out with the first portable MP3 player in the world. It was no iPod. The MPMan F-10 had just 32 megabytes of memory—enough for maybe a dozen

Hwang Woo-suk
Hwang Woo-suk, a former professor of veterinary medicine at Seoul National University, became a hero and major celebrity in Korea for his animal and human cloning breakthroughs in 2004-5. Too bad many of his biggest achievements were actually faked. Hwang protested his innocence, but he was expelled from the university and indicted for fraud and embezzlement.

Courtesy of Seoul National University

songs, if they were encoded at a low quality. Koh Young-whan had by that time left the music business and was working for Saehan, in its cable television division. He remembers being invited by the proud engineers to a small demonstration of the MPMan. "Wow," was the first thing Koh said, followed by, "But how are you going to control copyright?" The problem with MP3s is that they are open, free from copyright controls or Digital Rights Management (DRM). That is the reason Apple and Microsoft and most companies that introduce an online music service or digital music player use one special format or another (or create a new format), to control copyright. But the MPMan F-10 was an MP3 player. Koh saw a Pandora's Box opening right in front of his eyes. But the engineers just shrugged. They had designed a great new product, a wholly new way of listening to music. Digital rights management? Who cares about a pesky detail like that? Koh says at that moment, way back before the Internet had taken off in Korea, before Sean or Il-hwan had begun even dreaming of Soribada, he knew the floodgates were opening. A Sea of Sound soon flooded the land.

Even Sean and Il-hwan were concerned for the health of the industry. Sean attended meetings with the Korea Music Copyright Association and the Ministry of Culture and Tourism (the branch of government responsible for copyright law), looking for ways to help P2P technology coexist with the music industry. But back in the early days of the new millennium, the technology had not evolved enough to provide many options. Sean had thought about starting a subscription system, but with no reliable DRM technology, he could not envision how to make it work. The pressure from the music industry continued to build.

Free As a Bird It took a year for the case against the Yangs to snake its way through the legal system, but on July 12, 2002, the word finally came down—judge Kim Sun-hye ordered Soribada to shut down. The injunction, however, only called for Sean to shut down the central server, the "phone book" that kept track of all the music available on the Soribada users' computers. Fortunately for the Yangs, the tiny size of their operations made them

a difficult target. Their online service used just one server, housed at the Korea Internet Data Center, and they did not even own that. On July 18, RIAK sent bailiffs to the KIDC to seize Soribada's server, but the KIDC's manager said the warrants did not grant the authority to take the Center's servers, and sent the bailiffs away empty-handed.

In the United States, by this time, lawsuits had already taken their toll on Napster, forcing it to shut down at the peak of its influence in 2001. In May 2002, Napster was sold to the German media firm Bertelsmann for just $8 million. In June, a shadow of the giant it once briefly was, Napster was placed under bankruptcy protection. With Napster gone, enterprising programmers dedicated to the progress started by Napster (or at least dedicated to getting lots of music for free) had turned to other options. A second generation of peer-to-peer technology rose up, one not dependent on central servers to keep track of files being shared on the network (known by many names, such as Limewire, Gnutella, and Grokster). Sean and Il-hwan decided to move Soribada in the same direction.

Worried about losing their users, they had to move quickly. RIAK had returned to court, asking the judge to clarify her ruling so they could take the Yang's server. But the hard work for Il-hwan had been in creating Soribada, making a service that was not dependent on a wide array of servers. Creating a new system that required no servers was relatively easy, and after fewer than three weeks of all-nighters, Il-hwan had Soribada back online as Soribada 2.

Without a central phonebook anymore, Sean and Il-hwan were legally protected, but it created a big problem for them—no income. As a completely free service, Sean knew Soribada 2 was hurting the music industry without giving anything back. Also, it was so decentralized that Sean and Il-hwan could no longer track information about the files being traded, which further limited their ability to commercialize it. Sean knew they would have to change and start working with the music industry.

Almost immediately the Yangs began working on Soribada 3— on a complicated points and pay system. Users would get twenty points for just signing up for Soribada 3. Every day users logged on, they earned one point. Every time someone downloaded two songs from a user's computer, they received a point. Or, to bypass the point system altogether, users could download all they wanted for

one week for just 500 won (about 50 cents). They also created "Bada cash," a virtual money system that cost a minimum of 1,000 won. Users could also download songs as ringtunes and other forms for their mobile phones. That might sound modest, but Soribada by that point had nearly 8 million members, and soon the company was earning 500 million won a month ($530,000)—of which, Sean says, 45 percent went to the record labels.

Of course, Soribada was not happening in a vacuum. By the time the Yangs were working on Soribada 3, Korea's music industry was well into its startling transformation. Sean and Il-hwan may have had the most popular online music service in Korea, but imitators and competitors were legion. Bugs Music, also started in 2000, quickly became the most popular music-streaming service in the nation, with nearly as many users as Soribada.

The key to the change came from mobile phones. For centuries, Koreans have been an incredibly connected society, where family ties and other relationships were pivotal to determine identity and position in society. No one was an individual as much as each person was part of a huge spiderweb of interconnecting relationships. So when Korea went electronic, it is no surprise that technology followed right along.

When I came to Korea in the mid-1990s, pagers were all the rage. Mobile phones were too expensive and bulky to be practical for most people, but nearly everyone had a pager (generally called, in typically Korean onomatopoeia-ness, a *ppi-ppi*, or "beeper"). Everyone had these, from schoolkids to grandparents. As a result, Korea was packed with pay phones, and all of those pay phones, it seemed, had a giant lineup of people, waiting to check their ppi-ppis. There was an entire pager culture, with a long series of numerical messages that everyone understood. "8282" meant hurry up, and woe betide the person who received an angry "1818." People also liked to customize their pagers, including with cool ringing sounds. But options were limited, and programming a single chosen tune, beep by beep, was mind-numbingly tedious.

So when the price on mobile phones dropped, it was natural for everyone to switch *en masse*, bringing with them the pager culture. Young people especially lived on their mobile phones, typing messages to innumerable friends for hours, just staring into their phones'

tiny display screens, face muscles seemingly paralyzed while their thumbs twirled on the keypad with the speed and grace of a hummingbird's wings. Getting music onto mobile phones, unlike onto pagers, was relatively easy.

Almost overnight, an entire industry sprang up. The country was full of ads for music service, offering 700-xxxx numbers to call to get the hottest hits loaded onto

Korea's first online radio service Nine4u launched in 1998 by Yun "Channy" Seokchan.

phones, usually for around 1,200 to 1,800 won per song. At first, the songs offered just the simple tink-tink-tink of a Casio organ, but the sound system in phones quickly got more sophisticated and orchestral. Users could load songs to play when their phones rang, and other songs for the caller to hear instead of a dial tone. They could have special songs for different callers. Korean young people especially ate it up. Increasingly, Internet portal sites and service providers joined in, too, with Daum, Naver, Freechal, Lycos, and dozens more offering music, too. Seriously, it would be hard to exaggerate how big this trend was. From 2000 to 2001, the entire digital music market more than doubled, from 45 billion won to 91.1 billion won (or $47.9 million to $96.9 million). It climbed to 134.5 billion won the next year, and, after 3G phone service began in November 2002, it jumped again to 185 billion won in 2003. The CD and cassette markets may have been in freefall, but between ringtones and the Internet, Koreans' demand for music was bigger than ever. And with a business model for Soribada that now included an actual source of money, Sean thought Soribada could lead this change.

RIAK had not given up, of course. It launched a new lawsuit almost immediately. While the Korean Music Copyright Association (KOMCA) was relatively easy-going about these new platforms (typically asking for just a small share of all revenues), RIAK was more assertive about asking for specific per-song fees. RIAK's aim was rapidly widening, too. Bugs Music and Nine4U got hit by RIAK lawsuits,

and local press reported that Korean prosecutors were looking into about one hundred Internet music sites.

Now that Soribada 3 was charging money for music, it became a much more inviting target for lawsuits. RIAK again took Sean and Il-hwan to court, this time for abetting copyright infringement, but in May 2003, the Yangs got a lucky break—the court simply dismissed the latest charges against the brothers. Rather than decide whether the Yangs were guilty or not guilty, the court instead took issue with the prosecutor's case. Basically, the court said that while the prosecutor had built his case that the Yangs were helping people break copyright laws, he had not described the actual copyright violations. It was like the police arresting a person for helping someone rob a bank, but forgetting to find the robber.

Sean and Il-hwan, not yet out of the woods, found themselves facing a new foe—yet another music organization, the Korean Association of Phonogram Producers (KAPP).

What on earth is the KAPP? Well, once the phone and online music markets took off, music labels quickly discovered that Korea's music laws did not address this new technology very well. KOMCA took care of copyrights, but that just addressed songwriters. But how do music labels make money when phones use the original master recordings for ringtones? Who and what determine rates for an online download? The Korean government was working on new regulations for this brave new age, but there was fierce competition to become the collection society for those rights. The Recording Industry Assocation of Korea had those rights at first, but the small, upstart KAPP wanted to take over for digital rights, and it lobbied the government hard to win them.

In many ways, the Korean Association of Phonogram Producers is one of the most unlikely bureaucracies in the Korean entertainment world. Located down a maze of small streets in the extremely unfashionable neighborhood of Shingongdeok-dong, it could not be in an area less artistic or modern (most music companies are located in the same hip, affluent neighborhoods south of the Han River that the movie business also calls home). Secretary-General Park Ki-yong, co-founder of KAPP, was a career military man, spending fifteen years in the Korean Marines before leaving as a lieutenant commander. Along the way, he earned a Bachelor of Science degree

from the Naval Academy in 1981 and an MBA from the Graduate School of National Defense in 1990. In 1999 he joined RIAK, then helped found KAPP in 2002. KAPP's chairman, Lee Duck-Yo, has been a manager for comedians and musicians since 1980, coming to KAPP in 2003.

While KAPP is now responsible for online and mobile rights and collections, it is far from a monolith. In fact, it represents only about 30 percent of music labels. Most of Korea's biggest music labels have refused to join, preferring to set their own rates and ink their own deals with the telecoms and other next-generation platforms. Despite these divisions, KAPP has the authority to take legal action against online companies that, in its view, violate its members' copyrights, and it went after Bugs, Soribada, and others.

On November 14, 2004, KAPP applied for a "provisional disposition" against Soribada. It took until August 2005 for the Seoul District Court to decide to accept one of KAPP's complaints, but from there KAPP moved quickly. At the end of August, the court ordered Soribada to shut down. In early September KAPP filed a criminal suit against Soribada, asking to seize Soribada's domain name. In October, KAPP moved toward a provisional seizure of Soribada's stocks, which meant that Sean and Il-hwan were prohibited from selling their 960,000 shares of Soribada. Soribada lost the last of its appeals at the end of October. The Court said that if Soribada continued, it would face a fine of 10 million won ($10,600) a day. The fines and court rulings were too much, and with that, Korea's first and most popular P2P service, with 22 million registered users, was gone.

Sort of. The Soribada story is full of twists and turns. As the courts struggled to understand what Soribada was and how it fit into Korea's convoluted copyright laws, they repeatedly reversed themselves, pronouncing the Yangs guilty of copyright-related crimes one moment, then saying they were free the next. As I described earlier, they won a major case in 2003. And in January 2005, just eight months before the beginning of the end for Soribada 3, the Yangs won another court case, as the court said the Yangs were not responsible for the wrongdoings of Soribada's users. The Yangs' argument in general has been that they are no more responsible for people who used Soribada to violate copyrights than the phone company is when people discuss committing crimes over the telephone. The

courts' rulings make it clear that the judges rarely had much under-
standing of the technology involved.

But what often it came down to was money. The courts thought
that Korean law protected services like Soribada as long as they
were not making any money. Whenever Sean and Il-hwan came
up with a business plan to make money from Soribada, the courts
ruled against them. When Soribada was entirely free, however, like
Soribada 2, then the courts generally stuck up for them. Logging on
was generally frowned upon, too—if there was a service to log on to,
then there was a means of control. But without logging on, there was
no way to make money.

Going Legit Sean and Il-hwan saw no choice but to cooperate with
the music industry (at least a little). The only way to sur-
vive was to settle with all the music societies, most im-
portantly KAPP. But KAPP was insisting on 30 billion won ($32.6
million), way too much money for the Yangs. It was time to grow
Soribada beyond a two-man operation.

The first thing they did was to bring aboard Yang Seung-guk
as chairman. Introduced by one of their uncles, Yang was an older
man with great connections throughout the Korean music industry,
dating back to the 1980s and '90s, managing artists such as So Bang
Cha and Shim Sin. He had started a joint venture with six music
labels before getting into trouble with his investors and fleeing to
the Philippines for a time. Yang Seung-guk used his venerable ties
to talk the KAPP's demands down to a much more affordable 8.5
billion won.

Eight billion won might be a lot better than 30 billion, but it
was still a lot more money than Sean and Il-hwan had, so they were
forced to look for outside finanancing. Remarkably, for all the ups
and downs and successes over the previous six years, this was the
first time they had looked for outside funding since they incorporat-
ed (when the Korea Technology Investment Corp., or KTIC, invested
$2 million). Soribada was able to make one of those infamous "back-
door listings" onto the KOSDAQ stock market in October 2006, via
the company Bio Media (technically, they merged; however, Soribada

was much larger, so in effect Soribada took over Bio Media). Then KTIC helped Sean meet up with the software distributor Softland, which bought a 20 percent stake in Soribada for $10 million (which was later sold). With that money, Soribada could pay off KAPP. Other rights groups were still knocking on Soribada's doors, but KAPP had a legal head-

Soribada, Korea's top P2P music service, has faced numerous legal challenges over the years, but it is still going strong.

© Soribada

lock on them, and KAPP had to be dealt with asap. Once KAPP was happy, Soribada could fire up again and attempt to make deals with everyone else.

In addition to paying off debts and settling lawsuits, the $10 million allowed Soribada to grow up. For the first time, the company had a staff and offices (in Seoul's tech central neighborhood of Yeoksam). Il-hwan still concentrates on the fun coding work, while Sean is the face of the company, doing just about everything else. In a humorous bit of irony, Soribada even bought Manine Media, the biggest music rights company in Korea. With the rights to 70,000 songs, Soribada now has an interest in music rights being paid out to copyright holders, too.

In April, just five months after being shut down by KAPP, Soribada was back, this time with a for-pay service called Soribada 5 (they skipped 4 because the number is considered bad luck in Korea). The technology is basically the same as before, but now the company keeps track of all users and their usage, and gives the appropriate royalties to the appropriate music labels. By spring 2007, Soribada 5 registered 5 million unique visitors a month. Each paid 3,000 won per month for a subscription (soon to be raised to 4,000 won). Of that fee, 45 percent goes to the labels (much higher than Apple's iTunes rate), 10 percent to KOMCA, 5 percent to the performer's association, and 15 percent for other licenses, leaving Soribada with 25 percent.

Yet legal headaches keep coming. In July 2007, for example, nine Korean record labels and the four major international labels called

on Soribada to stop trading their music without permission. Soribada won the case, pointing out that it was filtering out their songs using "digital fingerprint" technology, and then struck deals with almost all those labels.

In the meantime, the rest of the Korean online world was also sorting itself out. The infamous Bugs Music reached a deal with KAPP in August of 2005, settling outstanding copyright violations for 2.2 billion won ($2.3 million), and by September was charging for its service. And in the summer of 2006, under further pressure by KAPP, eight of Korea's top eleven file-sharing services announced they would no longer allow music trading.

The most significant aspect of the Soribada story is how the company led the move in Korea to an online music market. Today, online is absolutely huge. In fact, Koreans have spent more money on music for their computers and mobile phones than they have on compact disks since around autumn 2003 (exact numbers are hard to pin down, of course). While the CD market collapsed, the digital market exploded, from $45 million in 2000 to $321.3 in 2006. All the telecoms have music services, and SK Telecom's MelOn is particularly successful (although SKT will not release its exact figures). Some industry analysts have predicted the digital music market could hit $1 billion before the end of the decade.

This online pattern extends beyond just music in Korea—to

Other Music Services

Soribada may be Korea's most infamous file-sharing site, but there are plenty of other Korean services and sites on the Internet for listening to music while violating copyrights. Some have come and gone, others have gone legit, some are popular with millions of users, while still others are smaller, designed for a more select crowd.

The biggest and most famous alternative to Soribada is Bugs Music. Bugs was started by Park Sung-hoon in Busan in 2000, the same year that Soribada was launched. What Soribada was to P2P, Bugs Music was to streaming, peaking with 16 million users.

What was perhaps the first online music service in Korea was launched by Yun ("Channy") Seokchan after graduating with a degree in geology from Pusan National University. He started Koreamusic.net in April 1997 with the intention of creating an online shopping mall for music. Soon after, he added streaming music to his site. The next year, he launched Nine4u, Korea's first online radio service, offering nine channels of music. With over 100 MB of bandwidth, Nine4u was one of the biggest Internet companies in the country at that time.

Things were going fairly well for Yun. As the Internet was just on the verge of exploding in pop-

video games, movies, and even comic books. Young Koreans have shown themselves to be eager to move online for whatever kind of entertainment. For video games, piracy has long been a huge problem in Korea. No matter what safeguards a company installs, enthusiastic hackers always seem to get around them. So what works in Korea is to give away the games, but charge for online use and upgrades. A CD can be copied fairly easily, but it is much harder to fake a paid account. And since Koreans love online communities, having video games connected to large online communities made them fun and even more addictive. Korea's big free-to-air TV stations have broadcast over the Internet for years, allowing bored office workers to waste the day watching the shows they missed the night before. Several comic book artists have done well for themselves with online publishing, too.

How responsible are Soribada and other Internet file-sharing services for destroying the Korean music industry? The evidence looks damning, at least at first. The Korean music market fell by more than 77 percent from 2000 to 2007, from 339 billion won to just 75 billion won ($339 million to $75 million). That plummet corresponds well with the rise of broadband Internet and CD burners in Korea.

There are, however, counterarguments. As I noted already, legitimate online sales have soared in Korea, despite the presence of illegal file sharing, helping to replace much of the losses from declining

ularity in Korea, the nation quickly filled with Internet cafes. No one had an inkling that the music market would collapse in a few years, and young online music companies were able to work with many music labels. Yun created deals with such record labels as Synnara, Samsung Music, Sony, EMI, and Warner Music to offer a (somewhat) legitimate online music service. He even worked with SM Entertainment, creating the company's first homepages and fan sites.

As broadband grew in Korea, the market quickly changed. Soon a plethora of new music services began to spring up, with varying degrees of legality. Some, like Nine4u, Muzcast, and MaxMP3 made at least some attempt to work with the labels. Others, like Wizmax and Letsmusic, were operated by or completely tied to one or more music labels. But many were straight-up illegal, ripping off music without regard to copyrights or the musicians.

Then in 2000 came some new competition for Nine4u—Soribada and Bugs. Bugs was the most troubling, since it was a streaming site like Nine4u only Bugs' music streams were of higher quality 64K compared to Nine4u's 56K. Soon, Bugs was consuming 3–4 GB of bandwidth (so much that the Korea Internet Data Center kicked Bugs off of its server). Then came another competitor, MaxMP3 which offered even higher-quality music, using even more bandwidth—first 5GB, then 10, then 16 "It was madness," recalls Yun, "But on the other hand, it was an innovative time."

Yun realized that Nine4u could never compete

CD sales. In addition, do not forget that piracy was far from unknown even before the Internet age dawned in Korea. For years, pirated cassette tapes were sold all over the Korean Peninsula—on the streets, in the subways, at highway rest stops, and at the entrances to national parks. Koreans have long been able to buy illegal copies of local and foreign music. Of course, copied cassettes do not have the quality of CDs, but their sheer ubiquity shows that the music industry was able to live—and thrive—alongside the pirates. The music industry even worked with those blackmarketers on occasion, as they tried to build new acts' reputations (much as the American music labels worked with mix-tape DJs in the United States for years).

But the biggest proof that the crash of the music industry was not Soribada's fault is television. Since the 1990s, television ratings for music performance shows have also fallen dramatically. If file sharing were only eliminating sales, then why would television ratings suffer? The top acts should still draw fans and ratings. The fall in television ratings seems like pretty good evidence for another conclusion—young people just do not like the bands and their songs as much as they once did.

Chalk it up to going to the well one too many times (well, more like a hundred too many times). The dance-pop fad that Seo Taiji started and SM Entertainment perfected has run its course. The music of today is not significantly different than that of last year or

with copyright violators like Bugs and so began to shift his service to other kinds of music content like music news, artist databases, and online CD sales.

Soon after 2000, the music industry began to see how the Internet was going to be a big problem as CD sales started to drop quickly. The record labels themselves had made their first attempts at launching online music services in 1999, but it was too early, and their services were no match for the lure of free, illegal services like Soribada and Bugs. Because CD sales were quickly dropping and the online market was still undeveloped, the music industry decided it needed to take action. At first a few more "motivated" labels tried storming the offices of the online companies and using some old-fashioned muscle to get results. But eventually they decided it was better to take their cue from the American music industry and protect themselves by launching lawsuits against the online music companies.

Bugs Music came under intense fire in a series of lawsuits. As the music industry won suit after suit, Bugs began to lose songs, and soon after, its large customer base. Finally, in 2005, the music industry scored a decisive victory. In January the courts ruled that founder Park Sung-hoon was guilty of copyright violations, sentencing him to eighteen months in prison with a $20,000 fine. His only option was to make a deal with the music industry, so he handed over his 60 percent stake in Bugs to a consortium of music labels led by Yedang Music.

Despite trying to work with the record labels, Nine4u had something of a target on it because

five years ago or even ten years ago. When pop keeps sounding the same, people lose interest, forcing producers to focus on new listeners to whom the sounds are new. Teenagers, basically. Because they focus only on teenagers, force-feeding them the same old music, year after year, producers also ensure that there is no catalog market—which is where the bulk of the money is made in the music industry in the West.

Think about it. As someone in the West gets older, he gets exposed to ever more types of music—in high school, in university, at work, wherever. But in Korea, no one goes to university and suddenly wants to know all about Seo Taiji. If a young person wants to branch out musically, he looks to Korean traditional music or Western modern rock (or jazz or whatever). Very rarely, he might look into old Korean rock from the 1960s and '70s.

This strange phenomenon is not relegated to the music industry. On home video, too, people in Korea have shown very little interest in classic movies, especially from their own history. The interest in and rediscovery of old Korean cinema was driven by fans from abroad. Across genres and platforms, Korea has been unable to build a significant market for its back catalogue, an invisible problem that drags down the entire entertainment industry.

One of the great possibilities of the Internet age, however, is increased accessibility. Netflix in the United States has shown how

it had been a pioneer, and soon lawyers from the Korea Music Copyright Association (KOMCA) came calling. Not wanting to go to jail like Park at Bugs Music, Yun made an agreement with KOMCA and became the first streaming service to charge for music in 2002, and Nine4u was dropped from the KOMCA lawsuit.

After a few decisive legal victories for the music industry in 2003, most online music services began trying to charge for music in July of that year (except for Bugs Music, which is a big reason why its founder, Park, ended up going to jail a couple of years later). Gradually, under pressure from the Korean music industry, each of those online services either reformed, joined a mainstream company, or folded. In July 2005, Max MP3 was acquired by Mnet Media, part of CJ Entertainment's sprawling entertainment empire.

But the most serious blow to the online piracy market was not the law or gangsters, it was commercial competition. By 2004 most of Korea's leading online companies had their own music services going. IRiver had Funcake, Neowiz had JukeOn. As for the telecoms, KT Freetel had Dosirak, LG Telecom had MusicOn, and SK Telecom had the most dominant service of all, Melon. Each is used by millions of customers, all willing to pay for the security and convenience of legitimately distributed music.

Online piracy still abounds in Korea, but it exists alongside a $320-million legal online market built in large part on the heritage of those early online wars.

people's tastes are far broader than most movie studio executives imagined. The music industry, too, datamines online piracy and legitimate music sources to gain deeper insight into what people really want. Chris Anderson at *Wired* magazine has called it "The Long Tail," the idea that the Internet age greatly increases everyones access to all kinds of music, movies, books, or whatever, and as choice grows, it becomes ever more valuable. When you have limited shelf space, like at Wal-Mart or Tower Records (well, like Tower once had), then the top ten or top twenty sellers account for a huge percentage of total sales. But when shelf space is infinite, as it is on the Internet, then the sum of all those small options adds up and becomes worth more than the top ten.

At least that's the theory. Korea unfortunately remains a troubling counterexample. So far, Korea's amazing Internet revolution has not led to much diversity. Which is something that concerns Sean Yang greatly. "There's no place for alternative music," he told me. "There is no access, no real video channels, no radio stations that air alternative music." A scan of music listings on the various telecom music sites reveals mostly the same local pop songs, along with a small (and rather egregious) sampling of Western music, mostly the likes of Michael Jackson and Black Eyed Peas. Western music, which once accounted for the majority of sales, and even in the 1990s still could climb into the 40 percent range, today limps along at barely 20 percent of the market.

Lack of choice becomes a miserable sort of feedback loop. When Korean consumers demand fewer options, distributors offer fewer options, so consumers are less likely to learn and more likely to see their taste narrow even more. Sean sees the data from his company, where there are zero restraints on what someone can listen to, and he says that choice is declining. That decline is no corporate conspiracy, no heavy-handed distributor. That is consumer choice. It is not a choice that makes me very happy—and Sean (and many others) hope that diversity will come to Korea's music scene, spurred on by the online world—but that is people's choice. Maybe through copyright violations, the mammoth choice machine that is the Internet will give everyone the chance to learn about anything and everything, regardless of what the music labels want. Some people think they see signs of diversity slowly taking root now (for instance, in the

number of interesting indie bands playing in Seoul these days). But if such changes are happening, they are happening slowly.

One change that the mobile phone music market has helped to bring about has been a distinct shift toward ballads, following the dominance of dance in the 1990s. Many Koreans think that hyperactive dance music sounds somewhat immature as a cell phone ring (especially for those who have graduated and function in the business world), so they prefer slower songs for their ringtones. Not the stuff of revolutions, perhaps, but notable.

Certainly much bigger changes to Korean music are on their way, thanks to Sean and Il-hwan and all the companies, legal and illegal, that have shifted music to the Internet. As I write this (in early 2008), it may be too early to see how it will unfold in the future.

Soribada still has a few outstanding issues with various music labels, but for the most part it has grown up. (I would like to say "and gone mainstream," except that, well, with nearly half of Korea registered to use Soribada, it has long been about as mainstream as you can get, at least from the consumers' point of view). The basic program and website chug along with minimal hands-on work needed by Sean and Il-hwan. After all, they never designed Soribada to get rich, but rather to combine their love of music and programming. These days, Sean and Il-hwan busy themselves on a whole host of new projects—designing overseas music services for Korean conglomerates, creating new online business models. They even supply music for other online music services.

Almost poetically, Soribada is now partially owned by and is an owner of Korea's largest music label, SM Entertainment. At the very end of 2007, SM Entertainment decided to unload its attempt at creating its own Youtube-like service called SM Online. Soribada bought it for $15 million. At the same time, SM Entertainment bought a 3.85% stake in Soribada. Then in March 2008, Soribada received government permission to begin offering unlimited download subscription services. After eight years, the former renegade of the music industry had at last grown almost completely commercial and, if not respectable, at least tolerated.

The important thing Korean customers have shown clearly is that a business can compete with free. Sure, consumers like free, and they will use services like Soribada or e-Donkey or whatever to

listen to whatever they want to. But given the choice between a legal, reliable, affordable music service and the hazards and difficulties of poking around on the Internet, people will choose the paid service. And people will choose in big enough numbers for their choices to be profitable for the music industry. The key (at least from the Korean example) is to take a little bit of money from the general population, a small fee distributed across a large base. A business can earn a lot more money getting a small amount of money from a large number of people than by appealing solely to serious fans.

This is the lesson and the business model that Soribada pioneered. From the beginning, Sean and Il-hwan believed that Internet music was unstoppable and potentially profitable. While legitimate music services brought money and respectability to the once untamed world of digitally distributed music, Soribada has in return grown respectable, too. From getting kicked out of home to getting kicked around by the music industry, Sean and Il-hwan combined their love of music and computers, firm in the belief that they need to follow what they love, then everything else will sort itself out. In doing so, they laid the foundation for the next musical age.

The Thin Black Line

The tale of *manhwa* (Korean comic books) has one of the oddest story arcs in all of Korean pop culture, its world long buffeted by a myriad of trends, technologies, and external forces. The Asian economic crisis, the Internet, online gaming, illegal imports, and lucrative exports have all shaped the manhwa industry. From humble beginnings, it grew to great prominence in the 1990s, churning out thousands of titles every year. Korean artists, growing up in the long shadow of Japanese manga, struggled to make a living, let alone create their own special identities. From the action-filled *Ruler of the Land* by Jeon Geuk-jin (started in 1995 and still going strong) to Park So-hee's fanciful tale of imaginary Korean royalty, *Palace Story* (or *Goong*), from the traditional designs of ink on newsprint to the all-digital online comics, Korea's manhwa have grown into one of the most creative corners of Korean pop culture, winning fans around the world.

In many ways, the comic book industry mirrors the music industry in Korea—both peaked in terms of sales and popularity in the mid to late 1990s. Both were devastated by widespread sharing, both online and offline. And both experienced surprising rebounds through Internet sales and international popularity, beginning around 2003. While the Korean music business evolved to be under the control of producers and managers instead of musicians, the comic industry remains the domain of the creators, who in Korea have a surprising amount of control over their art and fortunes.

So what's the deal with Korean comic books? What makes Korean manhwa different than Japanese manga? Well, obviously, manwha is very similar to Japanese comic books, in the art and the storytelling. With thousands of comics published in both countries each year, it is perhaps inevitable that there are more differences within each country than between them. It is like asking how British rock music is different than American—no single, pat explanation could encompass the Beatles, Led Zepplin, and Robbie Williams.

That said, there are a few differences worth noting, both big and small. The most obvious is how they are read—Korean comics read left-to-right, like in the West, not the right-to-left of Japan. Also, the Korean comic market is much more geared toward young people and tends to be more conservative than the Japanese market, especially when addressing sex. Although, as I will explain, do not overestimate this difference, and be aware that some of Korea's most famous manhwa have been notoriously excessive. On the whole, though, I think it is safe to say most comic artists in Korea are more shy about depicting sex.

But perhaps the biggest difference is simply scale—the comic book industry in Japan is huge, generating over $4 billion a year. And that does not include merchandizing and animated tie-ins, movie spin-offs, and the like. As one would expect from such a large enterprise, it is pretty corporate and "industrialized."

Korea's comic book industry, on the other hand, is much smaller, about $480 million in 2005. Exactly how much smaller is hard to say, since there are no official numbers. Comic book sales generated about $110 million in 2005, but that does not include many other markets, such as educational comics and money from the *manhwa-bang* (comic rental stores). Not only are comic sales much lower in Korea than in Japan, but also the whole business is much more limited, too. Few series are turned into movies or television programs (although this is on the rise these days), and almost none become animated series.

In other words, the Korean comic book industry never really industrialized the way movies and music did. Unlike Japan, where artists and writers are virtually married to their large publishing companies, and large teams work on titles, most artists in Korea work alone. Instead of a team of editors working on a comic, usually one editor

works on many comics. Instead of sprawling tie-ins to animated series and novelizations and more, Korean comics typically stand on their own. The low-rent economy of the manhwa industry simply cannot compare to the mammoth Japanese comic book machinery.

Now, as is so often the case, strengths can turn to weaknesses and weaknesses to strengths. The Korean comic companies might not be tightly connected to the rest of the entertainment industry, but the relative smallness and weakness of the Korean manhwa market allows more flexibility and out-of-the-box thinking. This can translate into more and unexpected opportunities in the long run, such as one of the most surprising aspects of Korean comics, their rapid embrace of online markets. "A man without hope is a man without fear," a Western comic hero famously said. And in Korea, that what-have-we-got-to-lose mentality has been an important part of driving comics forward.

Early Cartoons

Korean art, like art in Japan and China, had certain cartoon-like similarities, combining words and simple engraving, sometimes in sequences, to tell stories going back hundreds of years (although Korea did not have anyone quite as iconic as the famous Katsushika Hokusai). Cartoons and comics really began in Korea with the founding of the country's first newspapers in the late nineteenth and early twentieth centuries, and for several decades most comics were simple, one-panel images. The word "manhwa" was first used in 1923 by the *Dong-a Ilbo* newspaper, although there were several other terms also in use at the time (such as *hyehwa*, or "illustration," and *cheolpisajin*, or "pen photo"). Kim Dong-seong made Korea's first four-panel comic strip in the *Dong-a Ilbo* that year. It is also worth noting how many of the top cartoonists of the day were also respected artists, well known for their traditional paintings. Despite the Japanese occupation, the years after 1919 were surprisingly liberal, and cartoonists used their medium for much social criticism. But as time went on, humor became increasingly popular—not to mention increasingly safer, as the increasingly less tolerant Japanese rulers cracked down on dissent. By the time Japan's Pacific War was in full swing in the

One of Korea's first comic artists, Ahn Seok-ju's Manmun Manhwa *appeared in the* Cho-sun Ilbo *newspaper in the 1920s and '30s.*

1930s, the manhwa industry pretty much came to a halt, as did most of Korea's entertainment industry.

After liberation in 1945, cartoons came back in the newspapers and other periodicals. One popular artist, Kim Yong-hwan, who made his debut in Japan during colonial times under the name Gita Koji, returned to Korea after liberation, where he made cartoons in English for the *Seoul Times*, and in 1948 started Korea's first comic magazine, *Manhwa Haengjin*. Unfortunately, he slipped a smutty image onto the cover art of the first issue, and once people noticed it, the magazine was shut down.

In the Korean War and afterward, cartoons were widely used for propaganda by all sides, as well as to cheer up hungry and war-weary children. After the war, comics began to enjoy an increased popularity, and by the late 1950s and early '60s, there was much diversity and creativity in Korean comics—much as there was in movies and music in that period. New styles and genres of comics appeared, such as the *sunjeong* manhwa (romantic stories for young women) and the *myeongnyang* manhwa (humorous comics). It is interesting to look at the variety of drawing styles used back then. Korean artists were drawing from a wide range of sources beyond Japan—the stylish surrealism of Windsor McCay, the compact lunacy of George Herriman's *Krazy Katt,* and many others. This is before the giant eyes and elongated androgyny of Japanese manga had been fully developed and absorbed by Korean artists. In addition, comics began to appear in the form of longer graphic novels, often around 200 pages, featuring much more complicated storylines in all sorts of genres. The early 1960s also saw the appearance of the first manhwabang, or "comic room"—cafes and stores where you could pay to sit and read all the comic books you wanted.

Unfortunately, as with the movie and music businesses, the mili-

tary government of Park Chung Hee made sure this period of freedom and creativity did not last long. Manhwa censorship began in 1961, and in 1966 the government forcibly created a comic distribution monopoly, which allowed for further control over content. With so much of the present off-limits, most manhwa creators turned to either light-hearted, uncontroversial subjects or historical dramas.

Comic books and animation have from the 1960s existed in a strange limbo in Korea, at once loved and loathed. The love for manhwa was clear enough to see—the thousands of manhwabang all over Korea (although more clustered in the cities), dedicated to selling and renting hundreds of comics. The loathing, however, also ran deep, especially among more dour and uncreative adults. In 1967, the humorless Park regime listed comics as one of the six evils in Korean society. And the Children's Protection Policy of 1980, under the government of then-President Chun Doo-hwan, targeted science fiction animation as "empty and meaningless illusion" (ironically, one of Chun's sons would go on to run a major comic book publisher, Sigongsa, in the 1990s and into the new millennium).

Despite the moral crackdown under Park Chung Hee, the 1970s did see the birth of a new trend rather at odds with the general stultifying of most of the comic industry—the rise of adult comic strips in the Korean newspapers. The *Ilgan Sports* started the trend with Goh Woo-yeong's series *Lim Geok Jeong* in 1972, which was so popular that the style quickly spread. Comics such as *Goindol* and *Kkachi of Shimonosek* used sex and more mature subjects to find new audiences who wanted more than just childish pratfalls. On second thought, perhaps the adult comic is not so surprising. The movies, too, were looking at sex and risqué topics as the 1970s went on. It was as if the Park regime used sex as a safety valve to keep people from seriously pondering more important social problems.

And so the manhwa industry continued through the rest of the Park Chung Hee era and following Park's death into the 1980s under Chun Doo-hwan. Chun may have been just as autocratic as Park, but he never was able to amass the same kind of power that Park had, and cracks began to appear in the authoritarian government. In 1982, Lee Hyun-se would publish a popular and very important comic book series called *The Terrifying Mercenary Baseball Team*, which metaphorically and harshly critiqued the military dictator-

ship of the day. On the other end of the social spectrum, 1983 saw Kim Su-jeong create *Dooly the Dinosaur*, one of the most enduring children's comics in Korea.

As the 1980s wore on, especially with the 1988 Olympics and the return of democracy, Korea experienced a rebirth of freedom and openness. The founding of the adult monthly comic magazine *Manhwa Gwangjang* in 1987 was a big boost to the industry, creating a whole new generation of star comic creators. Not long after the birth of *Gwangjang* came a rebirth, with the founding, in 1988, of *Renaissance*, a magazine dedicated to the sunjeong manhwa, helping the romance comic find greater popularity than ever.

The Modern Comic Book Era

With the 1990s came the second great age of comic books in Korea. Sales soared, as did the number of publications each month. In 1990, 4,130 volumes of manhwa were published, selling 6.8 million copies. Those numbers would grow steadily over the decade, peaking in 2000 with 9,329 volumes published and 44.5 million copies sold. Sports newspapers were also rediscovering comics, as several serials became big hits, such as Huh Young-man's *Tazza: War of Flowers* and Bang Hak-gi's *Joseon Female Detective Damo*. The year 1988 also saw the birth of the first children's weekly manhwa, *IQ Jump*, by Seoul Cultural Publishers, followed by *Sonyeon Champ* in 1991 by Daiwon Publishing. *IQ Jump* was quite a phenomenon, the first weekly to publish over 110,000 copies per issue, and making a point of presenting new artists and ideas. Thanks to *IQ*, Seoul Cultural would be one of the top manhwa companies in Korea for years. There were monthly and bimonthly graphic novels, weekly anthologies, long-run series and short, all manner of stories. In the peak years, some publishers even created daily comics, with huge teams of artists cranking out 100-page-plus books every day.

Sonyeon Champ saw the birth of what would become Korea's biggest manhwa house. Daiwon had started as an animation house in 1973, then called Won Production. At first, it subcontracted the animation for such Toei cartoons as *Galaxy Express 999* and *Candy Candy*, and in the 1980s, it took on American shows, too, such

as *Rambo* and *Teenage Mutant Ninja Turtles*. In 1987, it made the first Korean animated TV show, *Wandering Gatchi*. Daiwon had also teamed up with director Shim Hyung-rae (*Yonggari, D-War*) and his movie production house to make a series of wildly popular comedies, which by the late 1980s had Daiwon flush with cash.

It was those profits that allowed Daiwon to move into manhwa in 1991, starting with *Sonyeon Champ*, a comic magazine deliberately modeled on the Japanese comic magazine system. Over the years Daiwon has used *Champ* to introduce many of the biggest Japanese manga to Korea—*Slam Dunk, Sailor Moon, Pokemon, Evangelion*, and more.

At the time, Korea's manhwa could not be found in normal bookstores, only in specialty stores, which greatly limited their appeal. Getting into bookstores improved not only manhwa's circulation, but also their image, making them more respectable. Women especially were not fans of the old, grungy manhwabang and comic stores, so being able to buy their romantic sunjeong in regular stores was a major boon to the girls' comic market. "Daiwon's success is because we've continually developed new writers and artists," said Kim Nam-ho, until recently the licensing director at Daiwon. "We've always used our profits from the popular Japanese comics to develop Korean writers." In fact, Daiwon was so successful that in 1995 it started its own competition, called Haksan Publishing. Daiwon and Haksan have for years been the No. 1 and No. 2 comic publishers in Korea, with Seoul Cultural firmly in third.

Today, Daiwon is still located down a set of small, dingy streets in the Yongsan part of Seoul, just a wrong turn from one of the city's larger red-light districts. The company is like a small campus, with three old buildings crammed onto a tiny lot. With the renovations going on when I last visited, it almost felt like Dr. Who's Tardis—rundown and plain on the outside, but remarkably nice and modern on the inside. The company went public in 2002, at the end of the heyday for manhwa, but it delisted in 2006. "We've always been located here," said Kim. "All the major comic companies are in this area." Even though Kim Nam-ho is now the head of his own comic licensing company, TOPAZ Agency, he continues to refer to Daiwon as "we." His office is not only in the Yongsan area with the other publishers, it is in the Daiwon complex.

The Animation Divide

Anyhow, Daiwon's animation-manhwa connection brings up an interesting point: the surprising lack of connection between Korea's comic book and animation industries. Despite what would seem like an obvious connection, very few manhwa have gone on to become animated television series or movies (although recently a few have been made into live-action movies and TV shows). Even Daiwon, with its resources and vast catalog, has tried to make the connection only a couple of times.

The animation industry in general in Korea moved along in fits and starts over the years, swinging wildly between feast and famine, with little mind paid to the government's sniffy disapproval of the medium. The first Korean animated film was Shin Dong-hun's 1967 retelling of the traditional Korean folktale *Hong Gil-dong* (using scavenged leftover US Air Force surveillance film). Kim Cheong-gi's *Robot Taekwon V* (modeled on the Japan's *Mazinger Z* series, a big hit on MBC TV in 1975) was Korea's most successful animated movie, hitting theaters in 1978. From 1976 to 1985, some sixty animated movies were released (mostly giant robots, in the mode of Japanese science fiction at the time). No animated films were released between 1972 and 1975, nor between 1987 and 1993.

After a seven-year feature animation drought (when mostly Korean television and foreign subcontracting was done), a government study released in 1994 reported that 98 percent of Korea's visual me-

Laying It on the Line—Nelson Shin's Life in Animation

t is the most Korean of folktales. A young girl, Shim Chung, gives her life to a sea dragon so that her blind father might see again—and then the young girl is rewarded for her filial piety when she becomes a princess.

In 2005, Shim Chung earned another reward for her selfless sacrifice—an animated version of the ancient tale became the first film to have a simultaneous release in North and South Korea.

Empress Chung opened on fifty-one screens in South Korea on Aug. 12, 2005, then six in the North on Aug. 15, sixty years after the United States and the Soviet Union divided control of the

Korean Peninsula, following the surrender of Japan that ended World War II.

Empress Chung was a labor of love for Nelson Shin, and an expensive labor at that. The Korean-American animator worked for seven years and spent over $6.5 million of his own money to tell the classic tale. After a lifetime of animating other people's stories and characters—Shin's AKOM Production Co. does the grueling work of grinding out the tens of thousands of drawings needed in each episode of *The Simpsons*, among many other television shows—this was his story. "I picked *Empress Chung* because it had the most

dia exports at the time were feature animations. Suddenly, bureaucrats decided animation was good business, and the ability to make money was more important than (their irrational) biases against the cartoon arts. The Ministry of Finance and Economy set up tax breaks for animation companies. The Ministry of Culture devised plans to create an animation festival (which became the Seoul International Cartoon and Animation Festival) and held it in August 1995, a year before the Pusan International Film Festival ever got off the ground.

It looked like it could be a new age for animation in Korea. In 1995 alone, Stone Flower made *Hong Gil-dong Returned*, and Young Production made *Hungry Best 5. Blue Seagull,* Korea's first adult animated film, was released, and Daiwon made *Redhawk* (a series based on their *Sonyeon Champ* magazine). And in 1996, the science-fiction saga *Armageddon* was released.

Unfortunately, most performed poorly. Animation was expensive to make, too expensive for most production companies at a time when Korea's movie distribution system remained anarchic. *Hungry Best 5*, based on the *Ilgan Sports* series of the same name, was criticized heavily for being an obvious knock-off of the seminal Japanese series *Slam Dunk*. *Armageddon* flopped in theaters, overwhelmed by Hollywood's cutting-edge animation (think *Toy Story*). Three more releases in 1997 did so poorly that most major films in production were scrapped.

Despite all the hoopla over animation, Korea's biggest conglom-

drama," Shin says, "and it is full of our Korean tradition."

While $6.5 million might be a lot of money to you or me, it is not much when it comes to producing a feature-length film. So Shin turned to animators in North Korea to help him tell his story more affordably. Shin worked with about five hundred animators ("One hundred in the South, and the rest in North Korea") over seven years to create the five hundred thousand drawings (cells) required for *Empress Chung*. "The usual *Simpsons* episode has about twenty thousand cells in twenty-two minutes," Shin says, "Empress Chung had a lot of details."

Since the late 1990s, the Pyongyang-based SEK animation studio has been active in working with a wide array of international productions. "North Korean animators are excellent," Shin says. "They learn quickly and work very hard."

It was also a natural connection for Shin, born in what is now North Korea back in 1939. Shin was just twelve years old when he walked with his family from North Korea to the South during the Korean War. "I remember bombs going off overhead," he says. Despite the hard times after the war, Shin knew he wanted to draw. After doing editorial cartoons for

erates had kept their distance. CJ Entertainment talked about setting up an animation division (modeled on that of Dreamworks SKG, in which CJ had made a major investment). And the birth of the cable channel Tooniverse would prove to be an important part in Orion's rise as a media power. But after the conglomerate Ssangyong's ill-advised investment in one of the 1997 flops, no one else was willing to make the move into animation and manhwa. CJ and Orion had been instrumental in building up the movie and television industries, adding a level of professionalism and scale they had been lacking, but no large investor was willing to transform the comic book industry. Even the biggest animation and manhwa company, Daiwon, found it too risky and retreated back to comic books and subcontracting the hard work from Japanese and American animators. Not glamorous, but it paid the bills. In fact, by the mid-1990s, Korea subcontracted over half of all global animation. People were making a living, but there was little connection to the thriving manhwa business.

Why did Korea have so many problems creating original animation when the comic industry was booming and the two biggest comic publishers—Daiwon and Haksan—were owned by the major animation company Daiwon?

One of the biggest problems, somewhat counterintuitively, is the power that Korean comic creators have. Korean writers and artists have more power than do artists in other media. They control their copyrights. They have no fear of corporate corruption nor the wa-

newspapers and working on animated films, he immigrated to the United States in the 1970s.

There, he found work at DePatie-Freleng Enterprises—one of the main subcontractors for Warner Bros. Cartoons—continuing there after Marvel Comics bought it in 1981. Highlights of his tenure included the light sabers in the original *Star Wars* film, and producing *The Transformers* television series and directing the animated movie.

But it was an emergency rush for the 1986 film *My Little Pony: The Movie* that allowed Shin to start his own company. In only ten weeks, his newly formed team of animators in South Korea was able to animate the three hundred thousand cells required for the film. "We all just worked non-

stop," he said, still visibly proud of the achievement after all these years.

It was a bountiful time for animation. In 1994, the Korean government finally recognized the economic potential of the industry and began to support it. By the late 1990s, Korea took in almost 50 percent of the world's subcontracted animation. AKOM at one point employed more than 1,700 people.

Today, however, AKOM employs just 150 people, as most of the Korean animation industry is suffering a serious slowdown. A rising standard of living makes Korean labor less of a bargain, as animation companies increasingly move to the Philippines, Vietnam, and, yes, to North Korea. In addition, 2D animation has fallen out of favor, as

tering down of their dreams for multi-platform, mass-market campaigns. That freedom has harmed the industry.

This might seem like a sacrilegious idea to many. Isn't artistic control an absolute good? Well, frankly, no. Creator rights are, of course, very important, but having all the rights in the world does not matter very much when the rights are worthless. Strong companies, able to capitalize on those rights to expand their markets, are also good for the comic industry. In Japan, where many comics are created in publishing companies as part of much larger corporate plans, the comic is much more than just the paper it is printed on. It is the animated series. It is the movie. It is the trading cards and the toys and the novelization and more. Comic creators may lose some freedom, but by working as part of the much larger corporate machine, they get the benefits of having their stories marketed in many forms. In America, too, the comic publishing part of the comic book industry pales beside the other rights. An *X-Men* comic book might sell to 200,000 people, but millions see *X-Men* movies.

Korea's system can be quite lucrative when a creator wins big. Some estimate that Lee Myung-jin's *Ragnarok*, for example, has earned over $60 million in royalties, thanks to the incredibly popular video game and Japanese animated series of the same name. Daiwon, however, did not share in that success. Good for Lee, sure, but bad for Daiwon. Daiwon knows it will not profit from its comics when they find success in other forms, so it puts little effort into find-

audiences increasingly turn to 3D films like Pixar's *Toy Story* and *Ratatouille*.

Most seriously, Korean animators did not learn how to tell their own stories, preferring to churn out others' tales. "Koreans' technique is okay, but they don't know anything about creation," Shin says.

Recent Korean attempts at original animated stories have a grim history at the box office. The $10 million science-fiction film *Wonderful Days* barely made $2 million. *My Beautiful Girl, Mari* and *Oseam*, both Grand Prix winners at the Annecy International Animated Film Festival (2002 and 2004), barely made a blip at the Korean box office.

Empress Chung—which also won a special prize at Annecy in 2003 and the top prize at the Seoul International Cartoon and Animation Festival in 2004—did not escape that fate either, earning just $140,000 in its opening weekend (although it was an incredibly competitive weekend).

Shin did not finish working with North Korea after that, though. He says that North and South Korea both signed on to co-produce his next project, a six-part animated series on Goguryeo, an ancient state that once occupied the northern half of the Korean peninsula and much of Manchuria around two thousand years ago. China recently created a fervor in Korea when it claimed historical ownership of Goguryeo history. "I don't want to focus on where the land was, I don't want to make trouble," says Shin. "But it is a fantastic story."

Lee Myung-jin's manhwa Ragnarok *became the basis for a popular online video game that has millions of users worldwide.*

ing other platforms. Though Daiwon is the biggest comic book publisher in Korea and one of the biggest animation companies—so much synergy just waiting to happen—it has never been able to make a significant deal. Which is pretty incredible when you think about it.

However, it was the best of times for manhwa publishers, with year after year of sales growth. Even the Asian economic crisis (1997–98) could not derail the good times for comics—at least it did not seem that way on the surface. In fact, just from 1997 to 1998, the number of comic books sold leapt from 23.6 million to 33 million.

In the short run, the economic crisis actually helped the comic industry. Many unemployed people opened small shops to get them through the rough times. Some opened bookstores, others video rental shops, and several thousand opened manwhabang. This was a solid boost for the industry—rental shops needed to buy books, more locations meant availability, and sales grew. At its peak in 2000, the comic industry sold 44.5 million volumes.

Comics in the Internet Age

Alas, the increase in rental shops began to hurt the industry. Competitive prices cut into sales. After all, why bother to buy graphic novels and build collections that could quickly outgrow the limited shelf space at home (and risk incurring your parents' wrath for wasting money and not studying) when you could read all the comics you wanted for a fraction of the price?

Even worse, it was the beginning of Korea's Internet age. A big problem began when the comic fans started putting their favorite comics online, to be read by anyone for free, faster than the authorities could crack down on copyright violations. But a bigger problem was that comics suddenly had more competition than ever before. Games like *StarCraft* and *Ragnarok* (based on the manhwa, ironically enough) kept young people glued to cathode-ray tubes all over Korea, hour after hour, time once spent reading comics. Movies were on the rise, too, further competing for people's time and money. So sales began to drop. Slowly at first—in 2001, they fell to 42.2 million volumes. But then faster, until reaching a low of 20.7 million volumes in 2006—still three times higher than in the early 1990s, but less than half of their peak.

Mirroring what happened in the music business, the Internet hurt the manhwa industry, but also gave it new life. While some people violated copyright law and posted comics for free on the Internet, others made original comics for the Internet. With neither bosses nor distribution channels to worry about, the Internet provided a major creative outlet for artists, who launched a new wave of manhwa.

The first online comic service was the webzine *Hacking*, founded by Haksan Publishing and a bunch of Internet startup companies in 1999. *Hacking* focused on new talent and helped get many artists started but never really became a major hit. Business trouble among the partners ended the online venture within six months (the print edition continues).

For the next couple of years, the Internet began to take off in Korea, particularly the high-speed broadband Internet needed for viewing large graphic images quickly. Plenty of people tried getting new online comic ventures going, but they rarely lasted very long. Online portal sites, hugely popular in Korea, moved some offline comics to the Internet world, but didn't discover new talent or transform the industry (they just leeched off the publishers).

The online comic world began to shift in 2002, when Shim Seung-hyun's *Papepopo*, a unique combination of heartfelt essays and cartoons, first landed on the Internet. An agricultural processing major in university, Shim took a big detour in 1997 and started working in animation as a painter. He first posted the *Papepopo* sto-

ries on his homepage in 2002. They grew from a crush he experienced at university. He developed them into something more—and less—when he found he could express more through simplicity. He drew on ordinary A4 white paper, then scanned the pictures into a computer. Almost immediately they drew a big audience, as people excitedly passed them around.

Publishers had rejected Shim's unpretentious reflections on life and love as too simple and naïve. Online, however, *Papepopo* grew into a phenomenon. When he did get *Papepopo Memories* published offline in 2003, the book sold 1.2 million copies and was the number one book in Korea for eleven weeks. Shim has published three volumes of *Papepopo*, each a bestseller.

Many Internet artist wannabes tried to ape Shim's simple essay style. None made a notable impact. While Shim wrote simple essays with a minimum of story, Korea's next Internet sensation used the unlimited space of the World Wide Web to create long serial stories. He called himself Kang Full, but his real name was Kang Do-young. He became more influential than Shim.

Born in Seoul in 1974, Kang studied literature at Sangju University, but his interest drifted toward cartooning while drawing agitprop for student rallies. He found the art more interesting than the protests, too. On his website, Kang talks about looking at a dramatic cartoon in a prominent left-wing newspaper, the *Hankyoreh*, and thinking to himself: "This is a different way of looking at the world." From that moment, he was hooked.

After graduating, he did freelance cartooning for several years. His career took off in 2003 when he started posting his series *Innocence* (also known as *Cartoon Romance*) on Daum.net, one of Korea's most popular web portals. The warm-hearted story of a romance between a young office worker and a high school student, the series quickly became a huge hit, garnering 2 million clicks a day. When he gathered those strips together, the offline version became a bestseller, too. Unlike Shim, Kang wrote longer stories, arranged vertically to make them easier to read on the Internet. Smaller strips added up to form a coherent, longer story.

Since then, Kang has had several successful series. His thriller *Timing* was so popular it actually caused the massive Daum servers to crash when, on one day, 3 million people tried logging on to see

the latest issue. Since then he's had several other big hits, including the melodrama *Fool*, the horror tale *Apartment*, and *26 Years*, a comic about the Gwangju Uprising of 1980.

Kang opened the floodgates to a host of online comics, representing a great diversity of styles. Doha created the feline world of *The Great Catsby*. Kim Poong was another popular online artist, along with Koh Phil-hyun, Marley, and others. The Poongkyung group's *Estancia* was a popular free comic that switched to a pay service for the last issue (a very sneaky tactic). The artist who calls himself "B-Geup Dalgung" created an infamous web comic called *Dasepo Naughty Girls*. Dasepo pushes the envelope so hard with its extreme (and extremely funny) tales of the lurid, licentious, and all-round-fun world of Museulmo High School, that it's difficult to imagine the manhwa appearing anywhere but on the free-wheeling Internet.

One of the most remarkable aspects of Korea's online manhwa is how Korean they are. Unlike offline comics, which are about 70 percent Japanese in Korea, online comics are over 90 percent Korean. In graphic novels and books, the giant manga industry still leads, but on the World Wide Web, Korean audiences seek Korean artists.

Despite such popularity, it's very hard to quantify the online market. So far, I have been talking only about legitimate manhwa creators. Korea's online comic scene started with people uploading comics, blatantly violating copyrights. "Scanlations"—the work of people independently translating comics and posting the strips online—are a huge part of the market. The Korean Culture and content Agency estimates that $6.4 million worth of comics were posted online in 2005.

Even among legitimate comics, most are available for free, so artists must make money from online reprints, advertising, licensing, or other methods. The Internet portal Daum has 50,000-plus comics on its website—available for free. Other services, like SK Communications' Crayon site or Ecomix Media, charge for viewing their thousands of manhwa. Some artists shy away from putting their works on the Internet for fear that Internet piracy will hurt their offline sales, but other artists (including the veteran Won Soo-yeon) now publish their online works first, offline works second. In short, Korea's Internet manhwa market is like much the rest of

its Internet economy—wild, dynamic, constantly in flux, and a hard place to make money.

Artistic License Another big change for Korea's comic market is the significant rise in licensing, as more and more manhwa make it to big and little screens. Of course, a few comics were adapted in the past, but only a few. From 1990 to 1999, three manhwa were turned into live-action movies, three into live-action television series, and one into a stage play. From 2000 to 2006, the count was five movies, four television series, and six plays, with many more in production. Video games follow a similar trend: seven in the 1990s, but eleven since 2000 (plus fourteen for mobile phones). Animated movies are a little different, with sixteen manhwa turned into animated movies or TV series, but many of those happened in 1990 (four) and 2005 (three).

Some manhwa to make it to the big screen include *Beat* (1997), *Bichunmoo* (2000), *Fighter in the Wind* (2004), and *The Duelist* (2005), which had roots in Bang Hak-gi's 1970s comic *Damo Nansuni*. On television, the biggest shows were *Goong*, *Damo* (from the same comic as the movie), and *Full House*. In live theater, Kang Full's *Innocence* was the biggest hit, onstage twice already. Overall, Heo Yeongman (the creator of such hits as *Tazza: War of Flowers* and *Gourmet*) is the biggest manhwa star for adaptations, with two animated adaptations, two movies (plus another in production), two TV shows (plus another in production), and two video games.

Kang Full has been highly in demand, as four of his stories underwent the movie treatment. *Apartment* was the first to hit theaters, renamed *A.P.T.* and directed by Ahn Byeong-gi (*Bunshinsaba*). *Fool* was made with Cha Tae-won and Ha Ji-won. *Cartoon Romance* and *Timing* are in the works, too (*Timing* will even be directed by Park Ki-young, best known for his *Whispering Corridors*). In addition, *Cartoon Romance* was turned into a stage play, and *Timing* is also being made into a television series. Kang is ambivalent about the whole process. "I'll leave the movies to the movie professionals," says Kang. "I just concentrate on making comics."

One comic book, Hyun Min-woo's gothic spaghetti-western

Priest, was famously optioned by Sam Raimi and Sony Screen Gems, and will be made into a Hollywood blockbuster.

"There has been a significant increase in the number of movie productions over the years, but not enough story material for all those projects," says Lewis Kim, a movie producer who has much experience dealing with comic book titles. "The relative success rate for those comic-book projects . . . means this trend will go on."

Catherine Park, head of international business at iHQ, similarly sees the need for content, along with cost con-

© Daiwon C.I. Inc., Hyun Min-Woo

Hyung Min-woo's horror/Western graphic novel Priest *is set to be turned into a big-budget Hollywood production.*

trol, driving this trend. "First of all, it's cheaper to option comics, rather than hire writers to write original stories," she says. "Secondly, with P&A (prints and advertising) costs increasing a lot, sometimes more than the cost of filming the movie, being able to use comic books' built-in audience helps raise awareness, which helps market the film."

Another reason Korean movies are increasingly turning to comic books is because of the growing skill of Korean comic artists and the sophistication their work. "The children who grew up reading manhwa are now grown-ups, mostly in their twenties and thirties, which means the market for these readers has been growing along with them," says Lee Ju-youn, formerly an editor at the comic book publisher Sigongsa. "Also, some new magazines target older readers with more sophisticated stories. And some adult comics have been published on the Internet, which is a new trend."

But still, old prejudices remain, and for all their creativity and all the adaptations of their works, manhwa artists still struggle to find respect. "I'm not sure if this trend can reach the point where comic

book authors get to be co-directors (of the film their work is based upon), like in the case of *Sin City*," says Lewis Kim. "In Korea, still not many people consider comic books to be a serious art or craft, like in Japan or the U.S.."

One person who worked early on to up the respectability of Korean manhwa creators is Eddie Yu, CEO of Seoul Visual Works and founder of Eddiestudio. With his short hair, goatee, gold necklace, and wire-frame glasses, he looks like an intense hipster, and for over a decade, Yu has been deeply involved in connecting the Korean and international comic worlds, getting Korean comics onto the Internet, and finding international licensing opportunities.

Yu got started in the comic industry in the United States in the mid 1990s, where a relative's husband was coloring for Jim Lee (the famous superhero artist). Through that connection, Yu grew increasingly interested in the comic book industry and started working to connect Korean artists with American comic studios and writers. Korea had a lot of talented artists struggling to make a living and America had a lot of jobs, so it seemed like a natural connection.

Around the same time, Yu also tried to sell Korean comic books to America, but he was unable to drum up interest. Back in the 1990s, American comic distributors knew little about Asia, and almost all of that was about Japanese comics. "No one would buy the books," Yu said. "Around 1997 I offered them to Dark Horse at a really low price, just to get started, but they said no, they weren't interested."

It turns out Yu was a little ahead of his time, as American comic distributors began to notice Korea soon after. As the 1990s went on, sales of Japanese comics began to grow. Companies like Tokyopop and AD Vision got into a fierce battle, trying to secure the rights to as many titles as possible, buying scores of titles at a shot. As the best Japanese titles were mined, the American companies began to look for alternatives, and Tokyopop's founder Stuart Levy already had a budding interest in Korean manhwa.

Tokyopop was still a fairly young company, begun in 1996 in Japan, then incorporated in California in 1997. By 2000, its presence in the United States was still relatively small, so taking a gamble on the unknown world of Korean manhwa was quite a risk. But still Tokyopop came to Korea and started buying up titles, looking to ramp up its publishing from 350 to around 500 volumes a year. Learning

the ins and outs of the Korean market took a little time, as did translations and all other preparations. But finally, in 2002, the titles were ready to roll.

Right from the beginning, Tokyopop's manhwa did well in the United States, thanks to such strong titles as *Ragnarok*, *Island*, and *Priest*. AD Vision also had some well-received manhwa (although it stopped publishing them due to internal problems in 2004), and when Shueisha and Shogakukan (two Japanese manga publishers) started VIZ in 2002, the competition for Japanese titles got even tougher. Even more serious, leading Japanese publisher Kodansha signed a deal with American publisher Del Rey in 2005, further depleting access to the top titles in Japan.

Korea, too, was growing more competitive. In 2004, several of Korea's top manhwa publishers, including Seoul Cultural and Sigongsa, teamed up to form ICE Kunion, forming a united front to tackle the North American market.

Korean manhwa exports, a mere $240,000 in 1999, shot up to $1.9 million in 2004 and to $3.3 million in 2005 (although many people reported a big drop in 2006). That would give Korean comics just 1 percent of the $300 million U.S. graphic novel market—not huge, by any means, but not bad either. Tokyopop alone has licensed over seventy-five titles, by far the most of any Western importer, and has had hits from the United States and Germany—in fact, Tokyopop's first number one hit in Germany was *Demon Diary* by the duo of artists known as Kara.

As suddenly as Korea's exports rose in the United States, their rise has been even more impressive in Europe. France especially em-

Quite a Quota
No matter how well Korean movies did in Korea, much of the industry remained firmly committed to maintaining the long-running Screen Quota system, which guarantees all screens in Korea must show Korean movies. The Quota may not have saved the film industry, but it did lead to some creative imagery.

© Garam Hui

braced manhwa, and many Korean artists became well-known stars in the medium. Korean movies have done well in Europe for several years, winning all sorts of awards in all sorts of film festivals. The Korean animated films *My Beautiful Girl, Mari* and *Oseam* both won the top prize at the Annecy International Animated Film Festival (in 2002 and 2004, respectively). But comics really had their coming out at the 30th Angouleme International Comics Festival in 2003. France takes comic books quite seriously, and from that moment, Korean artists were brought into the pantheon of the best in the world.

Korean comics grew dramatically throughout the 1990s at home, then expanded into the rest of the world and the Internet after 2002. It has been an amazing ride for Korea. Its comics industry went from boring also-ran, in comparison to Japan's, to being one of the most creative and exciting venues in the world for "sequential art."*

In the end, though, the story of Korean comic books is the story of modernization missed. Imagine if CJ Entertainment and the other big players never transformed the movie industry in the late 1990s. Imagine if television still looked like it did in the mid 1990s, before TV dramas took off and Korea's cable channels were created. In either case, those industries would look a lot like Korea's comic book industry today. Or a lot like Korea's music industry. If the manhwa industry had changed like the movie industry, lean(ish) and mean(ish), who knows what could have happened.

But the strange thing is, despite the social and business pressures moving all entertainment toward the unartistic middle, the comic book industry never sold out. Korea's comic artists and writers continue to create whatever it is they want to create, and over the years have produced some of the most interesting comic books in the world. Korean comic stories run the gamut from very male fighting/supernatural books to very female love/supernatural books (everybody seems to love the supernatural). They have that unmistakable, elusive, and vital artistic spark.

Major question: how long can the manhwa industry last the way it is? Can comics continue to attract the talented, creative minds

*I can't believe that term has caught on. I love Scott McCloud, but the first time he tried defining comics with the term "sequential art," I thought he was crazy. It's like if someone tried redefining jazz as "off-beat music," and a couple of years later, Winton Marsalis was using the term.

needed to keep the genre fresh and lively when most of the creators have trouble making ends meet? In the US, anime (manga made into animated films and TV series) very much drives the comic market for Japanese titles. Can manhwa improve its popularity in the United States without having animated films and series to cross-promote it? With comics providing so many raw ideas for movies and television in the United States, Japan, and now Korea, too, how long will it be before some media conglomerate absorbs one of Korea's top manhwa publishers, or else creates a bold new challenger? Perhaps the most important two questions are: Should the manhwa industry continue the way it is? And, how can manhwa creators keep their artistic spark once those corporate changes come?

Conclusion

On July 27, 2007, I was invited to give a talk at Kyung Hee University in Seoul, as part of a seminar about the Korean Wave. Given that movie, manhwa, and television exports had suddenly dropped, and over a year had passed without any big cinematic hits like *The Host*, there was considerable worry in the entertainment industry that Korea's great run of pop culture successes was coming to an end. I decided to have a little fun with the topic and people's worries, so offered the thesis that the Korean Wave was more than dead—it had never lived in the first place.

Just before hitting "send" on my email program, I looked at that thesis again and suddenly had a thought—what else is both dead and undead at the same time? Why zombies, of course. So I quickly titled the paper "Zombie Wave" and submitted it to the seminar organizers.

That turned out to have been a questionable move on my part. Some newspapers got a look at my essay and its catchy title, and not really understanding it, quickly cranked out a bunch of articles about how I was critical of the Korean Wave and thought Korean pop culture was worthless. Good, old-fashioned tabloid journalism. Of course, my essay was actually quite positive about Korea's many achievements in entertainment and the arts. Nonetheless, soon I was fielding phone calls from my contacts and friends in the industry, upset that I had apparently written such negative things. In the

grand scheme of things, the scandal was a small one, but in my little world it was more excitement than I prefer, and it took a few days of damage control to smooth the ruffled feathers.

But I did find it amusing and instructive to see how, despite years of writing positive stories and developing relationships, so many people were so ready to believe the worst. For all of the Korean entertainment industry's amazing triumphs and feats, there is a real insecurity still, as if people fear their accomplishments are not real and could be taken away at any time. In fact, in all the years I have lived in Korea, despite all the fantastic gains that have been made, I have never heard a producer or executive in the entertainment industry tell me, "Yeah, things are pretty good these days." The amount of money being made by local filmmakers grew nearly fifteen times larger from 1996 to 2006, but still the movie industry is in trouble. Korean TV exports have grown ten times from what they were, but television people still find times tough. Digital music sales are as big as CD sales once were, but that does not matter.

Part of that worry, I think, comes from how Koreans think about their cultural triumphs of recent years.* "The Korean Wave"—the term originally arose to talk about the success of Korean pop culture abroad, but it has also become emblematic in many people's minds of all of Korea's accomplishments, at home and abroad. "Korea is a small country," people repeat endlessly, "We need to be successful abroad."

But a quick glance around the world clearly shows that the size of the Korean nation is not the source of the problem. Plenty of artists, singers, actors, and directors succeed in much smaller markets than Korea's. Iceland is a country full of great music, despite having fewer than a million people. Quebec's film industry is surprisingly strong these days. Connecting with the world and finding success abroad is very healthy and helpful, but it is not always a necessity.

In Korea, success abroad is even thought to be synonymous with success at home. The reggae artist known as Skull barely made a ripple

*Of course, some of that worry comes from the natural pessimism of the bean counters. And Koreans do tend to be a rather pessimistic people, as explained by the late great scholar Hahm Pyong-choon in his wonderful essay "Shamanism and the Korean World-View," from the book *Shamanism: The Spirit World of Korea* (Berkeley: Asian Humanities Press, 1988).

at home with his band Stony Skunk (although he earned more than a few derisive titters), selling a paltry 30,000 copies of his first three albums combined. But as soon as his solo album made a little bit of noise on the Billboard charts, Korean journalists were suddenly clamoring for interviews. (Yet no amount of success would allow Korean journalists to embrace Korean-American comedian Margaret Cho.)

Waving Goodbye

The trouble with talking about a "Korean Wave" is that it does not really explain anything. Korean pop culture crosses many media, demographics, and regions, and it means very different things to different people. Can we really say there is anything specifically "Korean" that allows teenagers in Hong Kong to enjoy Korean pop music, adult movie critics in France to enjoy Korean cinema, housewives in Japan to enjoy its television melodramas, hip-hop fans in Germany to enjoy its b-boy dancers, and college-aged comic book fans in the United States to enjoy its manhwa? "Korean Wave" is a black box, a magical answer that explains everything and nothing.

Which is why I have told these stories with an eye to the business side of pop culture. Great artists come and go, sometimes famous but often unrecognized—the environment needs to be supportive to grow from a singular genius to a general trend. From the Renaissance to rock'n'roll, the great (and even the not-so-great) artistic movements have gone hand-in-hand with changes in society. Pop culture in particular is dependent on the mass media.

Korea's moments of great creativity seldom spread beyond the nation's borders. Shin Joong-hyun and the great rock music of the 1960s and early 1970s. The golden age of movies in the late 1950s and 1960s. Korea has had plenty of wonderful, creative artists and movements, but without a larger structure for them, they came and went like a breeze. Indeed, the policies of Korean military governments have been actively hostile to art of all sorts.

The common point through all the different facets of Korea's pop culture is bigger than just talented artists. It is the infrastructure and business behind the artists that supports them and allows them to operate on a global scale.

As a reporter who concentrates on the entertainment industry, I have seen a lot of changes in Korea's entertainment scene over the past decade. Indeed, I have seen a lot of changes in the entertainment industry across Asia. When I arrived in Korea for the first time, back in 1996, Korean movies were at their low point, in terms of domestic business, anyhow. The music industry, on the other hand, was at its apex, with the Seo Taiji phenomenon coming to an end just as H.O.T was starting an explosion of dancing pop bands. Television, too, was in a strong run, with drama after drama getting huge ratings, from *First Love* to *Sandglass* to *Hur Joon*.

But as far as the international community is concerned, the ups and downs of Korean pop culture were not on the radar. On occasion, a reporter from *Time* or *AP* might write about Seo Taiji or the phenomenon of the day, but on the whole there was little regular coverage of Korean entertainment. Even the trade magazines did very little—*Variety* ran a few stories out of Korea (often written by correspondents based in Japan or Australia), but *The Hollywood Reporter* had no correspondent, nor did *Billboard*. Even the Pusan International Film Festival, as impressive as it was from its beginnings in 1996, had a limited impact on the thinking of journalists.

If there was a big moment of change for the Western media, unsurprisingly, the moment was *Shiri*. Dimwitted editors in Los Angeles or New York may not know a Biryani from a Bibimbap, but they do recognize the words "record-setting," not to mention simplistic catch-phrases like "bigger than *Titanic*" or "the $5 million film pulled in $27 million at the box office." *JSA* and *Friend* cemented the idea in editors' minds that something was going on in Korea.

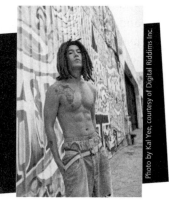

Head and Shoulders above the Rest
Despite many of Korea's biggest pop stars targeting the American market, the only one to make any noise on the Billboard charts was one of the most unexpected: a dreadlocked reggae artist named Skull, almost unknown in his home country, who reached No. 4 on the Billboard R&B/Hiphop Sales Chart.

Photo by Kal Yee, courtesy of Digital Riddims Inc.

At the same time, Korean movies were winning awards at international film festivals. Which may not mean much in terms of making money, but it raised awareness. Whether it was Lee Chang-dong impressing people in Vancouver, or Rotterdam with *Green Fish,* or Kim Ki-duk making people vomit at Venice with fishhooks, Korean films were building a reputation for their stories as well as their profits.

While Korean movies led the way to global recognition in the West, Korean music and television have fared less well there. Rain and Boa and the rest have enthralled fans around Asia, but to North American ears, they sound far too bubblegum and derivative to impress. Most stories about singing stars have centered on how well they are doing in Asia, or, on rare occasions, about plans to bring them to North America or Europe. Or else about the rise of digital distribution channels, which have been at the world's forefront in Korea.

But there have been no significant stories about Korean pop music that rave about the music for the music's sake. God knows I have tried to sell such stories but have been met with a brick wall of indifference. Recently, Shin Joong-hyun has gotten some press, but those stories were in large part about the brick wall of indifference the great songwriter has faced in Korea. For the most part, fans of Korean underground music have had very few outlets in the West or in Korea. In fact, several singers—such as Yoonki or Lee Sang-eun—have found they can do far better in Japan than they can at home. Hip-hop and b-boy dancing has gotten a little coverage over the years, especially recently, and Park Jin-young has worked tirelessly over the past several years building ties with American R&B and hip-hop producers. But now that Park's No. 1 creation Rain has gone his separate way, who knows what the future will hold?

Korean television also travels poorly to the West, coming across as histrionic soap operas most of the time. *Winter Sonata* has been huge all over Asia, and I have gotten emails from Egypt and Eastern Europe raving about *Dae Jang Geum*. But for people used to *CSI* and *The Sopranos*, there are only so many stories of separated twins and dying lost loves that one can take. Tellingly, the biggest Korean television impact in the United States has probably been Bobby Lee and MadTV's Korean TV parody *Taedo*, which they translate as *Attitudes*

and Feelings, Both Desirable and Sometimes Secretive. Which is saying something when the parody of a trend travels faster and farther than the trend itself.

Of course, Korea has not changed in a bubble. *Crouching Tiger, Hidden Dragon* really got people excited, getting unimaginative producers convinced that Western audiences were hungry to see endless martial-arts fantasies. Hollywood, ravenous beast that it is, has steadily absorbed much of Hong Kong's top talent. More than that, *Crouching Tiger* made producers all over Asia look to the rest of Asia. The number of coproductions continues to rise, as filmmakers look for the best star power in the region and for any secrets they can learn from their neighbors.

Also, travel within Asia is on the rise. More travel means cultural mixing, CDs and DVDs circulating in wider circles, more comic books, and just plain more. The Internet also has increased awareness in Asia of neighboring countries, their trends and tastes, hits and misses.

Pop Goes the World There never was a Korean Wave. Rather, what we are seeing is globalization in its latest iteration, and Korea was the first country in Asia to fully embrace the idea. In fact, most celebrities and producers I talk to these days wince at the words "Korean Wave." Some even grant interviews on the condition that I do not use the term. Clearly, there are a lot of negative connotations associated with The Korean Wave—shortsighted fad, poor financing, crude nationalism, and the like.

In addition, the business strategies employed by Korean companies (ones I have examined in this book) are not unique to Korea. They are eminently learnable. Today, we see creators all over Asia figuring out the lessons that Korean creators learned over the past ten years or so. Thailand is a rising star. Japan is trying to shake up its stolid movie industry, reluctantly and slowly learning the benefits of high-risk, high-reward entertainment. Even communist Vietnam is getting in on the act, creating TV dramas and movies very consciously influenced by Korean content.

As other countries learn the lessons the Korean entertainment

industry learned, the competition will only increase. Anyone who thinks there is something innately special about Korea will be rudely disappointed. Like so much else in international business, when a business is not growing and getting better, it risks fading in relevance and revenue, to be surpassed by those hungrier and more ambitious.

For all the great strides made over the past decade, there is still plenty more that needs to change. Korea's music industry desperately needs a live music scene, genuine artists, and clubs where young people can play and learn and grow. Its movies need a minor league to go with its major league, a place where young directors can break in with alternative projects and replenish the industry's creative engines. The manhwa industry needs partners who can inject money into the business, with intent to expand the manwha audiences with movie, TV, and animated crossovers.

But the single greatest problem with Korea's pop culture is its lack of historical connection. People buy today's hit songs, but they do not buy the hits of yesterday. They flood the movie theaters, but they do not watch films at the repertory cinemas or buy the DVDs. While in America, Europe, and elsewhere, media companies make as much or more from old music, old movies, and old TV shows, their Korean equivalents have lacked the luxury of those extra sources of revenue.

Catalog sales are essential to any country's pop culture, bringing in steady revenue streams that can tide over companies in the lean times and when big projects misfire.

Not to lay all the blame on Korean consumers, though. Their entertainment industries deserted them first. In figuring out how to better fire up the youth markets, the entertainment industry discovered a passionate, constantly renewing source of customers. But they also made their content even more disposable than pop culture usually is. It is in the industry's advantage to nurture both the talent of tomorrow and a love for the hits of yesterday.

The story I've been telling is important because it is not innate to Korea. It's the story of Asia. The story of the future. Korea was at the forefront of a variety of changes that are (or will be) affecting all of Asia and the rest of the world. People everywhere want the best, most engaging, most exciting pop culture they can find. But they

also want to see movies, listen to music, read stories, and watch TV in their own language, from their own culture, featuring their own stars. Slowly, our world is evolving into a place where people can have both. Where they will demand both.

The question for Korea is: How will Korea's entertainment industries respond to the new challenges and competition heading their way? Ten years is a long time to shine, and doubtlessly as other entertainment industries around Asia grow and learn, they will compete more and more intensely with Korea. Contending with this rising competition may be difficult, but it is also healthy, ever pushing creators and creative industries in Korea and across Asia. It has been exciting to watch and be a part of Korea's story over the past decade. I can only hope the next ten years will be just as exciting.

Index